INSIDE THE MAGIC: THE MAKING OF

FANTASTIC BEASTS
AND WHERE TO FIND THEM

IAN NATHAN

VALIDATED BY

M.A.C.U.S.A - REGISTER OFFICE Nº 289295

J.K. ROWLING'S
WW
WIZARDING WORLD

HARPER
An Imprint of HarperCollins Publishers

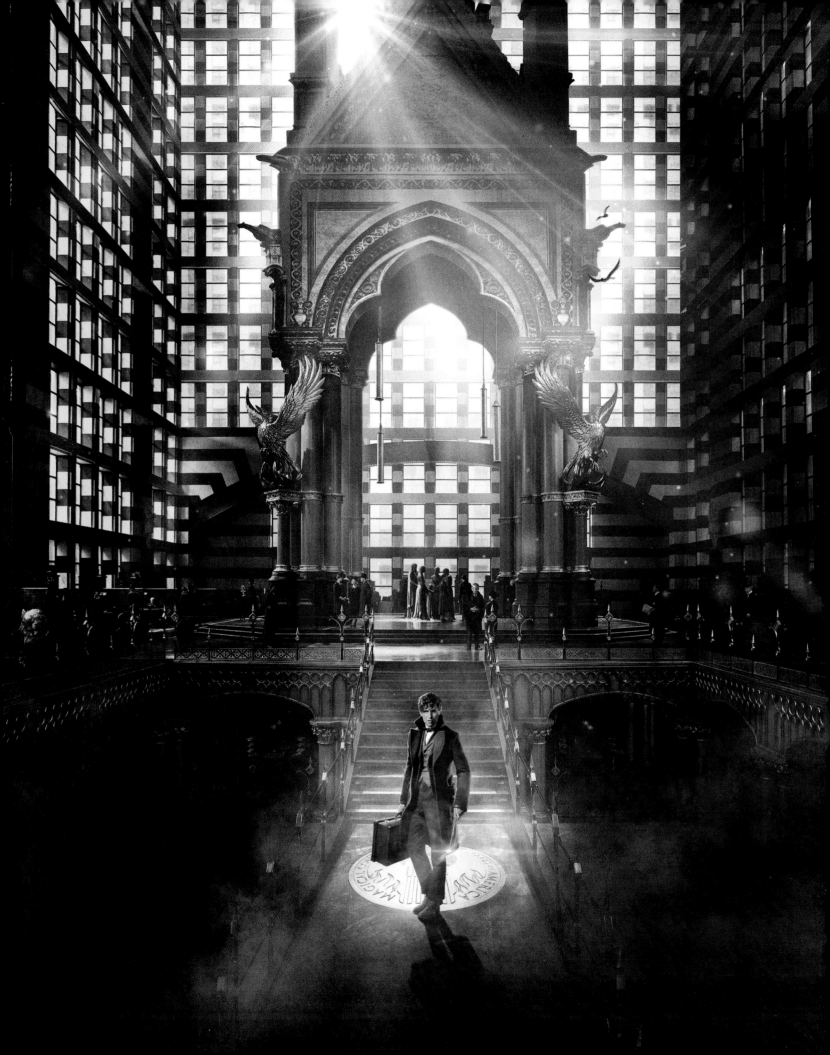

CONTENTS

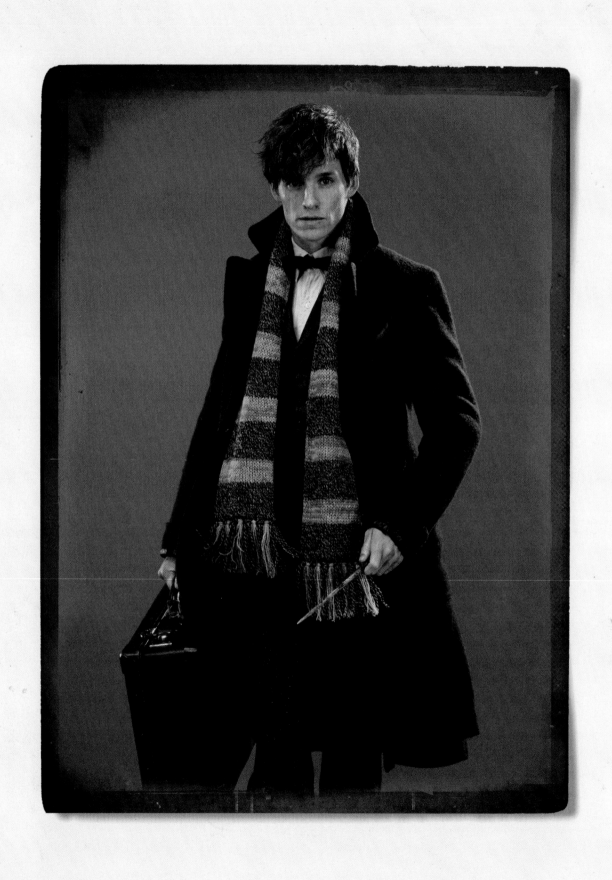

FOREWORD

It all started with a slightly clandestine meeting with David Yates about an unknown project. This was around Christmas time in the basement of a hidden little club in Soho, London, and there was a roaring fire. I knew that David had made the *Harry Potter* films, and during our meeting he began to reveal things about a screenplay that J.K. Rowling was writing. Sitting by the fire as he was telling the story, I was completely hypnotised.

Over the next year we would meet and he would gently tease me with more and more of J.K. Rowling's ideas. I became so invested in the story, hearing all these updates of what was going on in Newt's world, that when I was then cast I was elated. I finally got to read the script and I was astounded. J.K. Rowling had managed to encompass elements of a thriller, comedy, romance: different genres almost, and yet it was all woven together with such delicacy and was powerful emotionally. It actually had me sobbing.

What is wonderful for me in what J.K. Rowling has written, and what director David Yates has done when adapting her words, is their absolute conviction to the realness of the wizarding world.

One of my clearest memories was the day that David said, 'Eddie, pick a wand.' It was this extraordinarily magical moment. It sounds absurd but I felt like being a nine-year-old at Christmas. It was funny because, there I was, holding this thing – this was the moment my inner nine-year-old had been waiting for my whole life, and I had absolutely no idea what to do! Not a clue. I felt ridiculously self-conscious and got complete stage fright.

In the end I went back and watched many of Daniel, Emma and Rupert's moments in the Potter films and looked at what their 'wand-work' was like. They were pretty inspiring, I must say. I may have thieved a few ideas.

After years of secretly thinking I might be able to blag a part in the Weasley clan – being borderline ginger – it was wonderful to be able to jump into this world. But what was particularly great was to fall in love with my character specifically. Newt isn't easy. He doesn't ask for people's approval; he can be a bit hard and he marches to the beat of his own drum, but there is also a childlike quality to him, and you can hopefully sense from his relationship with the beasts that he has a great heart.

The whole experience of getting to play Newt was a complete riot. I'll never forget one scene on top of the department store with this gigantic winged creature called an Occamy. Basically, the Occamy goes a wee bit crazy and lifts Newt up onto its back. When we shot it I was suspended in the air riding some kind of massive green bucking bronco (because the creature will be added later, digitally) shouting about insects and teapots, with cameras soaring around me left, right and everywhere. It felt totally, totally surreal. But, touch wood, it will end up looking pretty thrilling.

Entering the wizarding world, the world of J.K.'s imagination, has superseded all the fantastical expectations that I had already had. I truly count myself a lucky, lucky man.

Eddie Redmayne

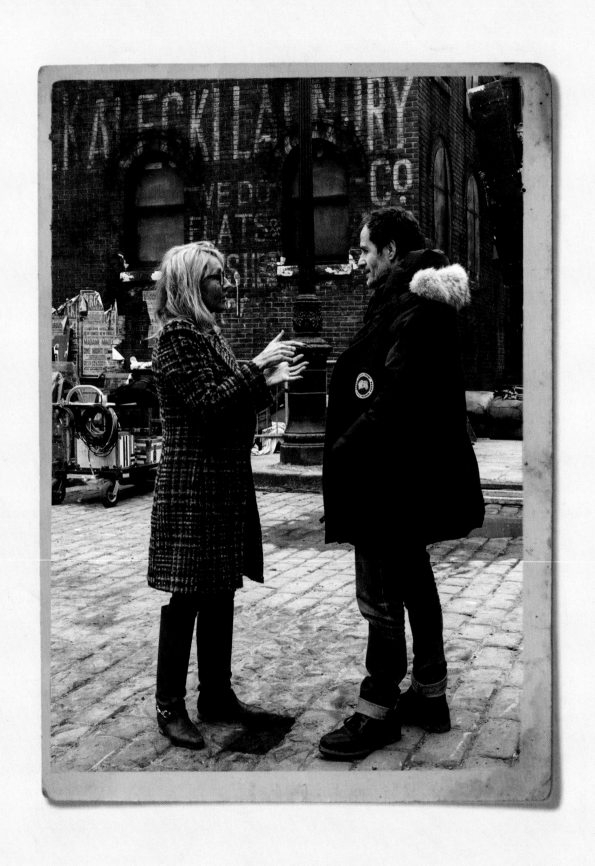

INTRODUCTION

In the summer of 2011, with the release of the eighth and final *Harry Potter* film, I closed the book on one of the most fulfilling chapters of my career, having spent more than a decade immersed in the wizarding world, created by the brilliant Jo Rowling. Little could I have imagined then that, just a few years later, I would be returning to that world for a new adventure, called *Fantastic Beasts and Where to Find Them*.

I will admit to feeling mildly apprehensive when Jo first announced that she was writing the screenplay for the film. Her genius as a novelist is without question; nevertheless, being an inspired author and an accomplished screenwriter don't necessarily go hand-in-hand. As soon as I began reading her script, however, my concerns evaporated. Her gift for creating vivid, enchanting characters, and for drawing the reader into engaging stories with true thematic depth, resonated on every page.

With this original screenplay, Jo has brought to *Fantastic Beasts* a number of the elements that have made *Harry Potter* so beloved. Her script is filled with the endless wonder and magic of the wizarding world; it delivers the same fun and thrilling adventure; and it weaves in rich, timeless themes that are both touching and thought-provoking—the fear of others that comes with a divided world; the feeling of being an outsider in search of a family; the need to be true to oneself. And yet this film is utterly fresh and distinct; offering untold surprises to the most dedicated of *Harry Potter* fans. It takes us far away from the insular world of Hogwarts into new and unexplored corners of this magical world: to the vibrant streets of 1926 New York, where wizards and witches exist in secret; and to the depths of Newt's magical case, filled with the weird and wonderful creatures he has gathered from around the globe – each with their own distinct personality. Our main characters are not teenagers: they are adults. And yet they are still innocents struggling with the challenges of finding their place in the world.

In bringing *Fantastic Beasts and Where to Find Them* to the screen, I was delighted to reunite with many of my *Harry Potter* colleagues, including my fellow producers Steve Kloves, Lionel Wigram and, of course, Jo Rowling. And the only director we wanted at the helm was the extraordinary David Yates. Amidst the magic, he brings truth to every moment and finds the humanity in every character. His ambition to push the envelope drives us all to be our best.

In the pages that follow, you will meet all the artists and artisans that worked tirelessly on *Fantastic Beasts and Where to Find Them*. It is an all-access look behind the scenes at the making of the film, showcasing the talent and dedication of everyone involved.

We invite you to come along on the journey; to begin this new adventure...

David Heyman

NEWT SCAMANDER

1

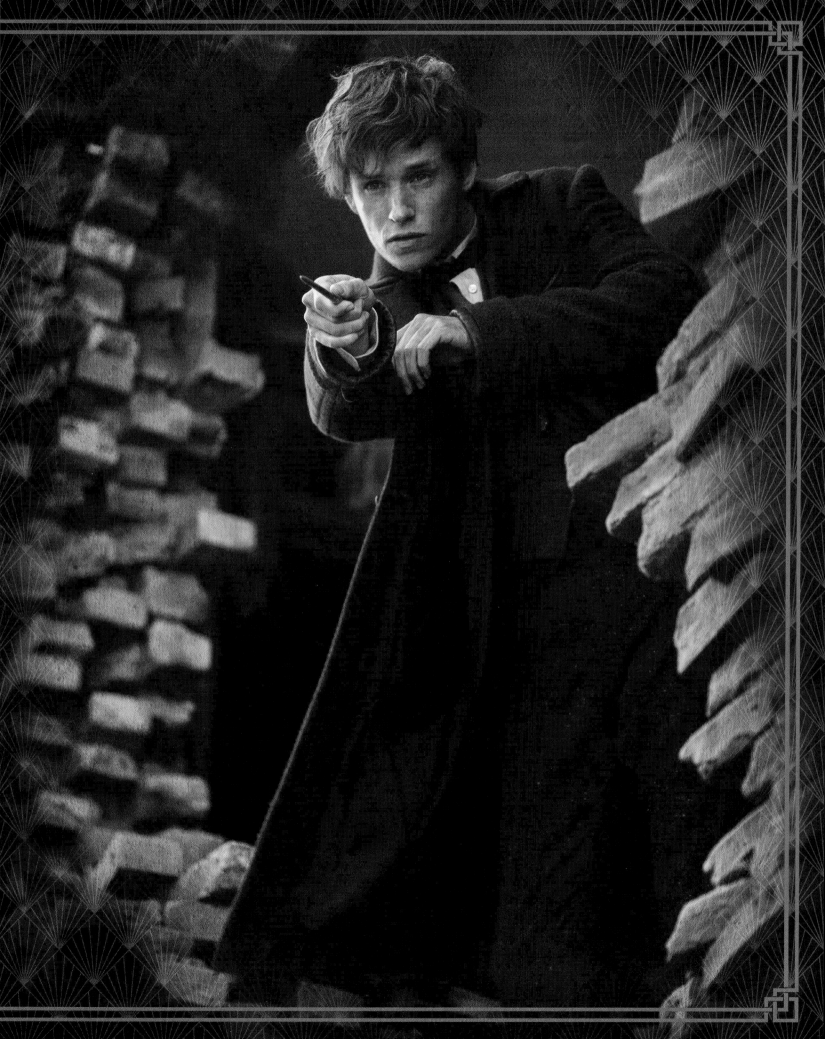

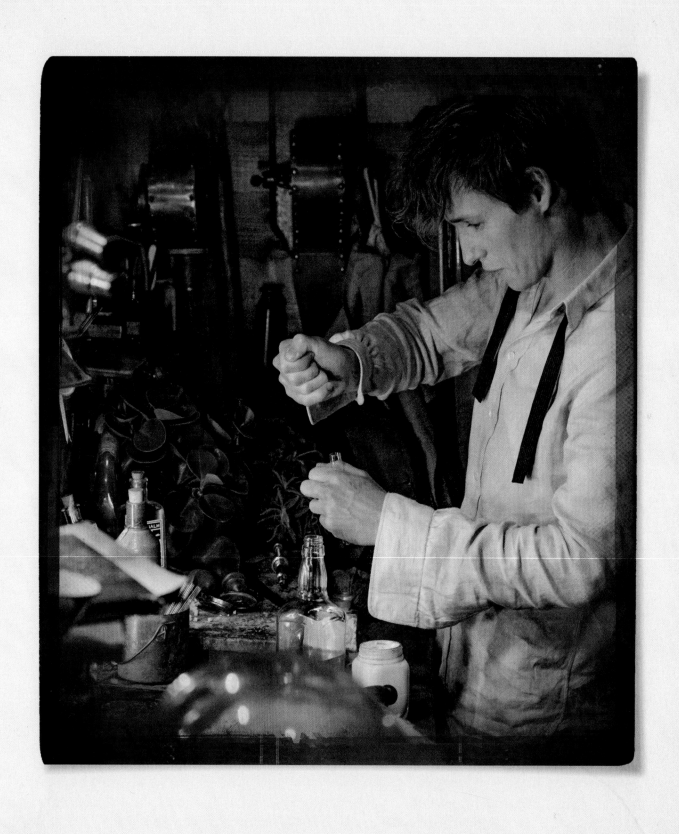

A BEGINNER'S GUIDE TO MAGIZOOLOGY

PUBLISHED IN 2001 IN AID OF COMIC RELIEF AND OTHER CHARITABLE CAUSES,
J.K. ROWLING'S *FANTASTIC BEASTS AND WHERE TO FIND THEM*
IS THE FICTIONAL VERSION OF NEWT SCAMANDER'S TEXTBOOK
FOR TEACHING CARE OF MAGICAL CREATURES.

Scamander, we are informed, is the wizarding world's foremost Magizoologist. The fact this is a pursuit frowned upon by some of the magical community in Newt's time (beasts are considered far too dangerous to be dabbling with), does not diminish a lifelong study of all the weird and wonderful creatures of the magical realm.

Written in Newt's upbeat, lightly meticulous voice it was a slim but wholly delightful extension of the *Harry Potter* universe, and it got Lionel Wigram thinking.

The experienced British producer can still remember the momentous day in 1997 when his counterpart David Heyman sent over a copy of the debut novel by a then unknown author, saying he thought it would make a really good movie. Wigram was equally smitten. He still treasures that faded copy of *Harry Potter and the Philosopher's Stone*, even though, he admits, it's not one of the 500 rare first edition copies credited to 'Joanne Rowling' and not 'J.K.', which have sold for upwards of £26,000.

Their instincts would, of course, prove spot on. Over the following fourteen years, Wigram was the Warner Bros. executive on the first four films and then the executive producer of the final four, which makes him, alongside Heyman, the longest-serving filmmaker in the *Harry Potter* world.

'It's been a great privilege, probably the greatest of my career,' he says, and coming from a man who has also produced the big-screen *Sherlock Holmes* films and *The Man from U.N.C.L.E.*, that means something.

J.K. Rowling's storytelling is, he thinks, attuned to something universal and timeless, like in the great fairy tales. She understands the human condition. Profound ideas and themes are communicated in a way that's very accessible and entertaining. 'And that,' he emphasizes, 'is a very, very rare thing.'

When they finally brought the eight-film *Potter* saga to a close in 2011, he admits he felt bereft. 'Was that really it?' he wondered. 'There had to be something more.' However, J.K. Rowling had been adamant there were to be no more *Harry Potter* books. So Wigram began to think more and more about the possibilities in *Fantastic Beasts and Where to Find Them*.

'Newt came to life for me on the page,' he says, 'this amazing character making his list of magical creatures, their different habitats, and how they behave.

PREVIOUS: *Newt Scamander, Magizoologist, begins his search for fantastic beasts.*
OPPOSITE: *Newt gives us a glimpse of the messy workbench inside his shed.*

TOP: *Newt mixes a magical potion.*
ABOVE: (*Left to right*) *This newspaper fragment gives a clue to the location of the Appaloosa Puffskein.*
• *Eddie Redmayne & Dan Fogler rehearse a scene with director David Yates.*
• *The boom camera zooms in on Eddie Redmayne and Katherine Waterston surrounded by a sea of extras.*

I couldn't help imagining him traipsing through various exotic environments, and the adventures he would have along the way.'

For J.K. Rowling, the relationship between her wizard and his beasts lay at the heart of her story: 'Newt has an affinity for them, a love of creatures that goes beyond our innate desire to cuddle something cuddly. Newt finds beauty in the most dangerous creatures.'

Wigram wondered if it was possible to transform what is essentially a catalogue of outlandish faunae into a fictional nature documentary. He admits it was just the glimmer of something, but you would follow this very eccentric explorer in search of different creatures.

Warner Bros. was receptive to the idea. Here was a chance to keep the *Harry Potter* flame alive while pursuing something entirely new – extending the universe in modern Hollywood jargon. So they pitched it to J.K. Rowling.

'I think she quite liked the idea,' laughs Wigram, 'and quite sensibly went off and came up with her own completely different story, which was much better, much richer, and more fantastic.'

J.K. Rowling explores the world of magic in New York in 1926. Newt Scamander has come to the city with his research almost complete, on his way to return a Thunderbird to its natural habitat in Arizona. But if asked, he will say that he's merely looking to pick up an Appaloosa Puffskein for a friend's birthday – one of the few Puffskein breeders is somewhere in the city. It will prove an eventful trip, filled with the full bounty of J.K. Rowling's enchanting sensibility.

'Nobody could possibly do it better than her,' insists Wigram. 'I don't think anybody but the creator would dare to take the creative licence to push the boundaries, to give you something new.' Rather than a series of new books, J.K. Rowling decided to cut out the middleman and compose the scripts herself, her first experience of writing directly for the screen.

'I really, really, really enjoyed it,' she confirms. 'And that's utterly different to being a novelist, where you're alone for a year, completely alone for a year, and then one person gets to read it. I thought, you know, I really want to write this screenplay. There's a story I want to tell.'

Even though she was exploring a 'new muscle group,' director David Yates has been flabbergasted at how easily she has adapted to the task.

'She can turn on a six-pence,' he says, amazed not just by her gifts for storytelling but her speed. Yates and producer Steve Kloves (responsible for seven of the eight screenplays for the *Harry Potter* films) would sit with J.K. Rowling, feeding through ideas from producers Heyman and Wigram at every stage. Every note sent her off in a fascinating new direction.

J.K. Rowling would then depart for her hotel and spend two nights at her keyboard, returning having not slept but rewritten huge portions of the script, sometimes producing an entirely new draft. Yates was staggered by the sheer output of that imagination. Even while making their changes she would come up with something entirely new. 'I know it's crazy but I just had to do it,' became almost a catchphrase.

'She doesn't have any of the fear,' says Yates. 'She doesn't have any of the experience of working in a system where ideas are constantly knocked back.'

If there was any downside at all it was that J.K. Rowling fed them too much goodness. As they homed in on the kernel of their story, she would provide layers of incredible detail, entire histories for even the most marginal character. 'She has so much flowing through her head,' says Yates, and he had to politely suggest they postpone some of her ideas to later movies.

It was never an issue. The director can look back on an entirely positive process. There were no prickly egos to negotiate, only a shared sense of purpose and the honesty that comes with familiarity.

'There's a huge amount of responsibility and pressure to go back to this universe and deliver something special,' he admits, 'but that is easier to bear when you are with friends and colleagues that you've worked with before.'

The finished script cast a remarkable spell – it was a *Harry Potter* film that was not a *Harry Potter* film. While set in the same wizarding world with many shared reference points – not least that Scamander is a former pupil of Hogwarts – this was a different kind of magical film. One less about the fulfilment of a child-hood destiny than the consequences of magic spilling out into the real world, albeit one as thrilling as New York in the 1920s. Newt has to fix his own mistakes, and in doing so fix himself. It is a film about grown-ups learning to grow up.

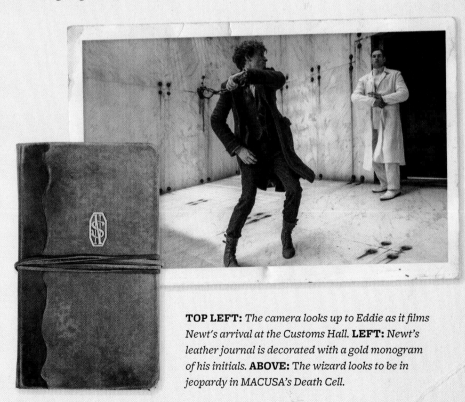

TOP LEFT: *The camera looks up to Eddie as it films Newt's arrival at the Customs Hall.* **LEFT:** *Newt's leather journal is decorated with a gold monogram of his initials.* **ABOVE:** *The wizard looks to be in jeopardy in MACUSA's Death Cell.*

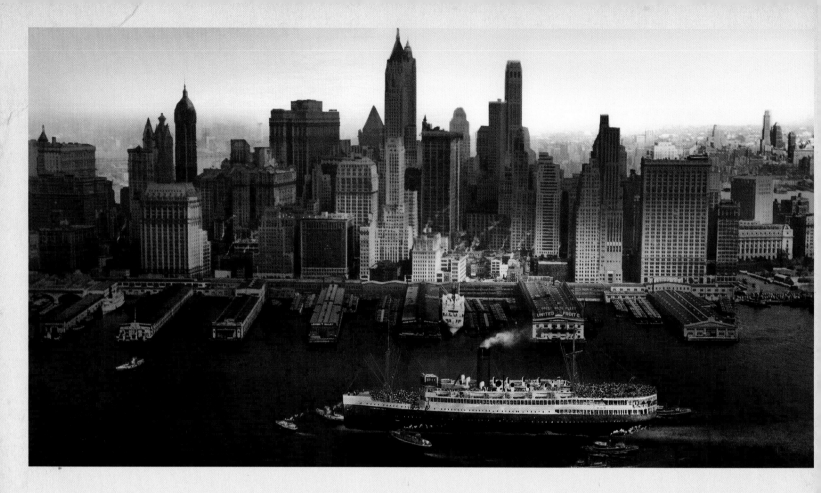

When several of Newt's fantastic beasts escape from his battered leather case, Newt must reclaim his extraordinary escapees before they become front-page news in one of the newspapers belonging to magnate Henry Shaw Sr. (Jon Voight). He is aided in his dilemma by a disgraced Auror (one of the wizarding world's police force) named Porpentina 'Tina' Goldstein (Katherine Waterston), as well as her beautiful, free-spirited younger sister Queenie (Alison Sudol). And, indeed, a luckless No-Maj (the American wizarding community's word for Muggle), and aspiring baker named Jacob Kowalski (Dan Fogler), who is about to have his horizons significantly widened. Assuming that no one Obliviates his memory.

Complicating matters, New York is not receptive to magic. Led by the glowering Mary Lou Barebone (Samantha Morton), The New Salem Philanthropic Society (or 'Second Salemers') agitates on street corners about the threat of a magical revival. Mary Lou has in tow three sullen, adopted children: Credence (Ezra Miller), Chastity (Jenn Murray) and Modesty (Faith Wood-Blagrove). Credence, especially, appears to be deeply troubled.

The Magical Congress of the United States of America (MACUSA) therefore has to operate in secret and any public demonstrations of magic are expressly forbidden, by either man or beast. Suave, elusive Percival Graves (Colin Farrell), Director of Magical Security and head of the Auror division, is paying very close attention to what Newt and Tina are up to. And as Newt's ship docks, an even greater peril has stirred in Manhattan – one that could have far more dangerous consequences than the odd missing Niffler or Erumpent.

All of the filmmakers are keen to point out the themes that run through the story. Darker ideas concerning prejudice and repression, and ecological and political veins that touch upon the way our world works right now. And more intimately, the Rowlingesque celebration of discovering kinship in the unlikeliest places, and being who you are without apology.

'Jo is interested in outsiders, people who are misunderstood or slightly out of kilter with the rest of society,' says David Yates. 'In this case one of our characters, Newt Scamander, is an outsider because he's a Brit in New York. He's an outsider because he believes and cherishes and collects extraordinarily dangerous, beautiful, exotic magical beasts that are banned from the wizarding world. So he's a classic Jo outsider. Yet he hooks up with some other characters in New York and sort of finds intimacy with them. It's really a beautiful journey for Newt.'

ABOVE: *Concept art by Peter Popken of Newt's steamship arriving in New York.* **OPPOSITE:** *Sketch shows how the interior of Newt's coat might look. Costume designed by Colleen Atwood, drawn by Warren Holder.*

A MAGIZOOLOGIST'S UNIFORM

Costume designer Colleen Atwood calls Newt an 'off-the-page character'. Everything she needed to know about him was right there in the script. 'He's been living in the wilderness,' she says. 'Therefore he adapts everything to what he needs in his own world.'

Nevertheless, he still needed to be able to blend in with the world of the 1920s. The trick was to take the general look of the age – what Atwood likes to call its 'silhouette' – and make his clothes a little mismatched and ill-fitting. There would be something quirky about him, but not clownish. If there tended to be a lot of warm tones in the menswear of the era – browns and so forth – Newt would wear something cooler.

'So I chose a dirty peacock blue for his coat,' Atwood explains, 'and that was sort of his defining look – he wears that the most. The layers underneath sort of work with the jungle and other places that he has been.'

Naturally, there would be more to Newt's overcoat than meets the eye. 'We had all kinds of pockets that had purposes in the script,' says Atwood, whose designs are as influenced by requirements of plot as much as character. 'His little friends hide in there and then he has some of his medicines in there, and his cures. So I researched magician's coats and learned how they had all these secret pockets.'

Atwood actually begins her design process during rehearsal, studying how an actor moves, all the little character traits he might be giving the part. The most important element in any costume is how it fits not just an actor's body but also their performance. Reaching that indefinable moment when actor, role and costume become one and the same. And she loves how Eddie Redmayne became 'integrated' with his costume. 'He sort of lives in it,' she laughs. 'He makes it feel like his own clothes.'

Redmayne has loved that he really only wears one outfit the whole way through the film, but changes as he does: 'The collar pops open. The trousers go into his boots. I suppose there's a slightly eccentric, nerdy quality to him that turns into more like an adventurer by the end of the film.'

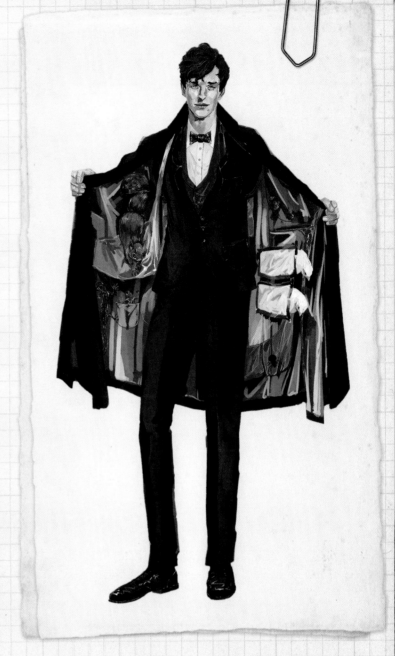

'WE HAD ALL KINDS OF POCKETS THAT HAD PURPOSES IN THE SCRIPT'

NEWT SCAMANDER

NEWTON ARTEMIS FIDO SCAMANDER, MAGIZOOLOGIST, IS A TYPE OF WIZARD WE HAVEN'T ENCOUNTERED BEFORE IN THE WIZARDING WORLD.

He has made it his life's work to study and understand magical creatures. J.K. Rowling describes him as 'weather-beaten' and 'wiry'. Played by the highly versatile and very English actor, Eddie Redmayne, he has the appearance of a bewildered student dressed in an ill-fitting bow-tie, blue greatcoat, and turned-up trousers. And he is inseparable from a leather case that has seen better days.

'What I love about Newt,' says Redmayne, 'is he's a passionate fellow. He's got his own agenda. He's got his own interests. In many ways, he's not a people pleaser.'

No matter how dangerous, or peculiar looking, Newt is of the opinion that every beast is fantastic. It's in the company of humans he's all at sea. He is not what you would call one of nature's conversationalists.

'He's an oddball,' beams Redmayne happily. 'He feels more at home with creatures than he does with human beings.'

As director David Yates explains, 'He's one of the very few wizards who believes that creatures have a place in the wizarding world and they should be cherished and appreciated. Everybody else thinks he's nuts, because they're so dangerous. So he's a bit of a lone figure.'

Newt's great hope is to bring the wizarding world round to see the value in these beasts. With the proper education they could learn to live side by side with them, and appreciate how extraordinary they are. So he has been travelling round the world, researching his book. At the beginning of the film he has spent a year in the field collecting these endangered species, which he keeps, naturally enough, in his case.

Redmayne does a quick tally in his head: there was definitely Egypt, where he found a Thunderbird; there was India; and also Equatorial Guinea. 'Take it from me, he's a well-travelled man,' he says. But nowhere has been quite as eye-opening as this incredible city.

New York was really only supposed to be a brief stop on his way to Arizona, where Newt would return his majestic Thunderbird, Frank, to its natural habitat. But when some of his creatures get out, well, things get complicated.

'What's wonderful is when you read Jo's script you take it into your own world,' says Redmayne. 'And you add ideas of your own. It's been kind of childhood dream stuff. You sort of have to regress to your inner child.'

Yates has encouraged all the actors to come up with their own ideas. Redmayne calls it, 'trouble shooting by magical ideas'. For instance, when he came up with idea of using his wand as an umbrella, Yates was delighted: 'I love it. Use it.' Indeed, apart from a small amount of puppetry, the beasts were going to be conjured up later with CGI. On set they mostly existed entirely within the actors' imaginations.

With the welcome assistance of the design department showing him concept art and even acting out how they behave, he was able to picture the likes of the Niffler – 'the bane of his life' – that looks like a cross

OPPOSITE: *Eddie Redmayne as Newt Scamander, wearing his signature blue coat and armed with his ordinary looking case.*

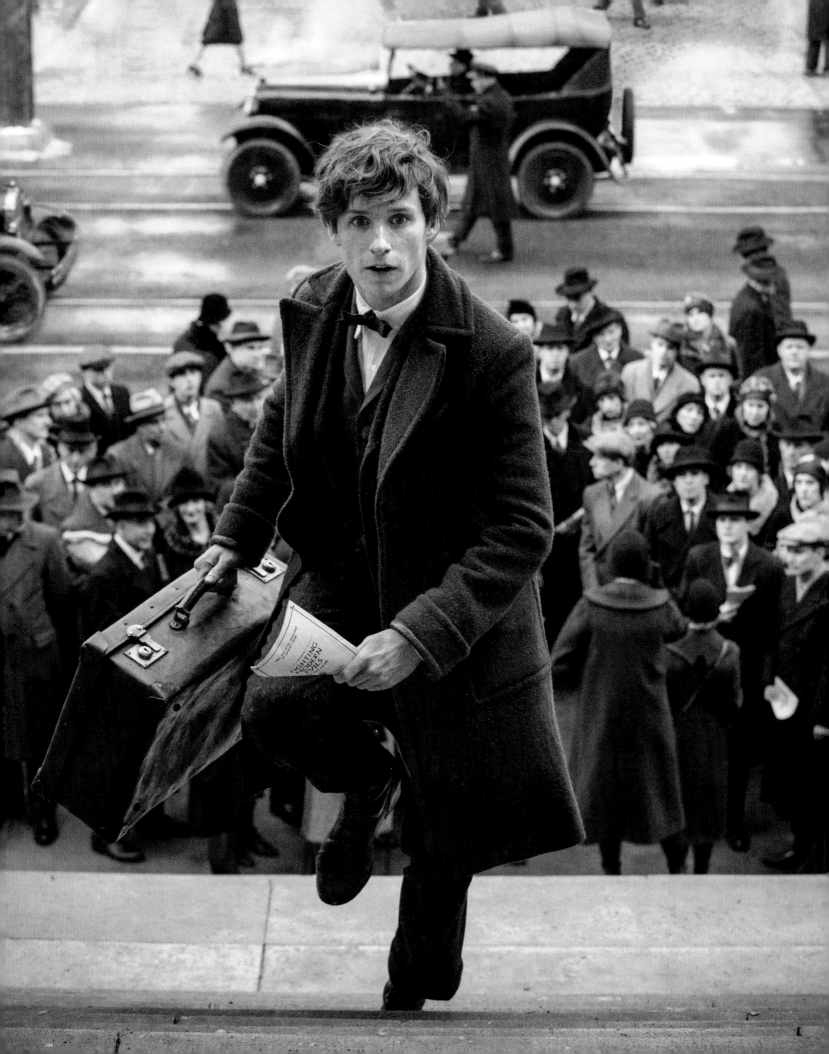

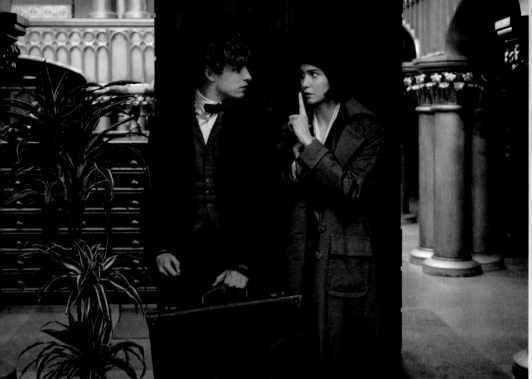

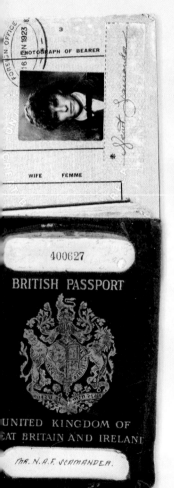

between a badger and an anteater and has a fondness for shiny things. Or the tiny, twig-like Bowtruckle, one of which has 'attachment issues' and Newt keeps in his pocket. Or, for that matter, a female Erumpent – like a mix of rhino and elephant – that is currently in heat.

'Newt has to try and entice her back into the case,' Redmayne recalls ruefully. 'That involved one of the more humiliating moments in the film. I had to do an Erumpent mating dance. It is weirdly exhausting trying to seduce an Erumpent.'

Katherine Waterston, who plays the witch Tina Goldstein, found herself mesmerized by the different relationships Redmayne created with each of the beasts he is looking after.

'It might be my favourite thing,' she laughs, 'because he has developed ways of communicating with them. It's the middle of the film and suddenly we're watching an excerpt from a nature show. He crawls around with them, he makes cooing sounds – it sounds ridiculous, but it's really awesome and sweet, and Eddie's done such detailed work with that.'

Over the course of the story, however, the fantastic beasts Newt is going to learn most about are human beings.

'There's something really sweet and endearing about him,' thinks David Yates. 'He's amazing with these beasts, and his journey is ultimately to discover how to get on with regular people.'

'He is learning to be himself,' says Redmayne, which means he must learn to trust and find comfort in other people. Almost out of necessity, Newt will form two very different friendships with two very different locals. First, he literally collides with Dan Fogler's forlorn Jacob Kowalski, a No-Maj whose dreams of opening his own bakery have come unstuck.

'It has this odd buddy movie quality to it,' says Redmayne, capturing this unlikely but touching partnership. They are comical opposites: portly Jacob, aspiring baker, is a real people person, whereas Newt is a tall, thin, scatty wizard who is a bit standoffish. Somehow they will draw out the best in one another.

Meanwhile, Waterston's witch Tina, a former Auror with a complicated past, is hot on his trail. With some justification, she suspects all is not what it seems with this tourist and his case.

Yates explains that, 'In the course of the story Tina and Newt have this unrequited, quite tender, quite funny journey together.' Newt's romantic past, which complicates matters, is as haphazard as most of his dealings with humankind, particularly his family.

The Scamander family are none too impressed with the career path the younger brother, Newt, has taken.

The wizard has a significant background. 'Newt actually went to Hogwarts, and he trained under Albus Dumbledore,' says Yates. The director goes on to explain that Newt was expelled from the famous wizarding school under 'enigmatic circumstances' and only Professor Dumbledore spoke up for him.

Dumbledore has always had an affinity with misunderstood wizards.

NEWT'S WAND

'Wands are weird,' declares head prop modeller Pierre Bohanna, 'because they can be so simple, literally a stick. But there are so many opinions that have to be included in how they look, because they are absolutely bespoke to the characters.'

The process of designing each of the principal wands – those belonging to Newt, Tina, Queenie and Graves – began with junior concept artist Molly Sole, who worked in Stuart Craig's art department.

Beyond a general sense of the fashions of the era and the American setting (wands owned by New Yorkers are more Art Deco than Gothic), individual wand design boiled down to what best reflected the character in question. In *Harry Potter* lore, a quasi-sentient wand matches a wizard or witch's character. How they look speaks volumes about who is casting the spell.

After the design is set, a prototype wand is first carved out of wood, and then, if possible, crafted with real materials. This is then used as a reference to create a mould, from which various replicas can be made. There were practice versions for the actors to take home and get the hang of casting spells round the house. As well as rubberized versions that were action

safe. 'A fourteen- to sixteen-inch long, half-inch-thick shaft made out of wood is actually quite dangerous,' says Bohanna. 'If it splits and cracks it'll get quite spiky, so it's only for very close-up work that you'll use the original wand.'

When it came to Newt's wand, says Bohanna, they wanted something that could be traced back to some 'animal component'. However, Eddie Redmayne, who attended special 'wand-work' classes and, like all the wand-wielding actors, was thrilled to have input into the final model, was insistent there could be no leather or horn involved. Newt wouldn't stand for that. Which definitely ruled out anything macabre like bone.

More practical than eye-catching, the handle was conceived to be made out of a piece of shell, but tubular like a sandworm's shell. In reality, the prop department made it from a piece of ash wood, which was then given a pearling effect for the desired texture, and finally weathered to look as if it had already seen years of service.

'It had quite a lot of character,' says a satisfied Bohanna: 'chips, knocks and bangs to show a well-worked life.'

As soon as Eddie Redmayne read the script he knew he had to play Newt Scamander. 'I found it funny. I found it thrilling. I found it dramatic,' he says. 'It took all the imagination and escapism of *Harry Potter* to the New York of flappers and prohibition. It was just a really exciting place to be.'

Newt, he recognized, was a 'wonder' of a role.

Which is a good thing. The core team of producers had originally put together a long list of all the stars they thought might be right to fill the boots of their eccentric Magizoologist. It was full of great actors and star names. But something strange had happened. The more they worked on the script, and the better they got to know Newt, the shorter the list became. Before they knew it, there was only one name left.

'It all kind of led to Eddie,' says director David Yates. In fact, it was like a spell – once you thought of him, you couldn't think of anyone else. It was as if he was already Newt.

'What Eddie has in spades is soulfulness,' Yates explains. 'I also love the shape of Eddie. He's got an extraordinary shape, this vertiginousness. And I loved the idea of Eddie doing funny stuff, because he has done all this lovely serious stuff. Once we got Eddie it was about fitting the world around him.'

Getting Redmayne, however, wasn't a foregone conclusion. The London-born actor had deservingly won an Oscar for his remarkable portrayal of the scientist Stephen Hawking afflicted with a rare form of motor neurone disease in *The Theory of Everything*, and was about to embark on the equally demanding drama, *The Danish Girl*. After maturing from theatre and television work into films as diverse as *My Week with Marilyn* and *Les Misérables*, he was now one of the most

sought-after actors in Hollywood. As Yates admits, he could practically do anything he wanted.

But this wasn't just anything; this was a script by J.K. Rowling set in her legendary wizarding world. Redmayne called back as soon as he could. He loved it.

'One of the things I love most is the variety,' he says. 'It jumps seamlessly between genres from physical comedy into a love story into action.'

Fantastic Beasts and Where to Find Them was about far more than casting spells and tracking down runaway beasts. As with all of J.K. Rowling's work, there were hidden depths. Redmayne insists that Newt is far from a straightforward hero. 'Throughout the film you realize that for all the wonder and excitement of his life there is a hole in there in some ways. There is a sadness and complexity in there.'

While making sure he was fluent in all the details of the wizarding world by rewatching the *Harry Potter* films, re-reading the books, and going over the script with a microscope, Redmayne met up with real zoologists. The script had described Newt as being like the great television presenter and animal expert, David Attenborough, and he wanted to understand why scientists devote their lives to studying animals.

His research took him to safari parks where he spoke to experts in animal breeding and discovered the extraordinary relationships they had developed with animals. 'They literally had new-born cubs sleep in their beds with them,' says an astonished Redmayne.

There was also something about the way they moved. Anyone tracking a wild animal has to be incredibly silent. They turn their feet outwards, placing each footstep with the utmost care, or

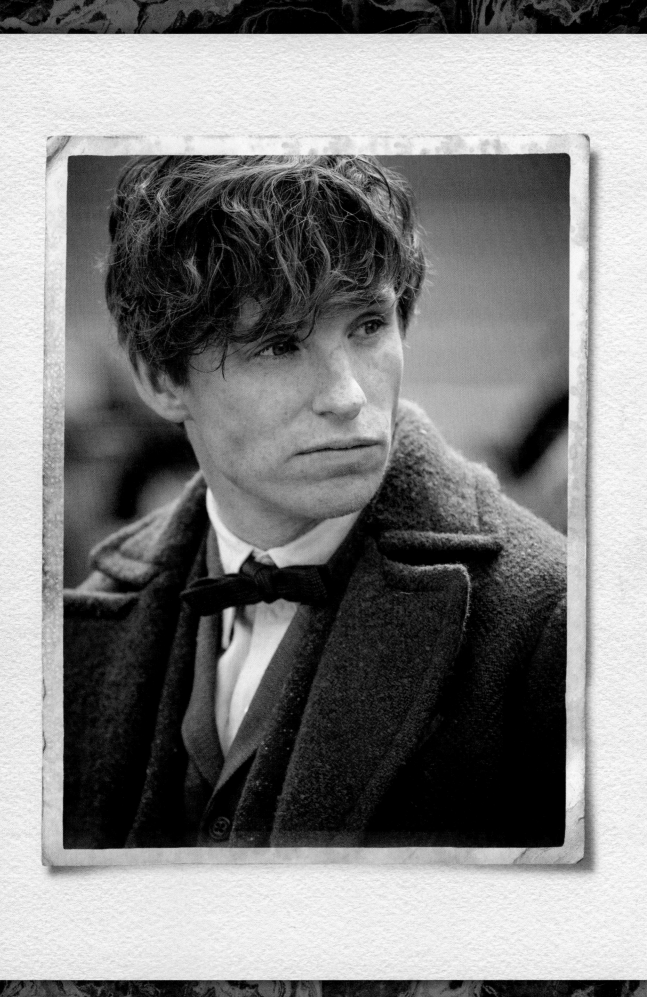

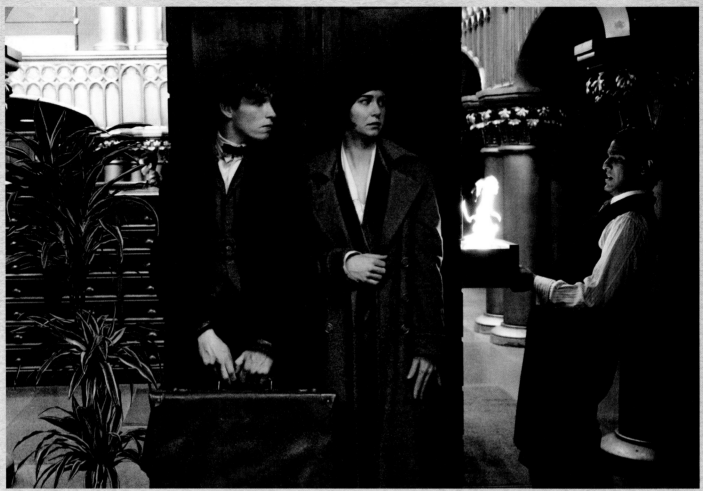

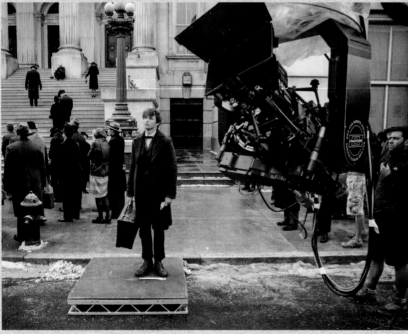

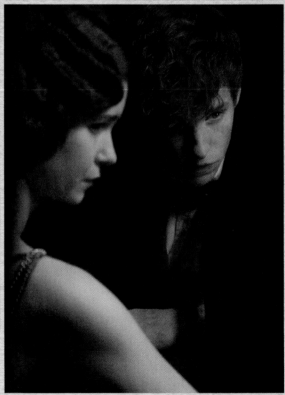

PREVIOUS: *Eddie Redmayne relaxes on set.* **TOP:** *Newt and Tina are careful to remain hidden inside MACUSA.* **ABOVE:** *The camera follows Eddie Redmayne's gaze as Newt looks up.* **RIGHT:** *Newt & Tina look for answers.*

even crawl along the floor. Redmayne points out how in J.K. Rowling's script she says that Newt 'walks his own walk.'

Such was Redmayne's dedication not just to his part but the film as a whole that days after he agreed to play Newt, he was on a plane to New York to spend a weekend meeting the various actors who were up for the roles of Jacob, Queenie and Tina. Yates is proud of how the actor took it all in his stride.

'It was like one of those Japanese game shows,' he laughs. 'He spent forty-eight hours in a hotel room doing the same scene with different actors. And out of that we were able to clearly see who was right for those roles.'

Out of that weekend of auditions they found the three actors who gelled perfectly with their Newt: Dan Fogler (as innocent Jacob), Katherine Waterston (as resolute Tina), and Alison Sudol (as dreamy Queenie).

'J.K. Rowling, David Yates and David Heyman were really keen to make the chemistry work between these people,' says Redmayne. 'It was wonderful to work with three such brilliant people, who all have such different qualities. We're all bound up by this sense of responsibility. We don't want to screw this up. We just want to do the characters proud.'

Fogler, whose character Jacob becomes almost a comic sidekick to Newt, claims they were all inspired by the excellence and strangeness of their lead wizard.

'He's so charming and funny. And he brings a real sensitivity to Newt that I don't think a lot of actors could pull off.'

Waterston became in awe of his diligence to the tiniest gesture. 'It was as if his work was never done,' she says, having shared so much of the film with him. 'It's always more fun to work with people who set the bar really high. Plus, he's not a jerk, which helps too!'

For Redmayne, entering this world has been all he dreamed it would be and more. He had half suspected he would face 'a world of green and blue curtains' but he was staggered by the scope and scale of the sets. 'The entire world is fastidiously detailed, from New York in the 1920s, with its shop fronts and the cobbles on the street, to the interior of Newt's case, which is more of an abstract world and yet fully realized. What has been so amazing to me is you read Jo's script and imagine what it is like, then you arrive on set and it is bigger, better and wilder than your own imagination.'

Redmayne claims that he couldn't have had two better guides through this world than the 'two Davids' – Heyman and Yates. 'I can't think of two more passionate people to take these stories into the world of film,' he says. 'They are scrupulous with character, but allow you the freedom and space to come up with your own ideas.'

He has also been enormously grateful that J.K. Rowling has remained so close to the production, visiting the set with updates to the script and yet more knowledge to impart on every aspect of the wizarding world.

'We just jumped straight into his character,' he laughs, 'and she gave me all of his backstory, and answered any question I had about him and this world and all the beasts. For an actor that's the dream.'

WANTED

FOR GRADE ONE INFRACTION OF THE INTERNATIONAL STATUTE OF SECRECY!

NEWT SCAMANDER

MACUSA REG. NO. 1908

THE ABOVE IMAGES ARE EXCELLENT LIKENESSES OF SCAMANDER.

BEARING WAND, MOST MENACING AND EXTREMELY DANGEROUS!

EXTREME CAUTION SHOULD BE EXERCISED AS THIS WIZARD IS A DEVIOUS LAW BREAKER AND WILL RESIST ARREST!

IF LOCATED, HE SHOULD BE IMMOBILIZED AND APPREHENDED AT ONCE. MACUSA-DEPT. OF AURORS MUST BE ADVISED IMMEDIATELY BY OWL!

DEPARTMENT OF AURORS
Major Investigation
Division • MCB/2

!REWARD!
ᕍ2500

(Chief Auror)

M. P. Carneirus
(Captain of Aurors)

M. C. Minus
(Auror Commissioner)

- PLEASE POST IN A CONSPICUOUS PLACE -

A NEWT KIND OF WIZARD:
CAST AND CREW FATHOM THE ENIGMA OF NEWT SCAMANDER

J.K. ROWLING (WRITER & PRODUCER)

'I like Newt as a character. I like what Newt's all about. I'm also very interested in the period of wizarding history in which he was living and active, and hardcore fans will know what I mean by that.'

DAVID HEYMAN (PRODUCER)

'Newt is an outsider, uncomfortable with people, comfortable with creatures. He marches to his own beat. He's never been to New York before. He's never seen steam coming up from the underground. He's never seen this much traffic in his life. He's very much a fish out of water.'

DAVID YATES (DIRECTOR)

'He's a unique character, because nobody thinks beasts are a good idea to get involved with. They can poison you.'

CARMEN EJOGO (SERAPHINA PICQUERY)

'I think that the way that Eddie Redmayne is approaching the character and the fact that he is an Englishman in New York really adds to the otherness that we're exploring in this film. Newt is the perfect embodiment of otherness in many ways. He is more like a Buster Keaton character. He's not quite an antihero, but he's certainly not your typical hero. He comes with foibles and insecurities and all kinds of messiness. From the costume to the hair to the mistakes he makes throughout. I think he is a really endearing leading man.'

ALISON SUDOL (QUEENIE GOLDSTEIN)

'Newt brings a humanity towards these creatures, which are previously misunderstood. That's the beauty of his character. Through his eyes we get to see how lovely they are.'

DAN FOGLER (JACOB KOWALSKI)

'When Newt is trying to coax the Erumpent back into the zoo by doing a very, like, sensual dance – because the Erumpent is in heat – that's hysterical, but it's also science. That's where he's like David Attenborough. I could just imagine David Attenborough sticking his head up in one of these scenes and trying to coax an Erumpent back into its case.'

EZRA MILLER (CREDENCE BAREBONE)

'There is something that is quintessentially perfect about Newt for Eddie, because there is this innate charm and what I can only describe as a wonderful Britishness that Eddie already has. He is someone with a lot of integrity and kindness and warmth. And Newt is like that. He's a little befuddled, a little all over the place, which we can all identify with.'

RON PERLMAN (GNARLAK)

'Eddie Redmayne, don't let him know I said this, because I don't want him to know how good he is. But just winning the Academy Award® shouldn't have been the signal. He's the real deal. He's going to have quite a body of work behind him before it's all over with. He's really deep and layered and kind of a beautiful dude to go along with it.'

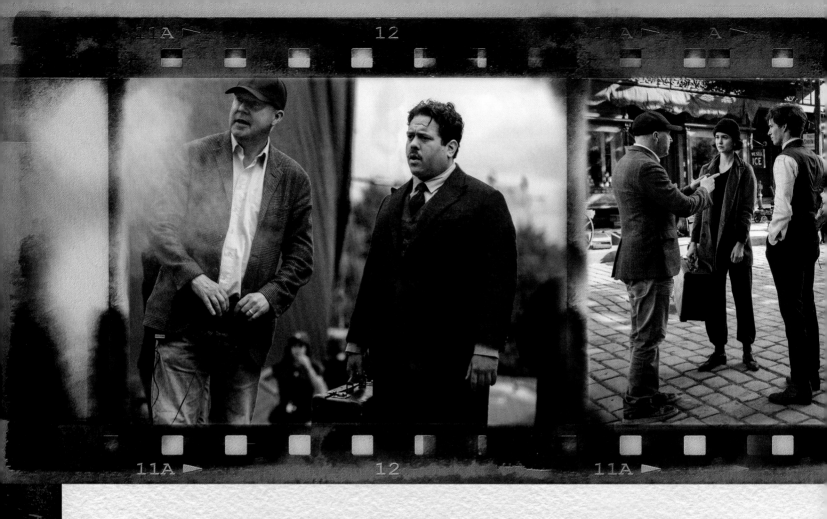

DAVID YATES – DIRECTOR

avid Yates was in the South of France when his phone insisted it be answered. David Heyman, his longtime producer, was on the other end of the line getting straight to the point: 'Would you read this script?'

Reasonably enough, Yates first wanted to know what it was.

'It's called *Fantastic Beasts and Where to Find Them*,' Heyman replied. 'Jo's written it.'

'Jo' was J.K. Rowling.

Yates had to read it. He had to know what it was about. A secret package duly arrived, if not by owl then by highly secure channels.

Yates' first encounter with Newt Scamander and Magizoology seemed blessed by its own magic. 'I was absolutely enchanted,' he recalls. 'It was so fresh and different and special.'

Twenty-four hours later it was Heyman's phone demanding to be answered, and his old friend was on the other end of the line getting straight to the point: 'I have to make this film.'

Yates earned his stripes on British television, garnering particular acclaim and a pile of awards for his six-part political thriller *State of Play* in 2003. Heyman admired Yates' dynamic direction, his ability to direct such a wide variety of tones, how in *State of Play* he made the world of politics so accessible, which felt appropriate given that the world of Potter was becoming more political. It is true that Yates has shown himself to be a wonderful director of actors and it was important that the actors continue to be pushed and challenged.

Heyman was keen for a director to stretch the young cast of *Harry Potter* into the dramatic demands of the later books.

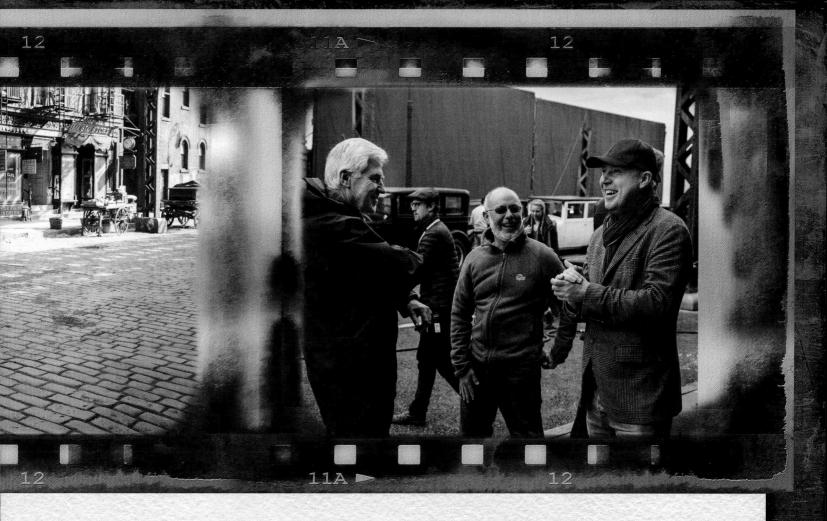

'It's changed my life really,' Yates reflects of the years he has spent in J.K. Rowling's universe. 'It's been an extraordinary journey. It's been good… and strange sometimes. You're privileged when you get a chance to work in this world, but in all honesty you can never quite get a handle on it.'

The stress and expectation, he says frankly, can be extreme. Still, he wouldn't have it any other way.

And over those years climbing the mountains of *Harry Potter*, and now navigating the peaks of *Fantastic Beasts,* he has come to know Heyman as a friend as well as a collaborator, establishing the key creative partnership behind the scenes of J.K. Rowling's expanding Wizarding World.

'He's very discerning and very hard to please,' says Yates with a smile.

Yates describes his own style as 'measured'. He tries to get the best out of everyone without resorting to hysterics. The work may be demanding, but there is no friction on his sets.

'So I need David for friction,' he laughs. 'I need David to drive me nuts. There's a very British thing of being diplomatic about getting to the point you need to reach, whereas David and I can just tell each other what we really feel without offending each other, which is quite healthy.'

Yates has also got to know J.K. Rowling fairly well, although save for a couple of special visits she stayed at arm's length from the earlier productions. Given she had written the new script herself, this was a novel experience for the both of them.

'It's been one of the highlights of making this movie, to work so directly with her,' he says. 'When she's at a distance she's kind of a rock star. She's sort of an icon. She is part of the cultural landscape. But when you are in a room with her bashing ideas

LEFT TO RIGHT: *Director David Yates and Dan Fogler watch the action unfold on set.*
• Katherine Waterston carries Newt's case as she and Eddie Redmayne take instruction from their director.
• David jokes with production designer Stuart Craig and associate production designer James Hambidge.

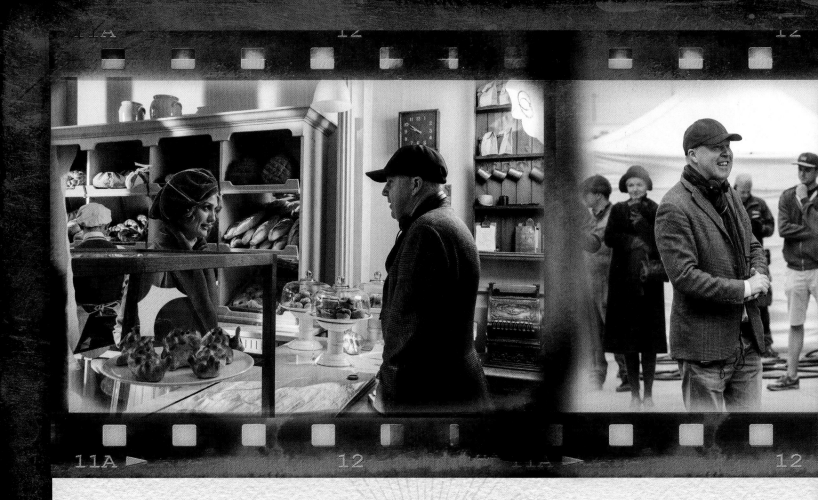

'I FELT INVESTED IN THE FOUR CENTRAL CHARACTERS, ALL OF WHOM ARE ACTUALLY GROWN-UP CHILDREN. THAT WAS WHAT WAS FASCINATING ABOUT THEM'

back and forth what is so enchanting is that she's very grounded, very pragmatic.'

The director who worked through some dark times with *Harry Potter* was charmed by how completely different J.K. Rowling's new slant on the wizarding world turned out to be. One of the chief draws for Yates was that, while it has its darker elements, it was an altogether more upbeat, well, beast.

'It just won me over,' he says. 'I felt invested in the four central characters, all of whom are actually grown-up children. That was what was fascinating about them. They are all quite pure. They are all trying to make their way in this bigger, grown-up world.'

In other words, it allowed him to flex a whole variety of storytelling muscles – *Fantastic Beasts* was emotional, funny, romantic, and twisted and scary all at the same time. 'Jo has such dexterity,' he says, 'she can write a scene that's utterly playful and witty yet has an authenticity to it.' As well as making some daring tonal shifts without ever jarring the flow of the story: from Newt's slapstick, to Jacob's yearning, to Tina's determination, to poor, damaged Credence who is mistreated by his authoritarian mother.

Everyone who has worked with him, can't speak highly enough of the level-headed filmmaker. Cast and crew tell of his calm under pressure; that measured approach. But also his ability to

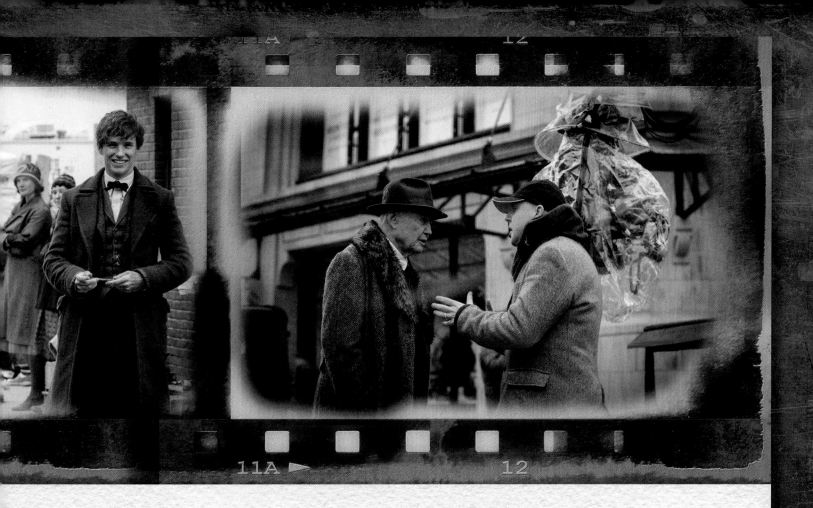

fully understand the needs of whichever department has come looking for insight, and an almost magical gift to communicate with those fantastic beasts otherwise known as actors.

'He doesn't miss anything,' says Jon Voight. 'His little notes to us are very specific and detailed. Elia Kazan, who did *On the Waterfront*, listed the things a director had to be: a psychiatrist, a doctor, a plumber, a builder – all these things. He has to understand the machinery. He has to orchestrate all of it and then work with human actors. David Yates is one of those fellows.'

'He's extraordinary really,' agrees Eddie Redmayne. 'I mean, the scale of these films – I've never witnessed anything like it. You have so many departments that you're shepherding, and what is amazing is that he manages to galvanize all of them, while remaining focused on the characters.'

For Yates, the promise of those characters, and all the splendid chaos that overwhelms them, has been borne out. He's been renewed by this return to magical concerns. Although he is emphatic this is somewhere entirely new.

'It's not a re-tread of where we've been,' he insists. 'Otherwise we wouldn't have done it, and I'm sure Jo would never have written that in a million years. It's a development of that world. It is a story that resonates now.'

And it is a journey that has only just begun.

'Jo's very kindly briefed me at least on the first third of film two,' he admits, prepared to go no further for now. 'There are all sorts of treats as we continue the story: it grows and grows into this bigger canvas.'

LEFT TO RIGHT: *Alison Sudol discusses her scene in a bakery with her director.* ● *David Yates shares a joke with Eddie Redmayne.* ● *Jon Voight listens closely to the director's thoughts on Henry Shaw Sr's next scene.*

NEW YORK CITY

2

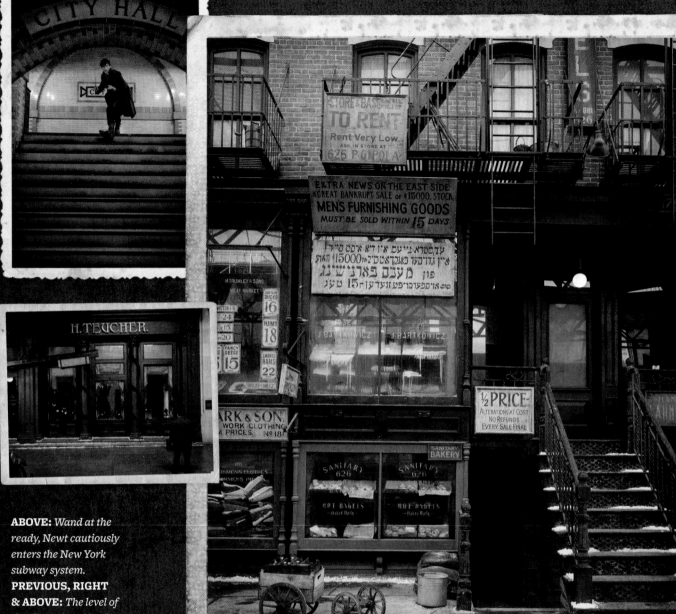

ABOVE: *Wand at the ready, Newt cautiously enters the New York subway system.*
PREVIOUS, RIGHT & ABOVE: *The level of detail employed by the set designers and prop department to recreate the city streets, from the dust on the shop displays and wear on the carefully researched signs to the snow-covered steps, was astonishing.*

NEW YORK

WHILE SET IN THE SAME MAGICAL UNIVERSE AS THE *HARRY POTTER* SERIES, *FANTASTIC BEASTS AND WHERE TO FIND THEM* INHABITS A STRIKINGLY NEW TIME AND PLACE – NEW YORK IN 1926.

Rather than transporting us into the wizarding world, this is a film about magic let loose in the real world.

'This feels more modern than *Harry Potter* did,' admits production designer Stuart Craig, who was Academy Award®-nominated for his work on the *Harry Potter* films. They may be set over 70 years in the future, but as Craig points out those films centred on a 1,100-year-old castle, and were more of a fairy tale where technology played no part. 'This is a different period, different country, different culture. Everything in New York, as you know, is big, big, big.'

'It's a world full of people who have dreams and aspirations,' agrees Yates. 'They've escaped from poverty in Europe, they've come to build a new life and the tenement blocks are teeming with them. It's a sort of precarious place to let some beasts out into.'

How exactly does the wizarding world fit into such a hive of industry? The answer is very carefully. In Europe a subtle cohabitation of Muggle and magic has been established, whereas the Magical Congress of the United States of America (MACUSA) operates in secret, out of sight of the prying eyes of No-Majs. A history of prejudice and persecution dates back to the Salem witch trials. Magic is frowned upon. Any leakage, so to speak, would be most unwelcome.

The filmmakers' initial thought was to shoot on location, and Yates and the producers hastened to the iconic city to see what was on offer. What they found was a metropolis whose headlong charge into the future has never ceased.

'Alas, there is remarkably little of New York 1926 in New York today,' admits producer David Heyman. 'There are bits of 1926 still in evidence, but the totality isn't. Which is why we built New York on the backlot at Leavesden.'

In a spectacular work of recreation, a giant city-set was fashioned on the studio's backlot, just north of London. Made up of entire blocks, it dwarfed anything constructed for *Harry Potter*.

On her initial visit to Leavesden to tour the production, J.K. Rowling was highly impressed: 'It was so spine-tinglingly exciting, the first time I went... walking in and knowing I was about to see sets for the new movies was so exciting. There's just something about an active studio. It's electric.'

Building their own Manhattan from scratch had its advantages: not only could they be authentic to their era, they would have a completely controllable environment. There was no need to get filming permits and block off unforgiving streets, and during the four months they filmed on the set, shop fronts and doorways could be re-dressed to become different neighbourhoods overnight.

'This is a really cohesive world,' says Yates of an interconnected set that will soar skywards in the finished film. On set it was only the bottom few rungs: Craig generally built to a height of two storeys, roughly 30 feet.

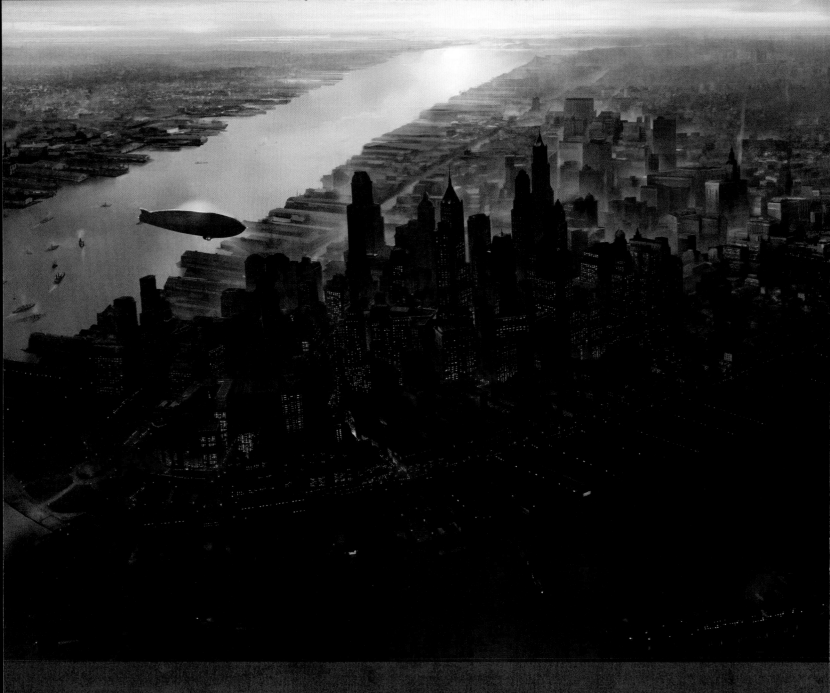

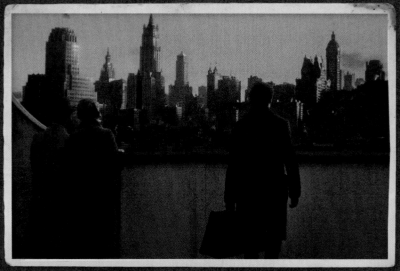

LEFT: *Newt gets his first look at New York.* **ABOVE:** *Concept art by Tom Wingrove showing the shape of New York at the time of the film, with an airship preparing to dock, and the Shaw Tower and Woolworth Building dominating the skyline.* **OPPOSITE** *(Top): Concept art by Tom Wingrove of MACUSA from above.* **OPPOSITE** *(Middle): The first stage of a digital set extension design is to create a 3D model and set up a potential shot (inset). In this design by VFX art director Hayley Easton-Street, the grey shows the physical set build of Jacob's tenement and the green represents the VFX set extension; this gives a clear guide so everyone knows exactly what will be achieved 'in camera'. The next stage of the process is to paint the 3D model and lock down the design of the VFX set extension (opposite middle image).* **OVER-LEAF:** *Once the street set has been prepared, barrows added and dressed with props, horses wrangled, the extras costumed, had their hair and make-up applied and given their directions, the boom camera will make a pass along the street for a single shot.*

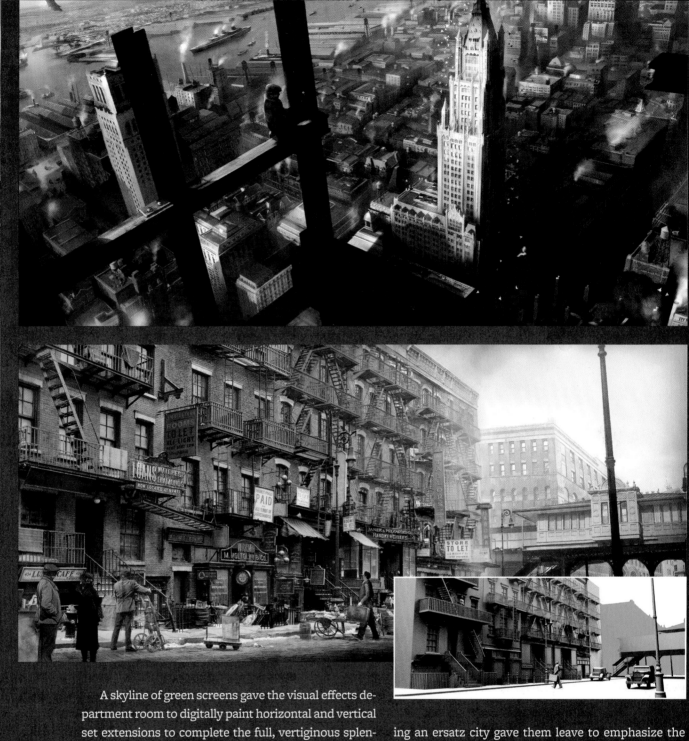

A skyline of green screens gave the visual effects department room to digitally paint horizontal and vertical set extensions to complete the full, vertiginous splendour of the city. Before production began, a wholly digital version of their city was created, so wherever there was any empty space in the camera's line of sight they already had concept views of what they would see. The visual effects team encouraged Yates and his team to shoot as high or as wide as they wanted.

'New York is probably the biggest creature we have had to design,' says visual effects supervisor Christian Manz. 'We wanted to make you experience what it was like to be in New York at that time.'

Their New York may have been firmly grounded in reality, with magic carefully under wraps, but build-ing an ersatz city gave them leave to emphasize the glamour and scale of the city. J.K. Rowling's script was full of references to the movie magic from Hollywood's silent era, and the visual effects team were amazed when they watched slapstick comedian Harold Lloyd's 1928 New York-set caper *Speedy*.

'We'd all seen films like *King Kong* and *The Great Gatsby* that had given that vision of New York at that time,' says Manz. 'And we watched this and we're like, my God, it's chaos. There are no rules for driving. That's what we wanted to create, the complete hustle-bustle of a city where everybody is creating a new world.'

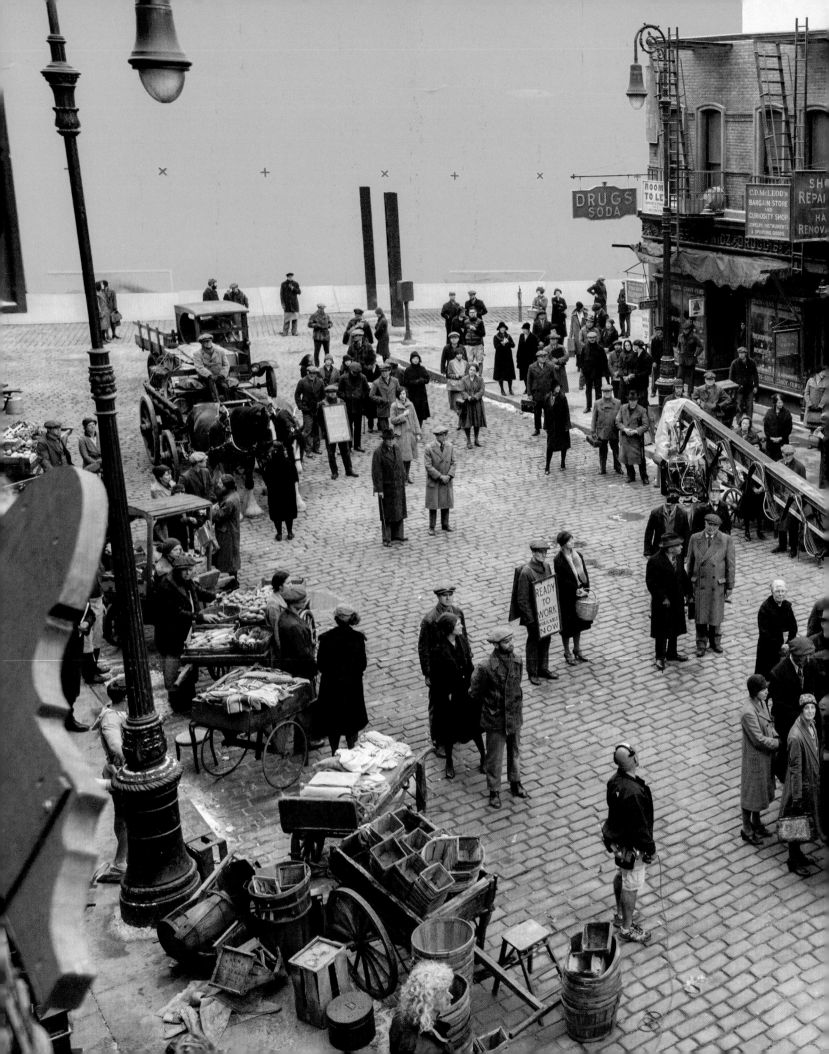

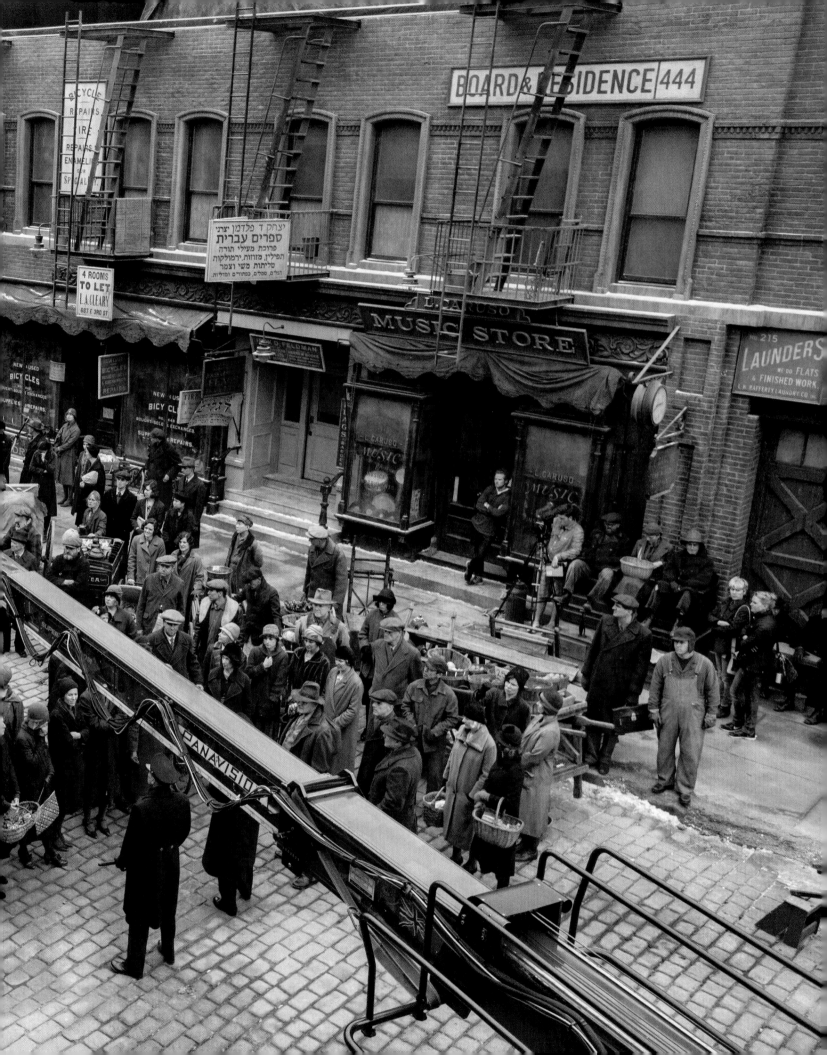

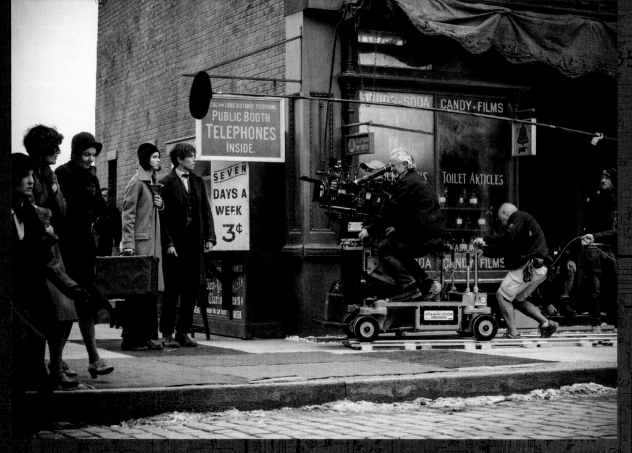

LEFT: *Eddie Redmayne & Katherine Waterston stand on their marks as the dolly camera zooms in on Newt & Tina.*
OPPOSITE *(Top): Newt Scamander takes in the sights and smells of New York. (Middle): A crew member hoses down the fake cobbles to reduce the amount of dust prior to filming. (Bottom): A group of extras on set.*

Set decorator Anna Pinnock spearheaded an army of dressers divided into different teams working on street signage, drapery, lampposts, shop windows, door hardware, newsstands, benches, post-boxes, bollards manholes... the list goes on. Inspired by the photographs, and a separate fact-finding foray to the city, they created their own storefronts and businesses; as well as adding their own flourishes imbued with a subtle magical edge. 'There were always the subtle magical twists to make things a bit stranger and different,' she says, 'without ever being too overpowering.'

For all its realism, seen through Newt's eyes there is something heightened about their New York – a wizard amazed at the world of the Muggles. 'We make it seem even larger,' says Heyman proudly.

'NEW YORK IS
PROBABLY THE BIGGEST
CREATURE WE HAVE
HAD TO DESIGN'

For a New York native like Katherine Waterston, who plays Tina Goldstein, inhabiting the set has been thrilling. 'All these amazing period details, there's just so little of it left today. My grandmother rode an elevated train on Third Avenue to work every day. It is so wonderful to see the environment she grew up in.'

In geographical terms, their T-shaped complex of streets managed the trick of shrinking all of Manhattan from the Lower East Side to Midtown into nine acres of set. The scale of which was incredible: their main thoroughfare along the stem of the T ran 800 feet, while the crosspiece at the top was 500 feet long. It took a miraculously swift 16 weeks to build, and would be re-dressed and renovated throughout the 20 weeks of main shooting that took place on the backlot.

'We had the rough-bricked tenement buildings in the Lower East Side where Jacob lives, along with warehouses and factory spaces,' says Craig, running through his artfully concertinaed districts. While on their first recce to the city, he visited the Lower East Side Tenement Museum on Orchard Street to gain a sense of the confinement the poorest quarters experienced. 'You learned how these poor families lived in these tenement dwellings: tiny rooms and so on,' he says, and the museum building itself resides in a renovated tenement block. 'Nevertheless,

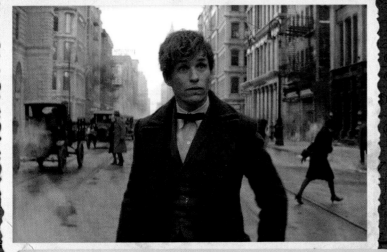

everything functioned. There was a kitchen range, there was running water, and there was a toilet, albeit in the backyard.

'The middle section is based on TriBeCa, the name derived from "Triangle Below Canal Street". We went for TriBeCa because it had some really interesting, very crisp architecture. There's a lot of cast iron in it which doesn't exist everywhere in New York.' This became the Diamond District, as its name suggests once one of the largest diamond and jewellery-dealing neighbourhoods in America. Suffice to say, the Niffler will find its glittering window displays hard to resist.

Constructed nearby on the main street is the exterior of the Woolworth Building, in which MACUSA is safely tucked away, which with artfully positioned green screens will be properly located on Broadway – requiring a full set of theatres and restaurants, shimmering with electrical light, that lead up to Times Square.

'Today they are LED,' explains Craig, 'but back then they were old-fashioned tungsten light-bulbs, hundreds and thousands of light-bulbs and that is what we have tried to recreate.' The visual effects team, led by Manz and Tim Burke, have digitally recreated the radiant street that crosses the ordered lattice of Manhattan at a diagonal.

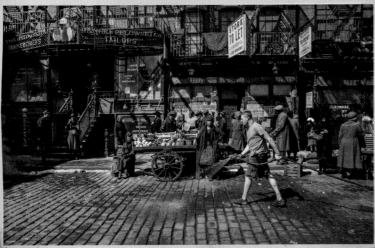

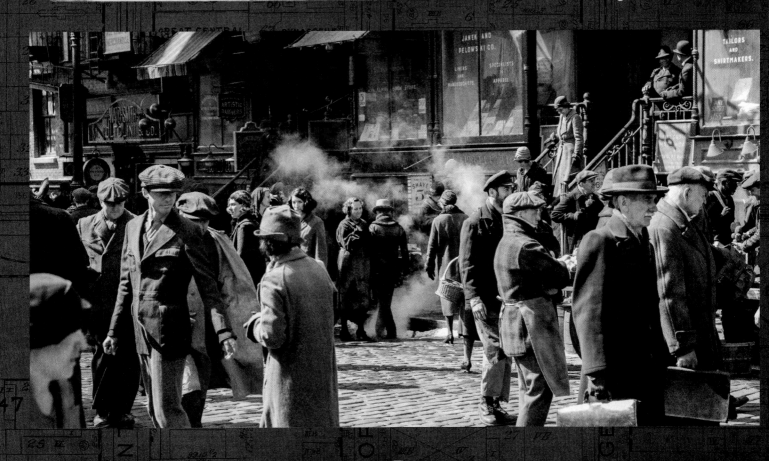

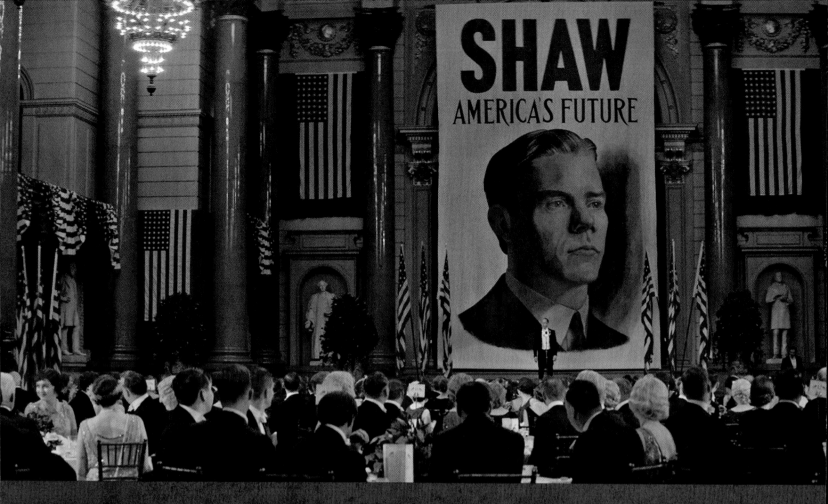

Also on the main street section is the ominous elevation of Shaw Tower, home to media magnate Henry Shaw Sr., and his fleet of strictly No-Maj, non-moving newspapers such as the *New York Clarion*, *Washington Enquirer* and the *Massachusetts Herald*. Herein, the grandeur speaks of impossible wealth, and the vainglorious ambition of Orson Welles' 1941 classic *Citizen Kane*.

Up to 80 bespoke desks were designed and made, and reproduction typist's chairs were imported from the USA. And not only did they provide rolodexes, inkwells, notepads, and dip pens, there were piles of paperwork and overflowing bins. This is a working office that never rests.

For a film concerned with Magizoology, Central Park Zoo demanded to play its part in Newt's misadventures. Except that technically speaking, just as King's Cross station never actually had a platform 10 to allow for a magical platform nine and three-quarters when the *Harry Potter* books were first written, so in 1926 was there not actually a Central Park Zoo.

'The Armoury was there, which is still there today,' explains Craig. 'And somebody at the Armoury started a collection of animals – small animals, I think. And so, in those days, it was called a menagerie. It wasn't a

zoo. It was a fairly modest collection of animals.'

So it is with a tiny bit of artistic license that Newt and Jacob visit the zoo, hot on the trail of a bewildered, rhino-like Erumpent. However, it has already been left wrecked by a stampede of escaping non-magical beasts (a look carefully crafted by the construction team).

So versatile has been Craig's splendid, proliferating New York set that it remains standing at Leavesden for the 'foreseeable future'.

Incredibly, for a shoot on the scale of *Fantastic Beasts and Where to Find Them*, the film only moved beyond the borders of the studio on two occasions.

For the scenes of Newt disembarking his liner, they went to the great hangars at Cardington in Bedfordshire, which in 1926 were still playing host to airships, but have long since been put to use as a super-sized soundstage for films as diverse as *Chitty Chitty Bang Bang* and *Inception*. Here they removed three panels of the titanic shed, beyond which they pitched massive green screens to digitally create the hull of the ship, while inside was the huge melee of passengers, luggage porters and customs officials. Though, this is not, as one would imagine, Ellis Island.

As Craig explains, 'We were puzzling about it for weeks and weeks and were pleased to discover that was

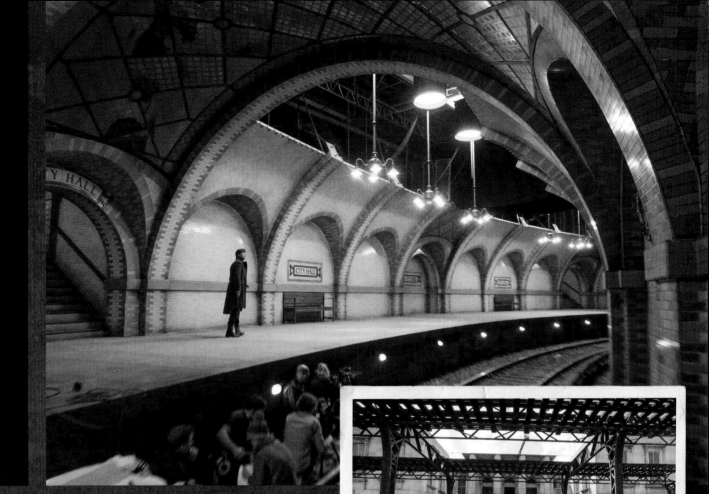

the definitive description of how it worked.' Research revealed that if you were a first- or second-class passenger you came straight onto the pier of the Hudson River. Only if you were a third-class passenger would you be taken by barge to be subjected to the notorious Ellis Island interrogation.

Then there is the department store, the interior of which is, in fact, the Cunard Building in Liverpool, which matched the size and confidence of 1920s New York.

In fact, Liverpool bears some unexpected architectural similarities to its American counterpart. After all, as Craig suggests, this was where the majority of the trans-Atlantic shipping departed from at that time. 'Liverpool was a big, prosperous port city, cosmopolitan in the way that New York was.'

The production also used Liverpool for a huge sequence filmed at St. George's Hall. This neoclassical edifice, with its immense concert hall, provided both the exterior space for the arrivals and an interior for a lavish fundraising gala at City Hall hosted by Shaw Sr. on behalf of his son's re-election as senator – 'America's future.' It is attended by the great and good of New York society. The large, dark, violent phantasm, however, is not on the guest list.

Magic is about to gatecrash reality.

OPPOSITE: *The fundraising dinner for Senator Shaw filled the concert hall at Liverpool's St George's Hall.* **TOP:** *Newt walks through the huge City Hall subway set, as the crew try to avoid being caught on camera.* **MIDDLE:** *The scale of the production is clearly shown here with this exterior set outside Steen National Bank, with full-size elevated train tracks in the foreground.* **BOTTOM:** *Newt & Tina hide behind an exquisitely decorated department-store Christmas tree.*

JACOB KOWALSKI

JACOB KOWALSKI, ASPIRING BAKER, IS A FIRST FOR J.K. ROWLING.
IN A RAGTAG SUIT A FEW SIZES TOO SMALL HE'S A HERO WHO
CAN DO NO MAGIC. A NO-MAJ WHO GETS UNWITTINGLY SWEPT
ALONG IN NEWT'S EVENTFUL VISIT TO NEW YORK.

It's all a matter of identical cases, a total mix-up. But the consequences will transform both their lives, as Jacob proves more useful in the wrangling of fantastic beasts than he might appear. With a stout heart and winning innocence, he is played by the very likeable actor-comedian Dan Fogler.

'When you first meet Jacob, he's back from the war,' says Fogler. 'He's like the last guy back from the war. Like no one told him it was over. And now he's really looking to get started on a lot of stuff that he missed out on. And he goes to the bank to get a loan to open this bakery. All he wants is a bakery. And he's got his case full of pastries...'

In the ensuing chaos caused by an errant Niffler, one battered leather case full of fresh *babkas* and *paczikis* ('grandmother's recipe') gets mistaken for another battered case full of fantastic beasts. When Jacob returns to his shabby apartment and opens the case, out come a few creatures, one after the other, demolishing his apartment and, in the case of a rat-like Murtlap, giving him a nasty bite. In no short time, Jacob has joined Newt in his magically assisted attempts to retrieve the missing beasts. Disapparating and Apparating take a lot of getting used to for a guy from the Lower East Side.

'Jacob gets thrown into this magical adventure, and he can't quite believe it,' explains producer David Heyman. 'He too is an outsider, and things haven't gone his way. However, he's always remained an enthusiast, believing in the possibilities of life. When he encounters these magical folk, he sees a whole world that he could never have imagined.'

One of the more delightful aspects of the story for David Yates was how much is seen through Jacob's eyes. 'Ultimately you're taken into it with Jacob, and we are Jacob. We experience many of these things from his point of view.'

Fogler was at Comic-Con when his phone rang. He was attending the famous fan convention in San Diego to promote the first season of the crime show *Secrets and Lies*. He was also manning a stall selling his comic-book series *Moon Lake* (a horror anthology about a mysterious body of water that proves to be a portal to other dimensions). He remembers he was making his way upstream like a salmon against the flow of costumed fans – including more than a few Harry Potters – to reach his stall when he felt the buzzing in his pocket. It was a David – he can't remember which one called first, and he tends to refer to them collectively.

'And they said, "Where are you right now?" And I was like, "I'm at Comic-Con!" Fogler laughs, knowing he'll be telling this story for a long time to come. 'They said, "Yeah, Comic-Con's going to be a lot different next year."'

OPPOSITE: *Dan Fogler as Jacob Kowalski.*

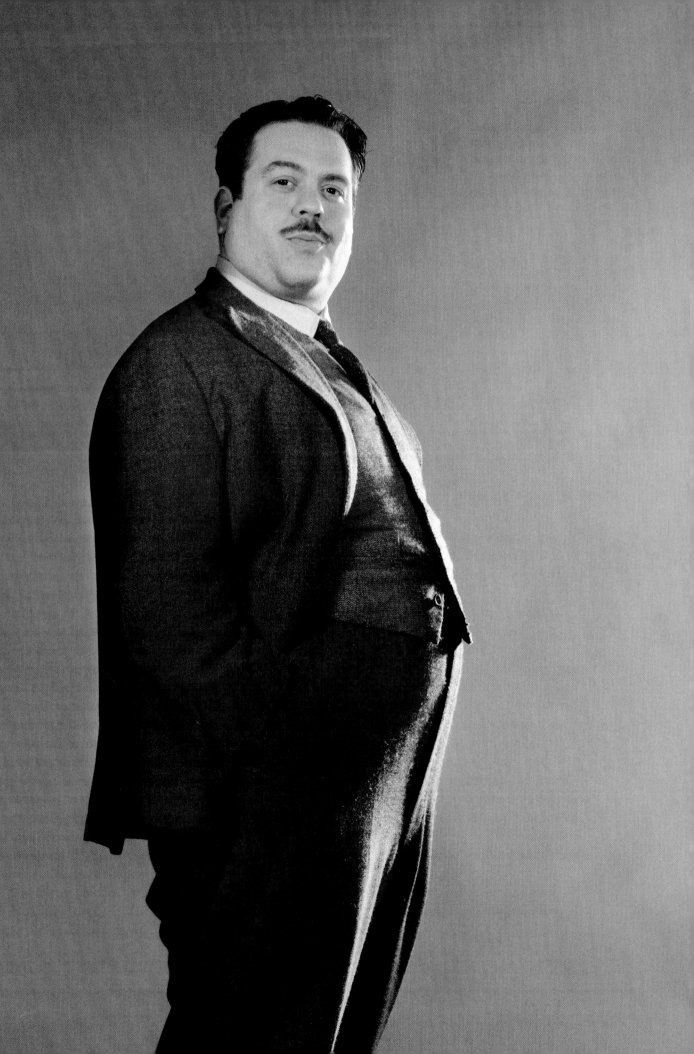

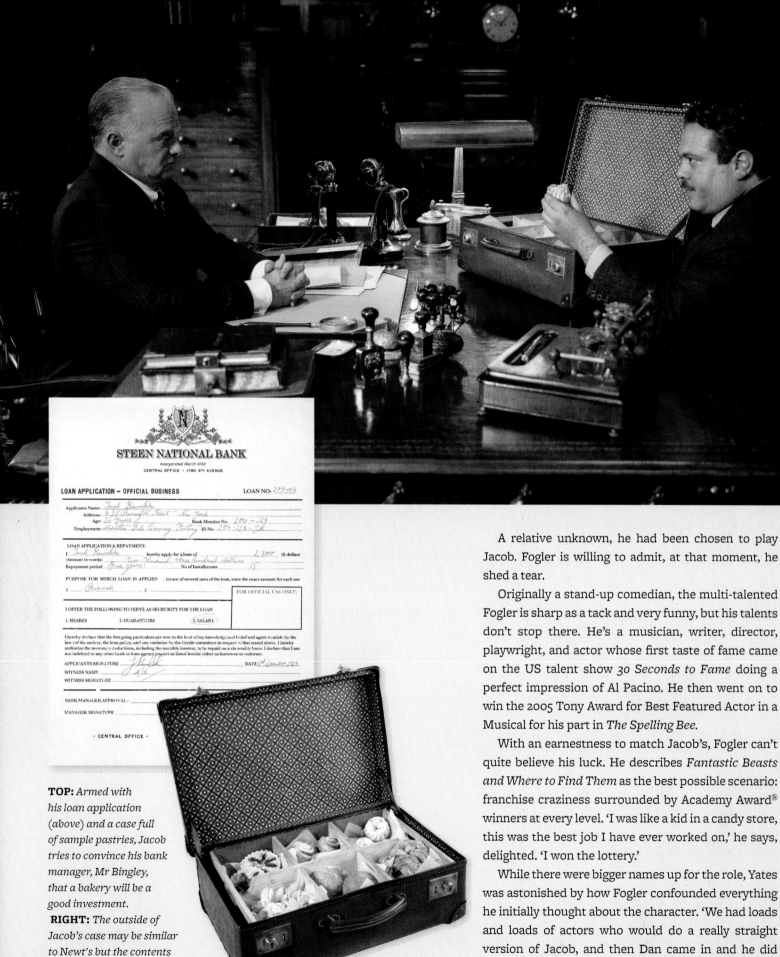

STEEN NATIONAL BANK
Incorporated March 1848
CENTRAL OFFICE · 1790 6TH AVENUE

LOAN APPLICATION – OFFICIAL BUSINESS LOAN NO: *203-014*

Applicants Name: *Jacob Kowalski*
Address: *435 Rivington Street New York*
Age: *26 Years* Bank Member No: *200 - 123*
Employment: *Moreton Dale Canning Factory* ID No: *206-128-JK*

LOAN APPLICATION & REPAYMENT:
I *Jacob Kowalski* hereby apply for a loan of *2,300* ($) dollars
(Amount in words) *Two Thousand Three hundred dollars*
Repayment period *Five Years!* No of Installments *15*

PURPOSE FOR WHICH LOAN IS APPLIED – incase of several uses of the loan, state the exact amount for each use
1 *Business* 2 _____ (FOR OFFICIAL USE ONLY)

I OFFER THE FOLLOWING TO SERVE AS SECURITY FOR THE LOAN
1. SHARES 2. GUARANTORS 3. SALARY

I hereby declare that the foregoing particulars are true to the best of my knowledge and belief and agree to abide by the law of the society, the loan policy, and any variation by the Credit committee in respect of that stated above. I hereby authorize the necessary deductions, including the monthly interest, to be repaid on a six weekly basis. I declare that I am not indebted to any other bank or loan agency (except as listed herein) either as borrower or endorser.

APPLICANTS SIGNATURE _____ DATE *5th December 1926*
WITNESS NAME _____
WITNESS SIGNATURE _____

BANK MANAGER APPROVAL _____
MANAGER SIGNATURE _____

· CENTRAL OFFICE ·

TOP: *Armed with his loan application (above) and a case full of sample pastries, Jacob tries to convince his bank manager, Mr Bingley, that a bakery will be a good investment.*

RIGHT: *The outside of Jacob's case may be similar to Newt's but the contents are very different.*

A relative unknown, he had been chosen to play Jacob. Fogler is willing to admit, at that moment, he shed a tear.

Originally a stand-up comedian, the multi-talented Fogler is sharp as a tack and very funny, but his talents don't stop there. He's a musician, writer, director, playwright, and actor whose first taste of fame came on the US talent show *30 Seconds to Fame* doing a perfect impression of Al Pacino. He then went on to win the 2005 Tony Award for Best Featured Actor in a Musical for his part in *The Spelling Bee*.

With an earnestness to match Jacob's, Fogler can't quite believe his luck. He describes *Fantastic Beasts and Where to Find Them* as the best possible scenario: franchise craziness surrounded by Academy Award® winners at every level. 'I was like a kid in a candy store, this was the best job I have ever worked on,' he says, delighted. 'I won the lottery.'

While there were bigger names up for the role, Yates was astonished by how Fogler confounded everything he initially thought about the character. 'We had loads and loads of actors who would do a really straight version of Jacob, and then Dan came in and he did something that had fireworks. He inverted it: things

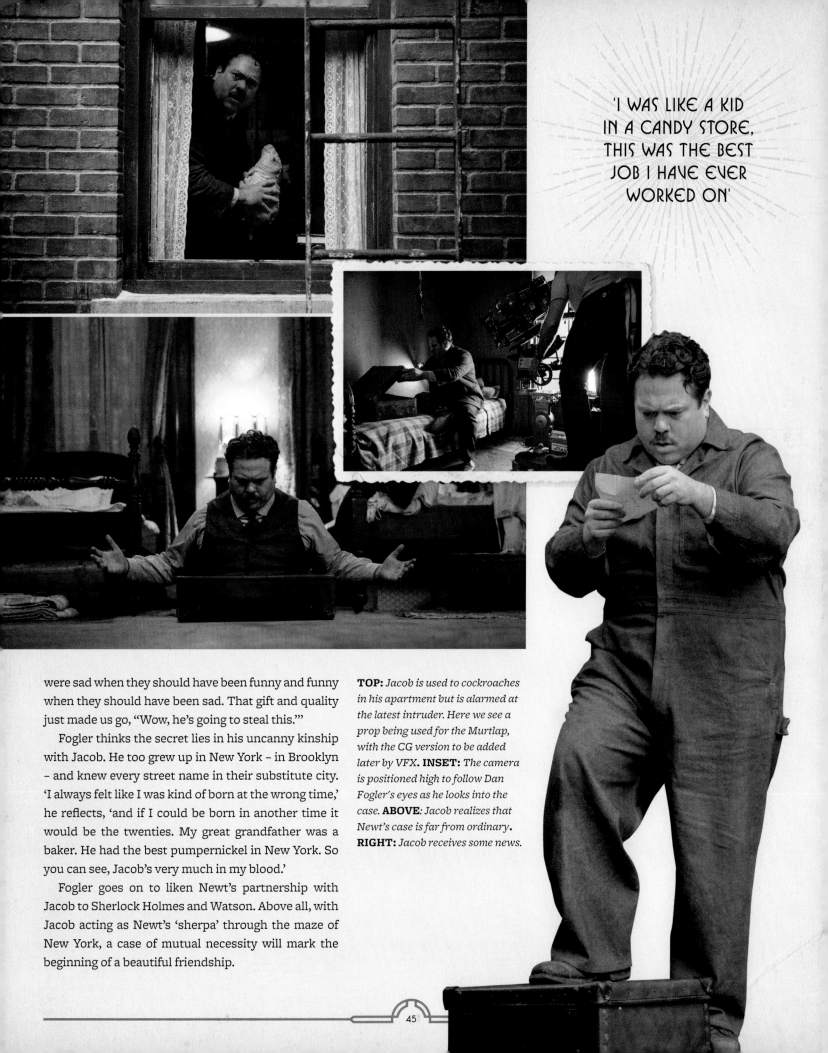

'I WAS LIKE A KID IN A CANDY STORE, THIS WAS THE BEST JOB I HAVE EVER WORKED ON'

were sad when they should have been funny and funny when they should have been sad. That gift and quality just made us go, "Wow, he's going to steal this."'

Fogler thinks the secret lies in his uncanny kinship with Jacob. He too grew up in New York – in Brooklyn – and knew every street name in their substitute city. 'I always felt like I was kind of born at the wrong time,' he reflects, 'and if I could be born in another time it would be the twenties. My great grandfather was a baker. He had the best pumpernickel in New York. So you can see, Jacob's very much in my blood.'

Fogler goes on to liken Newt's partnership with Jacob to Sherlock Holmes and Watson. Above all, with Jacob acting as Newt's 'sherpa' through the maze of New York, a case of mutual necessity will mark the beginning of a beautiful friendship.

TOP: *Jacob is used to cockroaches in his apartment but is alarmed at the latest intruder. Here we see a prop being used for the Murtlap, with the CG version to be added later by VFX.* **INSET:** *The camera is positioned high to follow Dan Fogler's eyes as he looks into the case.* **ABOVE:** *Jacob realizes that Newt's case is far from ordinary.* **RIGHT:** *Jacob receives some news.*

TOP: *Jacob, Newt & Tina prepare themselves for what awaits them as they sneak into the Goldstein apartment.* **ABOVE:** *Director David Yates briefs Dan Fogler ahead of Jacob's next scene.* **OPPOSITE:** *(Clockwise from top left) Jacob looks shocked after catching a glimpse of the Demiguise. ● Dan Fogler relaxes on set with producer David Heyman. ● Dan Fogler smiles between takes of Newt & Jacob leaving a jeweller's in scene 49 of 'Boswell', the film's working title. But why are they covered in so much merchandise? Have they robbed it as well as the bank? ● A wanted poster showing Newt and Jacob.*

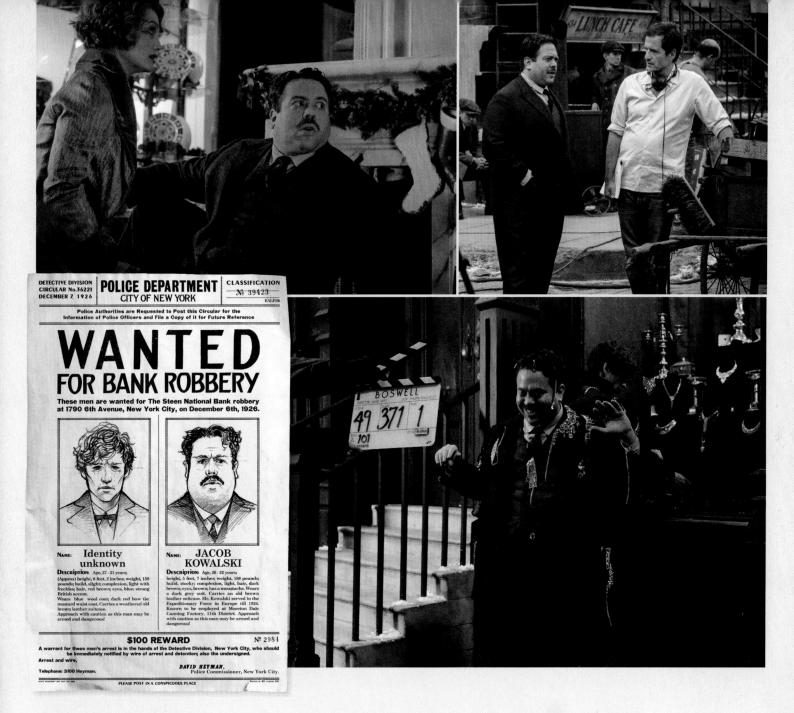

'These two guys who are from very separate parts of the spectrum come together,' he says. 'I basically teach him how to, you know, be a person with people. Newt really communicates better with creatures than he does people.'

Soon enough, the duo becomes a foursome when the magical Goldstein sisters, Tina and Queenie, are drawn into the escapade. This motley crew of misfits forms a unique family, but it is Alison Sudol's divine, mind-reading Queenie who will have an especially big impact on Jacob.

Fogler sighs: 'Queenie is just an angel. She gives Jacob a real reason to want to stick around. It's beautiful, you know? J.K. writes these amazing situations where I'm falling in love with this witch, Queenie. But in the wizarding world there are strict laws, especially in New York. It's forbidden. Which also mirrors people from different races wanting to get together – it's really quite beautiful how she parallels these cultural conundrums in the story.'

Much of the joy in J.K. Rowling's creations has been bound up with the theme of friendship and how strangers find one another. And that has never been more the case than with the heart-sore but optimistic Jacob, an old-fashioned kind of New Yorker who has the magic to bind people together.

'Even though Jacob is a Muggle, a No-Maj, he's a magical guy,' insists Fogler. 'He makes people feel good.'

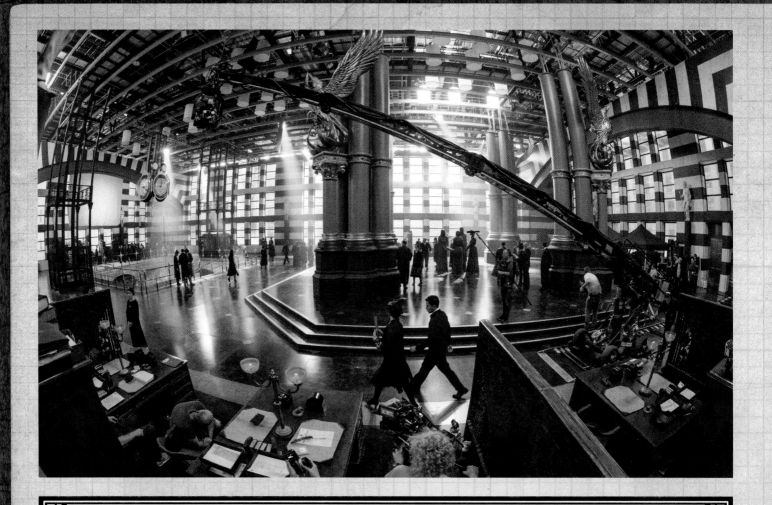

STUART CRAIG – PRODUCTION DESIGNER

When a new script arrives on his doormat, production designer Stuart Craig's first reaction is nearly always fright. How is he possibly going to achieve this? Then, as he explains, 'You begin to get into it, you do your research, and you begin to think about how you are going to tackle it – what you are going to build, and what form the building takes and so on. The further you go, the more the approach solidifies in your imagination. Only then do I begin to feel confident.'

Which is surprising given Craig is a three-time Academy Award® winner and seven-time nominee, and designed all the *Harry Potter* films.

'Stuart essentially brought the world of *Harry Potter* and Hogwarts to cinematic life,' agrees producer David Heyman. 'When people read or reread the books having seen the films,

they see Stuart's vision of Jo's world. He has such great taste and elegance, and no matter how magical an environment, he always roots it in reality so that the magic seems believable, true and possible. You inevitably feel safe with Stuart, knowing that whatever he designs will be just right, and extraordinary!'

So it was unthinkable he would not lead their venture into J.K. Rowling's kindred trans-Atlantic realm. And while terrified and thrilled in equal part to return to the wizarding world, it is Craig who has pioneered the creation of New York circa 1926, where magic dwells beneath the sidewalks. 'It was good to have some grey hairs around,' he says, waving away the praise.

Beyond its grand new setting, what Craig likes about J.K. Rowling's new script are the themes. 'It's about intolerance and condemning intolerance,' he says, 'specifically in the institutions and characters of our story. It's both very serious and lighthearted.'

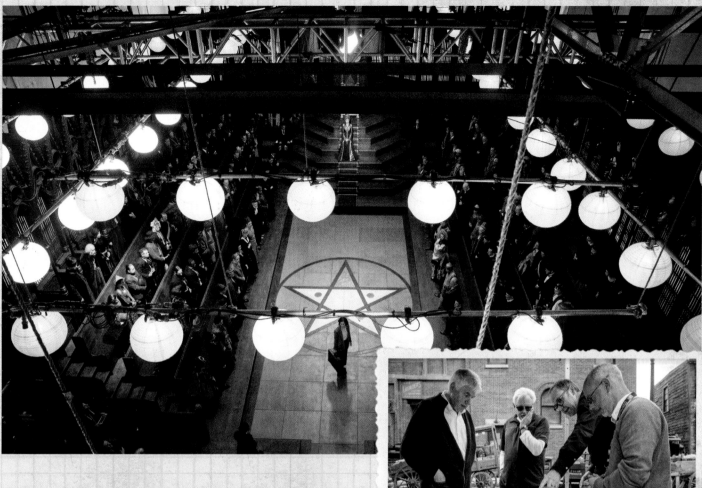

This tied in directly with how the film should look. Here was an adventure anchored in the vast steel and concrete of a real world that is ignorant of, if not opposed to, magic. Yet it was still a film about wizards that shares DNA with the *Harry Potter* series.

'What has been most fun is exploring where the magic begins,' says Craig. 'It's less in the buildings than in the small things: little light sources on desks that actually don't sit on the desk at all but levitate slightly and there's a wand polisher, which is a rather delightful prop.'

In one of Craig's inimitable touches, the house-elf that operates the wand-polishing machine in the MACUSA lobby feeds the wand between big ostrich feather buffers right up to his armpit. When he withdraws his arm it is as shiny as the wand. Craig smiles, 'We do look all the time to give a little exotic touch to proceedings.'

What has changed since *Harry Potter* is how Craig's work isn't necessarily done once shooting wraps. With so many of his beautiful sets being extended digitally (especially the New York backlot set), he has regularly made trips to Soho in London to check that his design intent is followed.

'I think the industry is getting used to the idea that designers need to remain involved into post-production,' he says. 'Critical design decisions are still being made.'

But, naturally, pushed on what he remains most satisfied with in *Fantastic Beasts and Where to Find Them*, and it remains two of the wonderful sets built from his designs. 'I like the MACUSA concourse, and the Pentagram Chamber,' he reflects. 'I think that they are big sets, and they are bold sets – I like the bold simplicity of them. They are not complicated. They are big and they are dynamic. Anyway, I hope the world agrees.'

TOP: *The sheer scale of production designer Stuart Craig's vision is revealed in MACUSA's concourse (left) and Pentagram Office (right).*
ABOVE: *Stuart reviews an intricate model of Central Park Zoo with (left to right) Warner Bros. Productions Ltd's executive vice president & managing director Roy Button, art director Martin Foley & associate production designer James Hambidge.*

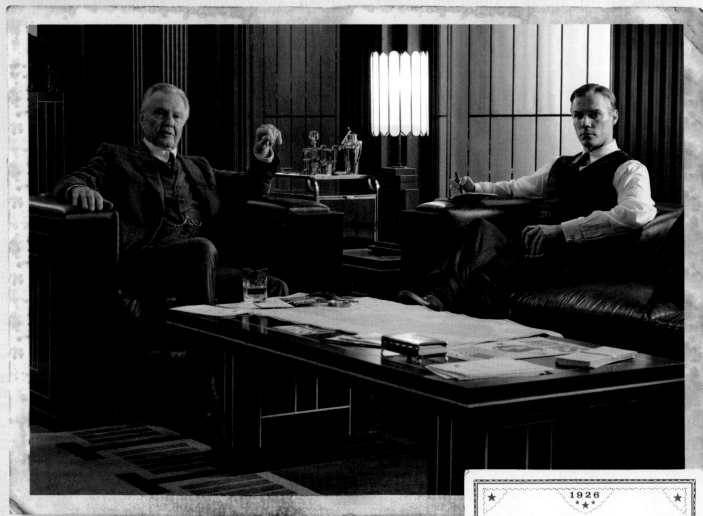

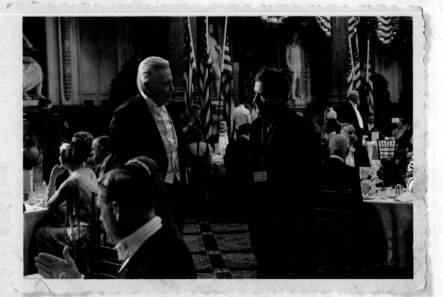

THE SHAW FAMILY

HENRY SHAW SR.

'He's the head of a newspaper, several newspapers,' says Jon Voight by way of introduction to his character Henry Shaw Sr. 'So he's a fairly big mogul.' The legendary Hollywood actor is being modest. From his lofty perch in Shaw Tower, Henry Sr. helps steer New York, an American titan in the John D. Rockefeller and William Randolph Hearst tradition. He is the film's finely tailored representative of the American Dream; and head of a dysfunctional brood, in the grand tradition of J.K. Rowling.

'He has two sons, and he favours one who is running for re-election to the Senate. The other son is a bit of a wastrel,' says Voight, who nonetheless suspects the audience will be rooting for neglected, outsider Langdon over glorious Henry Jr. 'My particular part of the plot is about this drama within the family, and how we're affected by this other world. It's an interesting piece of the puzzle.'

Ask him to describe the personality of this domineering patriarch, and the Academy Award®-winning star of *Coming Home*, as well as *Midnight Cowboy* and *Deliverance*, doesn't mince his words: 'I'm a powerful guy with no soft edges.'

Unbeknownst to Henry Sr., Dark magic will inveigle its way into his capitalist schemes. Langdon, for one, seems certain that wizardry is at the root of the recent, violent disturbances within the city.

'What's interesting is that I've been touched by the magical world but unknowingly,' says Voight. The question that arises is whether Henry Sr. will take a vested interest. In other words, is there a profit to be had from magic?

On his very first day, David Heyman met Voight at his car and took him on a personal tour of the backlot and the art departments, showing him concept pictures of various locations and top-secret designs for the fantastic beasts.

'I was watching his enthusiasm for every piece of it,' the actor remembers. 'He was so proud of it and so excited to show me. And David Yates too, such positive energy, so centred, never any airs. Everybody is encouraged to do their thing.'

Voight laughs, recalling a scene between Henry Sr. and Ronan Raftery's Langdon in the newspaper office where, in doing his own thing, he had spontaneously grabbed an inkwell. 'It was a square thing of the design of the period,' he says. 'And I was just playing around. Later on I found my hands were stained. I couldn't get these marks off my hands because the inkwell was filled with actual ink. It just shows you the attention to detail. And the frivolousness of some of the actors.'

SENATOR HENRY SHAW

Senator Shaw, elder son of the Shaw dynasty, has expanded the family's influence into politics. In fact, as the movie gets underway, he is seeking a likely re-election, and his square-jawed face can be seen

OPPOSITE (Above): *Henry Shaw Sr. (Jon Voight) and Senator Henry Shaw (Josh Cowdery) epitomize the wealth and power of the age.* **FAR LEFT:** *Jon Voight talks with producer David Heyman between takes at the Shaw fundraiser.*
LEFT: *Printed prop menu card for the Shaw fundraiser, offering guests such delights as cape oysters, mushroom soup, filet of sole, roast saddle of mutton, a salad of tomatoes and desert choices of sultana roll with claret sauce or assorted cakes.*

adorning campaign posters all over the city. 'I'm the golden child,' confirms Josh Cowdery, who plays the radiant Henry Shaw Jr.

Indeed, for a sequence set at a spectacular fund-raising gala in City Hall, the American actor who until recently has only had small roles in *Avengers*, *Godzilla* and television's *Agents of S.H.I.E.L.D* walked on to a set dominated by a 50-foot canvas of his face.

'I didn't realize it was going to be *that* big,' he admits. 'All you can do is laugh.' Once recovered from the shock, he found it helped him get into character. 'All that stuff helps you walk a little taller, and feel like you are giving a real speech. I'm sure I was a little bit more of a jerk on those days!'

The relationship between the Shaw siblings is another example of J.K. Rowling's recurring theme

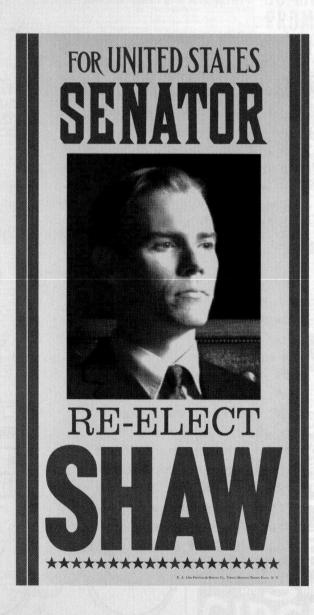

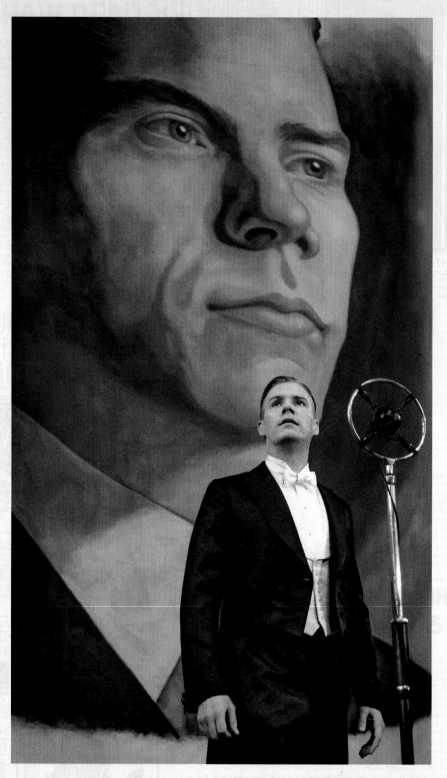

ABOVE: *Senator Henry Shaw (Josh Cowdery) prepares to deliver a rousing re-election speech beneath a giant, 50-foot banner of himself.* **LEFT:** *Campaign poster to re-elect United States Senator Henry Shaw.* **OPPOSITE:** *(Top to bottom) Langdon Shaw (Ronan Raftery) interrupts his father's meeting with his brother by bringing in the Barebone family, together with news that should be on the New York Clarion's front page.* ● *Each desk in the New York Clarion's newsroom was meticulously dressed to create the utmost realism.* ● *Concept art by Peter Popken showing the sleek office belonging to Henry Shaw Sr.*

of sibling rivalry. 'It's a really interesting conflict,' thinks Cowdery. 'Langdon, my younger brother, who's not chosen, makes all the mistakes and gets involved in all the wrong stuff. He and I don't see eye to eye on anything.'

Where the Henrys, father and son, are business focused, Langdon is adrift in the world, and David Yates was intent on capturing the shifting family relations. 'With every scene that's what he kept talking about,' says Cowdery. 'The movie is obviously much bigger than our family, but he didn't remind us of that ever. Family dynamic was the whole thing.'

And to make sure they were a united front, on the day they arrived, Jon Voight took his fictional sons out to dinner and a movie. 'He was just relaxing us,' Cowdery now grasps. 'He knows he's *Jon Voight*. So we hung out. He got to know us. And by the time we got to film, we already knew him.'

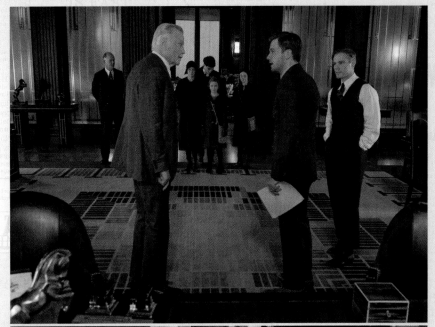

LANGDON SHAW

As played by Irish actor Ronan Raftery, Langdon Shaw is the black sheep of the family. 'I'm this somewhat drunk, belligerent second child,' he confesses; 'not as bright, not as driven, not able to focus like my brother.'

Yet it is Langdon who senses there is some kind of cover up going on when it comes to magic. He is convinced that something very strange is going on within the city. 'He's trying to spread the word,' says Raftery, 'but nobody will listen. He thinks that if he can convince his father of this magical jeopardy he might gain his respect.'

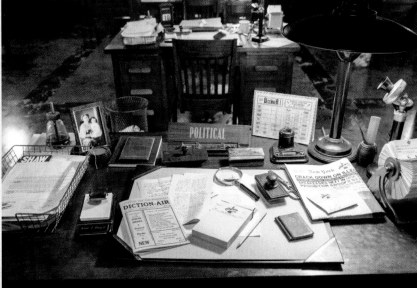

Hailing from Dublin, until now Raftery has been best known for television comedies *Moone Boy* and *Fresh Meat*, a quirky independent film called *Death of a Superhero,* and his theatre work. All of which pales into comparison with the opportunity to step into the Wizarding World.

'As soon as you hear something like this is being made, you want to be a part of it,' he says. 'Particularly because the previous *Harry Potters* directed by David Yates are so beautiful and so rich. I knew I wanted to work with him in any regard really, but it's amazing that it's J.K. Rowling's first feature script. Every character has a fully realized plot, but so much is left open. There are cliffhangers and you really want to find out what's going to happen to these guys in future movies.'

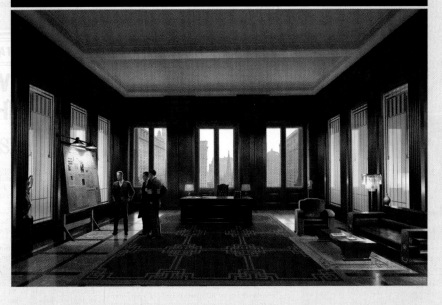

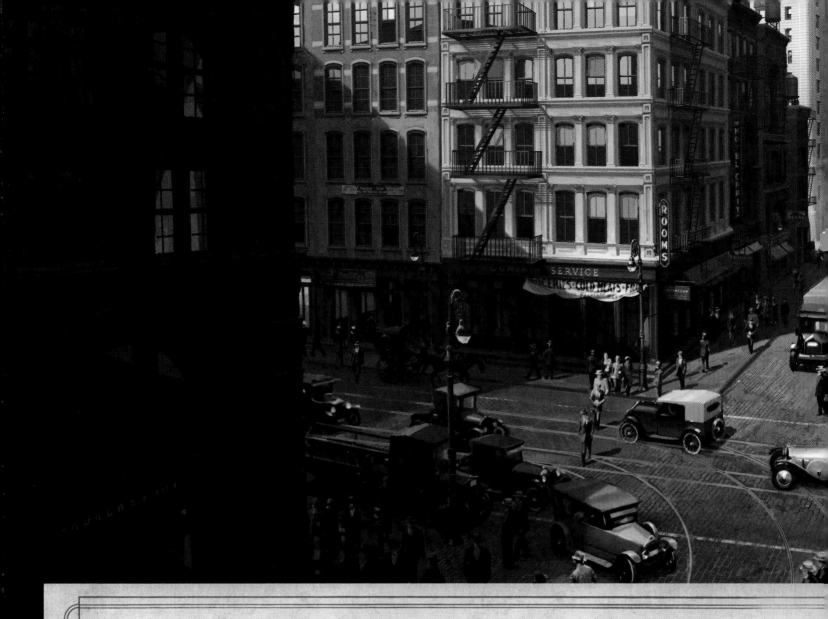

THE AGE OF THE AUTOMOBILE

On the day they had the vehicles up and running for the first time, everyone was grinning ear to ear. 'It just felt euphoric,' says Alex King, action vehicle coordinator. 'The set came to life.'

Supplying a backlot New York with an authentic stream of traffic had presented a sizable logistical challenge. The filmmakers weren't simply requesting a few jalopies to trundle past in the background; by 1926, millions of Ford Model Ts were driving off the assembly line. This was the age of the automobile.

Having sourced a range of vintage cars in good working order, the pride of collectors in the UK and Europe, King's team of engineers had to get down to some 'detective work'. Each individual vehicle had its own personality, he explains. 'They're all slightly quirky. The Model Ts all drive completely differently: the pedal selections are different, and some are even hand cranked.'

It wasn't only about the proliferation of Model Ts, either. They needed old trucks for the lower districts, and higher-end trucks for Fifth Avenue. And for the arrivals scene at the City Hall gala, King mustered police cars and motorbikes (Indian Scouts), a 'meat wagon' (a prison truck for the transport of miscreants) and, to top it all, a beautiful Rolls Royce Phantom for Henry Shaw Sr.

Then there was the tram (a light railway system that used to run along rails built into a street). The special effects team asked King if he could build something that could be digitally transformed into a tram. 'That was straightforward enough,' reports the unflappable King, 'it was an electric vehicle, thirty-two foot long, eleven foot high, seven foot wide.'

Then they asked if he could get people on it. 'We ended up taking the body off a London milk float and putting it behind

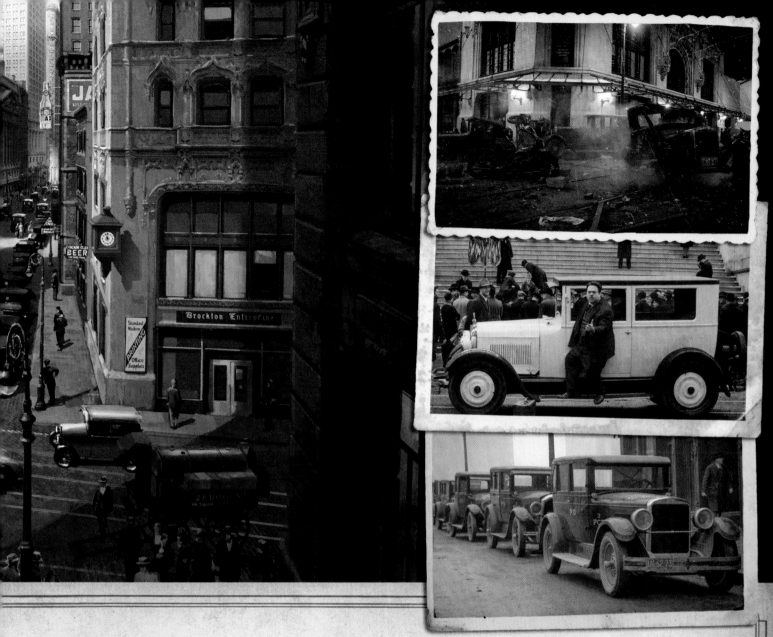

the cab, with steps up either side, and seats all the way along. All they had to do was drop in their visual effects tram on top.'

King also worked closely with special effects for those occasions the mechanical world falls foul of the magical realm. The opening sequence alone features an unexplained magical attack from beneath the city streets. That, he says, meant 'vehicles flying all over the place'. So they put a Model T moulding on a rolling chassis and swung it 'through the set like a pendulum'.

All of which beggars the question why didn't they simply do it all with CGI? 'Well, you could,' admits King. 'But when the streets are built, and the cars are travelling up and down, and you've got the noise, the smoke, and the occasional backfire, it all adds to the reality.'

Part of David Watkins' job as SFX supervisor was simulating the force of the Obscurus gliding through the streets. 'The Obscurus is almost like a tsunami wave, just pushing everything out of the way. We put a frame underneath the car which would take it off the floor so that we could move it in any direction we liked, and connect it up to a pickup truck and take it for a long track down a guided route down the street.'

Watkins' team worked with a company to mould multiple replica coupe Model T Ford cars out of fiberglass so that they could be destroyed. 'And the reason we replicated them,' explains Watkins, 'is because we wanted to ruin them basically, and you can't just go down to a scrap heap and buy ten of these to test with and ten of these to shoot with.

'Number one, we make it safe, number two, we make it look good, it's very important that they're in that order.'

MAIN IMAGE: *Concept art by Peter Popken showing the variety of vehicles that would fill the New York streets.* **TOP:** *Some cars would fare less well than others during the production.* **MIDDLE:** *Dan Fogler jokes around on the running board of one of the production's numerous police cars.* **BOTTOM:** *Some of the fleet of immaculately authentic automobiles.*

MACUSA

3

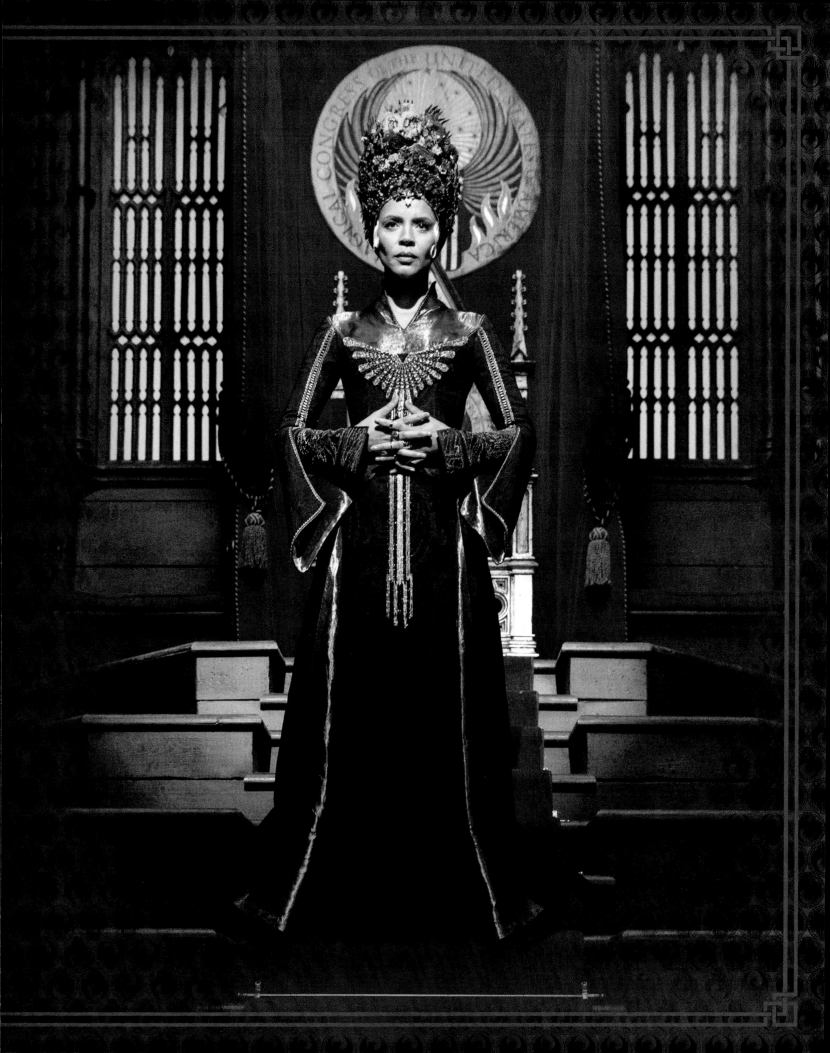

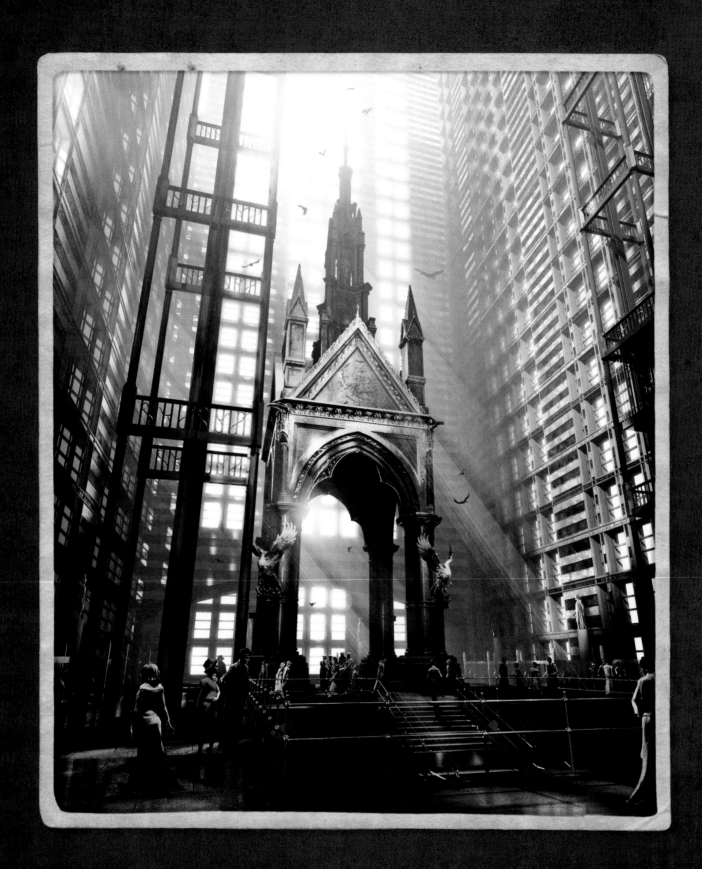

INSIDE THE MAGICAL CONGRESS OF THE UNITED STATES OF AMERICA

THE EXTRAORDINARY HEADQUARTERS OF MACUSA CAN BE FOUND INSIDE THE WOOLWORTH BUILDING AT 233 BROADWAY, TOWARD THE LOWER END OF MANHATTAN, ABOUT A BLOCK FROM CITY HALL, AND CONCEALED IN ANOTHER DIMENSION.

It was J.K. Rowling who picked the famous, 60-storey skyscraper as the ideal hiding place for the magical community of New York. In 1926, it was the tallest building in the world at 792 feet, but production designer Stuart Craig suspects the author might have been swayed by the neo-Gothic façade of the ground and mezzanine levels. The array of carvings and spires, echoing the great cathedrals of Europe, do have a hint of Hogwarts about them.

'That enabled us to acknowledge the *Harry Potter* connection,' he says. 'This is very much a turn of the twentieth-century Gothic detail, but it neatly tied things up, demonstrating that the aesthetic was common to both, fundamentally.'

Symbolically, at the point of the arch of the main entrance there is a carved owl. Craig laughs, 'She must've seen that and thought, "Eureka!"'

It is to this address that Tina will dutifully escort Newt, charged with a Section 3A – failing to Obliviate the memory of a No-Maj (Jacob) who has witnessed him perform magic. At street level you wouldn't notice anything more than the shop windows, accountancy offices, and insurance firms that face on to the ceaseless flow of traffic of the world's most modern city. 'There's a layer of Muggle activity around this seemingly Muggle building,' explains Craig.

Tina will surreptitiously point her wand in the direction of the stone owl, which launching into the air commences an intricate magical operation transforming a humble set of revolving doors into the entrance to MACUSA.

'The façade might be familiar,' says Eddie Redmayne, and an exact replica of the Woolworth Building front entrance was built as part of their elaborate New York set. 'But when you go inside it is another world.'

Forbidden from revealing their powers to No-Majs, the witches and wizards of America have to be very discreet. They are indistinguishable from the rest

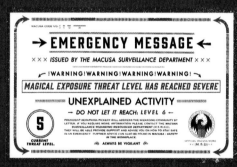

> **→ EMERGENCY MESSAGE ←**
> × × × *ISSUED BY THE MACUSA SURVEILLANCE DEPARTMENT* × × ×
> ⌐ !WARNING!WARNING!WARNING!WARNING! ⌐
> **MAGICAL EXPOSURE THREAT LEVEL HAS REACHED SEVERE**
> **UNEXPLAINED ACTIVITY**
> — DO NOT LET IT REACH: LEVEL 6 —
> **5**
> CURRENT THREAT LEVEL.
> ⚡ ALWAYS BE VIGILANT

*PREVIOUS: Carmen Ejogo plays President Seraphina Picquery. **OPPOSITE:** Concept art by Tania Richard of the cathedral-like interior of MACUSA headquarters; the central arch houses a group of bronze figures that pay homage to the Salem witch victims. **ABOVE:** An emergency message issued to the wizarding community reveals the magical exposure threat level has reached Level 5, Severe.*

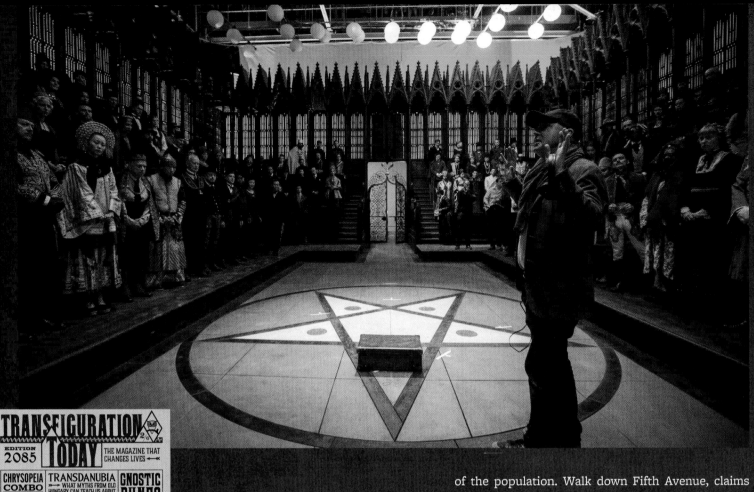

TRANSFIGURATION TODAY

EDITION 2085

THE MAGAZINE THAT CHANGES LIVES

CHRYSOPEIA COMBO
Wizard magics herself into **GOLDEN EAGLE**
..................Pg.9

TRANSDANUBIA
— WHAT MYTHS FROM OLD HUNGARY CAN TEACH US ABOUT TRANSFIGURATION TODAY...
Continues on.........Pg.4

GNOSTIC RUNES
REVEALED!......Pg.7

TEACHINGS FROM TIBET
— THE TIBETAN ORACLES OPEN UP TO TT!......Pg.1

GAUGING WAND POWER
➤ WHEN TO WAVE — AND — WHEN TO BEHAVE
Continues on....Pg.14

ANIMALCULES
— THE TRUTH ABOUT PREFORMATIONISM

WHAT IS MERGING?
.............Pg.2

HERMETIC HOWLERS · CHANGELING GAFFS · AWKWARD TRANSFORMATION

MICHIGAN DOGMAN
···· EXPOSED! ····

TOP: *Director David Yates gives his last-minute instructions to the exotic gathering of wizards and witches.* **ABOVE:** *The front page of the wizarding world's* Transfiguration Today. **RIGHT:** *The seemingly grand but ordinary entrance to the Woolworth Building – if you're a No-Maj...*

of the population. Walk down Fifth Avenue, claims director David Yates, and any one of the oncoming people could be concealing a wand about their person.

'There's a statute of secrecy that's at play,' says Colin Farrell, who as the enigmatic Percival Graves, Director of Magical Security, is effectively the chief of the wizard police. He claims it is simply a matter of safety – America has a dark history of persecuting those who display any unusual talents.

Suspended over the lobby is what appears to be a large station clock. It is about six feet across with a beautiful brass surround, but instead of conveying the time the dial displays the 'Magical Exposure Threat Level'. In other words, how close is the wizarding community to having their cover blown?

'It's four-sided, like the clock at Waterloo,' explains Miraphora Mina, who along with Eduardo Lima heads up the graphics department responsible for specially created props such as this magical barometer. 'Then inside you can see the cogs moving, and a little propeller at the bottom. It's quite a mechanical piece. It took about six weeks to build.'

As Tina and Newt cross the threshold, the hand points to 'SEVERE: UNEXPLAINED ACTIVITY'.

MACUSA is the American equivalent of Harry Potter's Ministry of Magic, and though we encounter MACUSA 70 years before we visit the Ministry of Magic, it feels more ar-

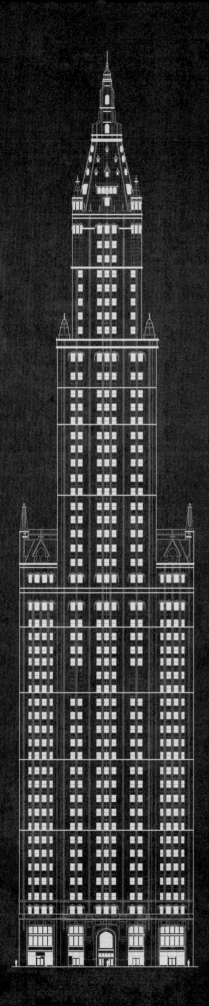

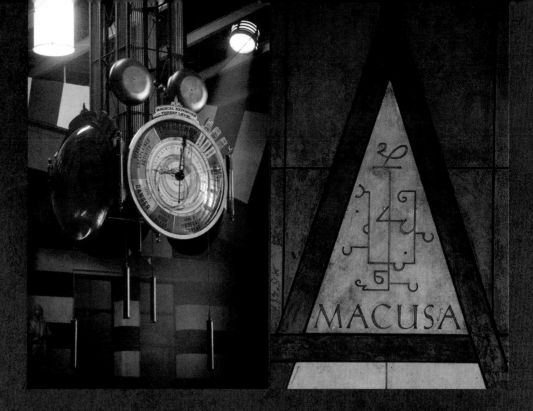

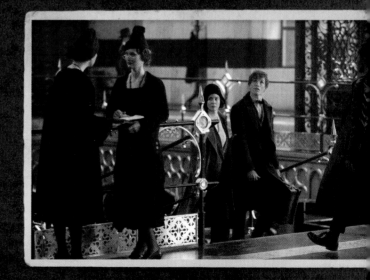

chitecturally modern. Like their real-world counterparts, magical New Yorkers think big. The scale and majesty of the interior dwarfs even the Great Hall at Hogwarts. This is another astonishing example of J.K. Rowling's capacity for invention; as well as Craig's ability to take her ideas and bring them to life through an extraordinary mix of set building and visual effects.

If you entered the Woolworth Building today, all you would see is a vaulted lobby lined in marble. Impressive enough, thought Craig, but this was to be one of the architectural wonders of the wizarding world. 'I had to think of what would elevate it to something magical,' he says. 'I couldn't quite tell you where this came from, but the chief decision with that in mind was to eliminate the floors.'

Forming a spectacular atrium, the lobby is effectively the last floor before the uppermost level of the building. It is as if the skyscraper has been hollowed out. The ceiling is 750 feet above a vast, open space framed by hundreds of windows. Craig describes it as a 'cathedral of light'.

'We have a shot that we've designed that carries you from walking in with Newt and Tina from the streets into the Woolworth Building,'

ABOVE: *A close up of the MACUSA pentagram.*
ABOVE (*Left*): *The Magical Exposure Threat Level clock was built as a full-size, four-sided prop. It displays the increasing level of threat from 'Zero' to 'Level 6, Emergency', plus totals for 'Witch Hunts', 'Exposures' and 'Obliviations'. Here, the hand sits at 'Severe: Unexplained Activity'.* **BELOW:** *Newt marvels at the ornate splendour of the MACUSA interior.*

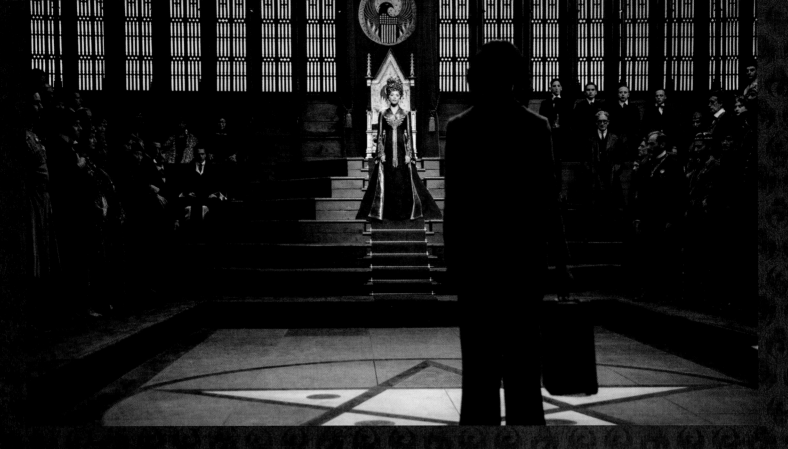

ABOVE: *Tina prepares to testify before the MACUSA congress.* **BELOW:** *The latest issue of* Transfiguration Today, *with guest contributor, Albus Dumbledore.*

says visual effects supervisor Christian Manz, 'then it transitions and they're in MACUSA and then we fly up into the lobby area.'

While the lower walls and floor of the lobby were constructed as a set on M Stage, the largest at Leavesden, the cavernous heights have been created digitally.

When Craig first produced a white-card architectural model of MACUSA, a visual aid he uses for almost every set, and showed it to J.K. Rowling she initially had her doubts. She thought it might be too modern. 'I kind of know what she meant,' admits Craig. 'Even the Woolworth Building, which was completed in 1905, has a certain modernity about it once you've got beyond the Gothic ornaments. Jo's instinct was that it should look more period than it did.'

During his research, Craig had found pictures of the interior of Sienna Cathedral where the marble walls were layered in light and dark horizontal bands. They made the medieval building feel unexpectedly modern. He convinced the author just such a banding would have the same effect on the walls of the entrance hall. They were staying true to the old-school Gothic aesthetic of *Harry Potter*, but blending it with the thrusting American spirit. 'I think we have given the lobby a very distinctive character,' says the satisfied Craig. It remains one of his favourite sets.

'The centrepiece in the central lobby was a representation of the five witches of Salem, which was referred to in Jo's screenplay,' says Craig. 'But we scaled it up to be slightly bigger than life-size figures under this gilded canopy, which was inspired by the Albert Memorial in Kensington Gardens. We as designers, as we always do, were borrowing from here, stealing from there, and everywhere, putting together what I hope is a very big, impressive, rich mix.'

Looming down from the wall is a gigantic portrait of the current President of MACUSA, Seraphina Picquery (Carmen Ejogo). It was painted for the film by Barnaby Gorton, the artist responsible for the various frescoes, as well as the Black family tree tapestry, in *Harry Potter*.

'The CGI guys take my picture and use it as a basis for a moving picture,' he explains. 'They'll keep the background and just have the head moving. They really took hold of understanding how a painting was painted rather than it looking like something created in CGI.'

The numerous wizarding world newspapers and magazines dotted throughout the film draw a neat parallel with those published by the Shaw Empire. The media is beginning to dominate both worlds. Incidentally, Gorton also created the huge No-Maj election posters of square-jawed Senator Shaw, basing them on the famous image of Orson Welles as Charles Foster 'Citizen' Kane.

'We did the news,' says a thrilled Mina. 'The script

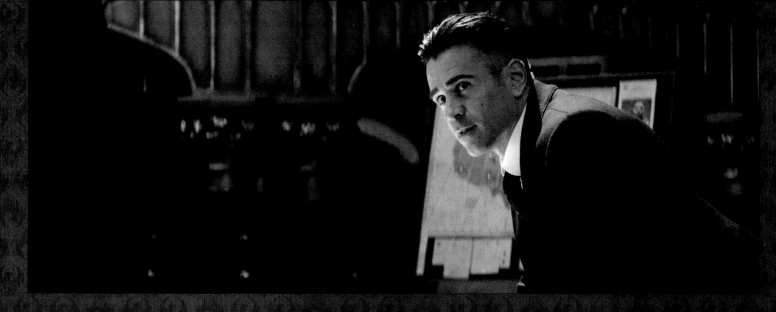

doesn't always have the headlines, so someone has to do it! All the typography and all the stories, we had to create everything.'

Up on the 13th floor, a long, long way up from the entrance hall, can be found the Pentagram Office. Well, sort of. Craig isn't entirely sure where the emergency council room is exactly located.

This grand chamber with a large star inlaid into the floor is the equivalent of the wizarding world's United Nations, presided over by President Picquery with Graves never far from hand.

Again Craig is particularly pleased with the results. 'We built this Gothic-style debating chamber. Madame Picquery sat at one end on a Dumbledore-like throne. It worked out pretty well. Tina is being interviewed in the middle of the open floor. And there are all these tiered seats with everybody bearing down on her. It was an intimidating space and that's exactly what it was supposed to be.'

Indeed, it reminded Farrell of the House of Lords or the Senate. 'There must have been two hundred actors and extras all in different costumes as,' he recalls, 'representatives from all over the world. It was amazing, because they were all wearing the culturally relevant garb, but with a little wizarding flourish. So it's just a little bit more bizarre.'

The six operating floors are to be found below the concourse. Foremost of these is the Major Investigation Department, MACUSA's centre of control and Graves' personal fiefdom. On the wall of the department is a map of North America that twinkles every time a spell is cast, pinpointing exactly where.

'It will only be seen very briefly in the film,' admits Mina, who nevertheless conceptualized an entire backstory for how the map is being used to spy upon wizard

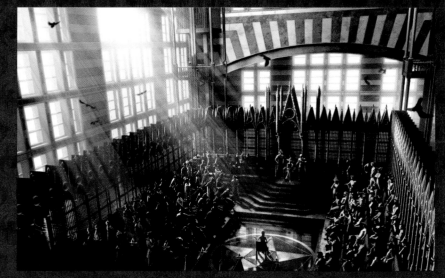

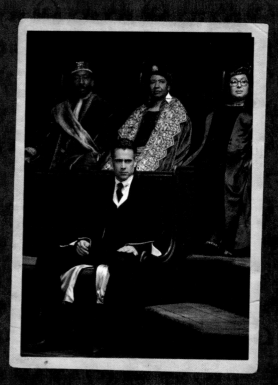

TOP: *Director of Magical Security, Percival Graves (Colin Farrell) stands in front of a chart of US Spell Contraventions, together with notices of known wrongdoers.* **MIDDLE:** *Concept art by Tania Richard of the MACUSA Pentagram Office, in which the wizards and witches appear to be in heated debate.* **LEFT:** *Costumer designer Colleen Atwood and her team ensured that every wizard and witch at the International Confederation looked unique.*

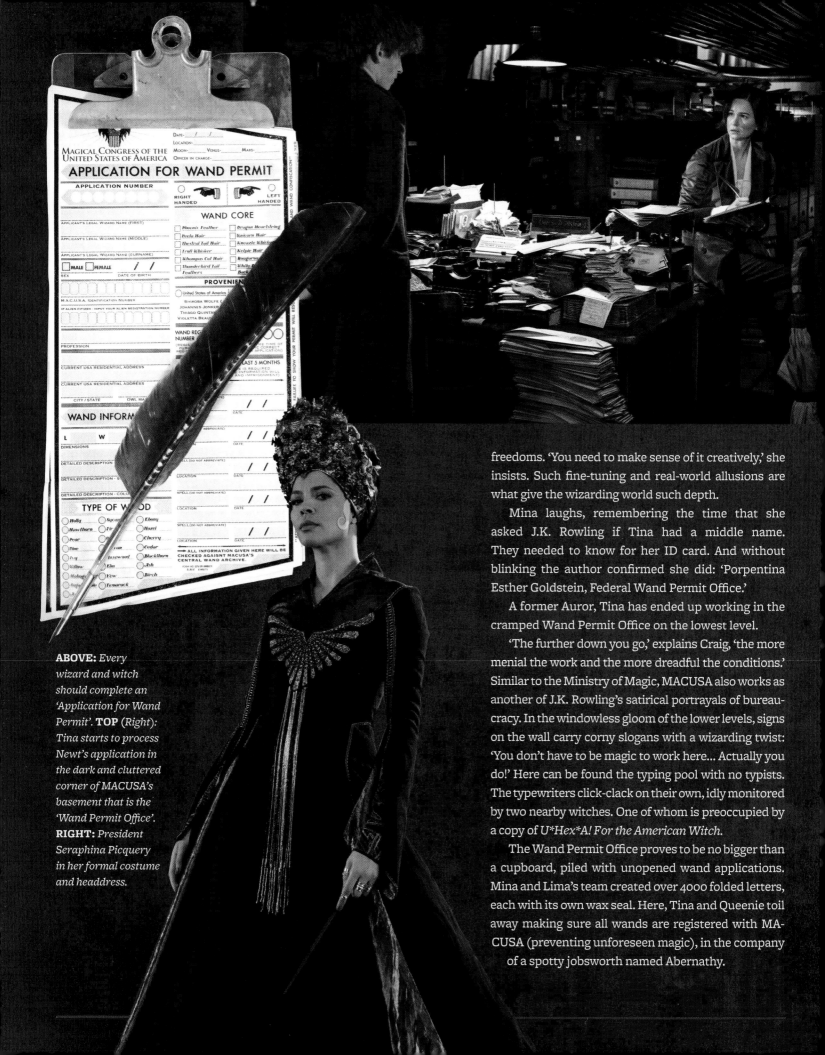

MAGICAL CONGRESS OF THE UNITED STATES OF AMERICA
APPLICATION FOR WAND PERMIT

APPLICATION NUMBER

RIGHT HANDED LEFT HANDED

Date- / /
Location-
Moon- Venus- Mars-
Officer in charge-

WAND CORE
☐ Phoenix Feather ☐ Dragon Heartstring
☐ Veela Hair ☐ Unicorn Hair
☐ Thestral Tail Hair ☐ Kneazle Whisker
☐ Troll Whisker ☐ Kelpie Hair
☐ Whampus Cat Hair ☐ Rougarou
☐ Thunderbird Tail Feathers ☐ White R...
☐ Back...

APPLICANT'S LEGAL WIZARD NAME (FIRST)
APPLICANT'S LEGAL WIZARD NAME (MIDDLE)
APPLICANT'S LEGAL WIZARD NAME (SURNAME)

☐ MALE ☐ FEMALE / /
SEX DATE OF BIRTH

M.A.C.U.S.A. IDENTIFICATION NUMBER
IF ALIEN CITIZEN - INPUT YOUR ALIEN REGISTRATION NUMBER

PROVENIEN...
☐ United States of America
☐ Shiroba Wolfe C...
☐ Johannes Jonker...
☐ Thiago Quintan...
☐ Violetta Beau...

PROFESSION

WAND REG... NUMBER

CURRENT USA RESIDENTIAL ADDRESS
CURRENT USA RESIDENTIAL ADDRESS
CITY / STATE OWL MA...

WAND INFORM...
L W
DIMENSIONS
DETAILED DESCRIPTION -
DETAILED DESCRIPTION - S...
DETAILED DESCRIPTION - COLO...

TYPE OF WOOD
○ Holly ○ Sycam... ○ Ebony
○ Hawthorn ○ Fir... ○ Hazel
○ Pear ○ ... ○ Cherry
○ Vine ○ ...an ○ Cedar
○ Ivy ○ Rosewood ○ Blackthorn
○ Willow ○ Elm ○ Ash
○ Mahog... ○ Yew ○ Birch
○ ... ○ Tamarack

— ALL INFORMATION GIVEN HERE WILL BE CHECKED AGAINST MACUSA'S CENTRAL WAND ARCHIVE.

ABOVE: *Every wizard and witch should complete an 'Application for Wand Permit'.* **TOP** *(Right): Tina starts to process Newt's application in the dark and cluttered corner of MACUSA's basement that is the 'Wand Permit Office'.* **RIGHT:** *President Seraphina Picquery in her formal costume and headdress.*

freedoms. 'You need to make sense of it creatively,' she insists. Such fine-tuning and real-world allusions are what give the wizarding world such depth.

Mina laughs, remembering the time that she asked J.K. Rowling if Tina had a middle name. They needed to know for her ID card. And without blinking the author confirmed she did: 'Porpentina Esther Goldstein, Federal Wand Permit Office.'

A former Auror, Tina has ended up working in the cramped Wand Permit Office on the lowest level.

'The further down you go,' explains Craig, 'the more menial the work and the more dreadful the conditions.' Similar to the Ministry of Magic, MACUSA also works as another of J.K. Rowling's satirical portrayals of bureaucracy. In the windowless gloom of the lower levels, signs on the wall carry corny slogans with a wizarding twist: 'You don't have to be magic to work here... Actually you do!' Here can be found the typing pool with no typists. The typewriters click-clack on their own, idly monitored by two nearby witches. One of whom is preoccupied by a copy of *U*Hex*A! For the American Witch*.

The Wand Permit Office proves to be no bigger than a cupboard, piled with unopened wand applications. Mina and Lima's team created over 4000 folded letters, each with its own wax seal. Here, Tina and Queenie toil away making sure all wands are registered with MACUSA (preventing unforeseen magic), in the company of a spotty jobsworth named Abernathy.

There is one more significant room lurking on the lower levels – the Death Cell. Alongside the whimsical touches and industrial scale, there is a shadowy side to MACUSA. It is a paranoid place, stifled by regulations. And when wizards are found guilty of breaking the cardinal laws they are brought to this room to be executed.

'That was an interesting, different look,' says Craig. 'It is very unexpected, down in the bowels of this place.' Rather than some dank medieval dungeon or torture chamber, Yates requested something clinical like a mortuary. Somewhere that looks like it is used for post-mortems where the executioners wear white coats.

'There are echoes of Nazi Germany,' the designer continues, 'the walls are lined with white marble, and right above them are massive cast-iron beams, which are the very foundations of the building. You get the sense you are deep, deep, deep underground, which helps the sinister connotations of the place. The corridors leading to the Death Cell are lined with cast-iron panels, a very Brutalist look. It's an exercise in architectural brutality.'

Filling the centre of the chamber is a square pool filled with a rippling black potion, over which a chair is suspended (the idea loosely being a magical variation on the electric chair) ready to be lowered. To pacify victims, the executioners first remove their happy memories and replay them before their eyes.

The initial design was based upon an installation at the Saatchi Gallery in London where there was a pool of oil that perfectly reflected its surroundings like a dark mirror.

'That was fairly impossible to create in reality with everybody stamping around,' says Manz. 'So we went for the same sort of thing, but using the language from the *Harry Potter* films of the Pensieve [a magical bowl used to review memories]. The idea is that there are these tendrils floating around on the surface. It's this beautiful surface and you see that the memories get cast and the victim can see images of their past.'

Once an executioner's wand is placed in the pool the liquid turns black, trying to grab the victim, and the chair lowers the misguided wizard or witch to their fate. 'You'd think wizards would have better ways of solving their problems,' says Craig.

TOP: *Colin Farrell poses for the camera in the City Hall subway.* **ABOVE** *(Clockwise): Prop design for the MACUSA Real Time Hex Indicator, which would feature a rotating brass dial with all the hexes inscribed on it, plus bulbs that would light up whenever a hex was cast.* ● *U*Hex*A, one of many popular witch magazines to be found in MACUSA's lobby.* ● *'You don't have to be magic to work here ... Actually, you do!': one of the signs to cheer up the witches working in the basement.*

PORPENTINA GOLDSTEIN

AT FIRST GLANCE, PORPENTINA OR 'TINA' GOLDSTEIN IS A NO-NONSENSE, CAREER-DRIVEN NEW YORK WITCH. INDEED, SHE IS THE FIRST OF A MAGICAL PERSUASION TO SPOT THAT NEWT MIGHT BE MORE THAN A PASSING TOURIST.

Dressed in her usual smart but inconspicuous mix of above-the-ankle trousers, grey overcoat and black cloche hat, she trails him into the bank; there, she is appalled to witness the wizard use his wand in broad daylight and promptly arrests him. Newt is clearly an exposure risk to the secretive MACUSA. He may also be a chance for Tina to redeem herself.

Tina has run into her own problems at MACUSA. 'She's recently been demoted,' explains Katherine Waterston, the New York-based actress who is bringing this complicated witch to the screen. 'She's gone from being a detective to the lowly work in the Wand Permit Office. Basically stamping passports.'

Up until her downturn in fortune Tina was an Auror, a wizard detective tasked with investigating crimes. But as director David Yates explains, 'She has done something really bad.' What her crime might be is revealed over the course of the movie. 'Like Newt,' he says, 'she is a wee bit of an outsider.'

Waterston finds her character fascinating. Nothing is quite what it seems. Tina is really proud to be a part of MACUSA. She still hopes to make something of herself there. Yet she also slinks about New York doing her own investigation like a private eye from an old-school crime movie.

'Tina has good instincts,' hints Waterston. 'She is good at her job. But when push comes to shove, she will abandon the rulebook.' She is a woman of great potential, but she just hasn't found a way to realize it yet, with pretty bobbed hair and a stern gaze.

Yates was taken with Waterston from the moment she walked into the first audition. She displayed similar qualities to Eddie Redmayne. 'Very much like Eddie, she can be quite deeply intense in a good way, and she can be very, very funny. She's got a great physical ability at comedy, which is quite rare. She's also a really powerful actor. I loved that combination.'

Waterston doesn't count herself as any kind of expert on the history of *Harry Potter*. She had seen some of the films, read some of the books, but admits she hadn't got completely lost in the world. She also thinks that may not be a bad thing.

'I felt in a fortunate place,' she says, 'because I wasn't so obsessed that I had a lot of preconceived notions, but I was familiar enough to have a sense of the tone of the world.'

She also had plenty of opportunity to pick the brains of J.K. Rowling, who provided a wealth of knowledge on Tina.

'You just want to curl up by the fire with her and hear her stories,' sighs Waterston happily. 'She sees a whole, incredibly detailed universe.'

Two key relationships will emerge in Tina's busy corner of that universe. Firstly, with her sister Queenie, played by Alison Sudol, with whom she shares a small Brownstone apartment.

OPPOSITE: *Katherine Waterston as Tina Goldstein.*

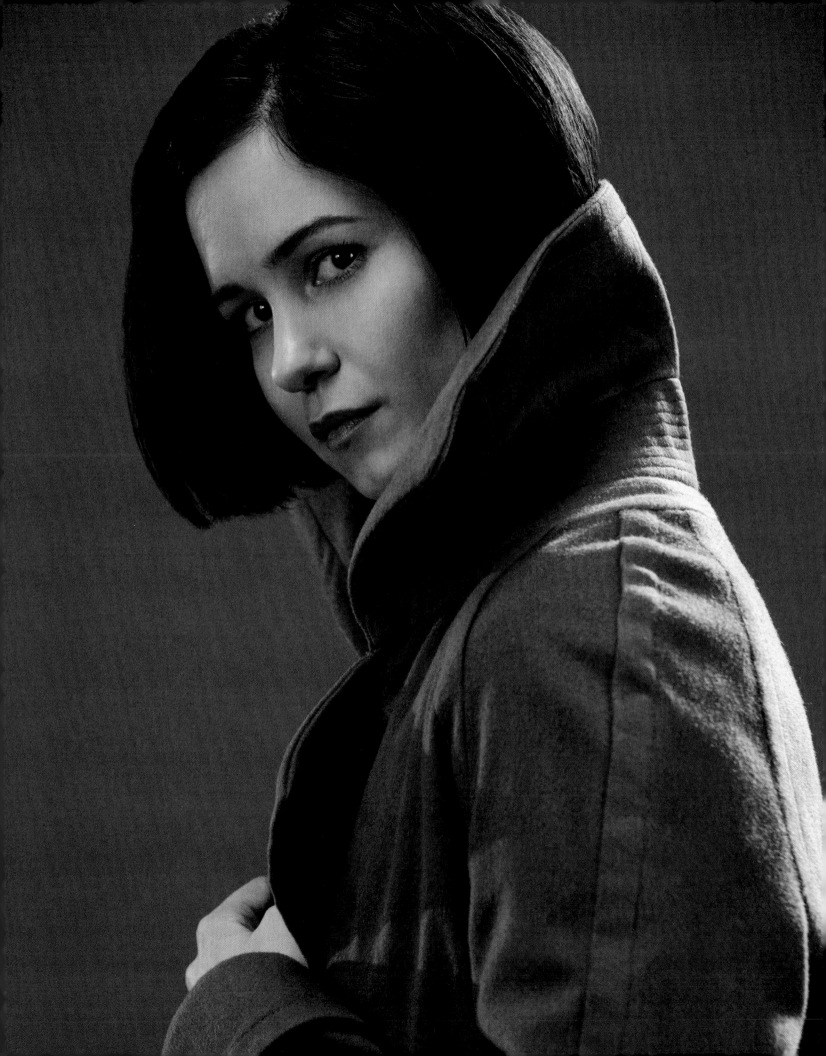

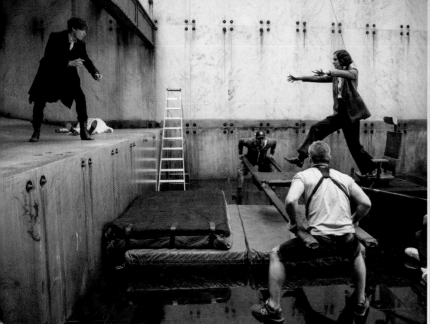

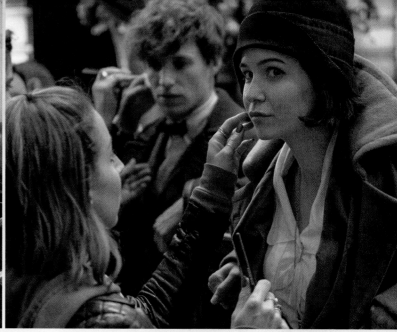

TOP (*Left*):
Crewmembers
brace themselves as
Katherine Waterston
as Tina prepares
to take a leap
of faith. **TOP** (*Right*):
Katherine Waterston
& Eddie Redmayne
have their make-up
perfected prior to
filming. **BOTTOM**
(*Left*): Tina in the
bank lobby. **BOTTOM**
(*Right*): Newt & Tina
are being watched by
the Aurors lurking
in the shadows
behind them.

Tina and Queenie lost their parents to dragon pox when they were young, and at different times have been a parent to one another. 'In their loneliness they have sort of fallen into that dynamic,' says Waterston. Tina, she admits, may be a bit more the father, and Queenie the mother, cooking these wonderful meals. Queenie is as vivacious as Tina is restrained, yet they couldn't be closer.

'It feels true to life to me, the way Tina and Queenie relate to one another,' insists Waterston. Having only just met, she and Sudol developed an instant chemistry as they shot the scene of the Goldsteins preparing dinner for Newt and Jacob. It was their first day working together and they had to glide about the kitchen casting spells with their wands as if it was second nature.

'We kind of scrambled to figure it out – whose chore is whose?' recalls Waterston. 'I'm sort of setting the table with my wand and she's preparing the meal. We developed a little, superstitious salt-over-the-shoulder thing, just to give the audience a sense of their life together.'

Then, of course, there is Newt. Someone Tina can't quite figure out. Not at first. 'Part of what I love about Tina is that she's flawed,' says Waterston. 'Things don't work out for her. She meets Newt and she suspects there is something to him, but she doesn't know exactly what.'

Throughout the film, as she watches him interact with his fantastic beasts and sees the way he is, Tina will come to view Newt in a different light.

'With Katherine's character it is sort of a slow-build connection,' says Redmayne, 'these two people, who are outsiders yet passionate people, begin to glimpse things in one another.'

Waterston describes it as a love story albeit in an unconventional way. They have a lot to deal with in the meantime – escaped beasts, death sentences, going on the run, tackling the outbreak of dark magic – and yet Newt sees all the potential in her that she has trouble seeing in herself. 'At first, she thinks he's dangerous and untrustworthy, and probably kind of cute too,' she says. 'Then as the relationship evolves you start to notice these parallels between them. I mean, both are passionate but not very good at expressing themselves.'

She pauses, trying to capture one of the themes of the film: 'It can be lonely being an oddball until you find another oddball.'

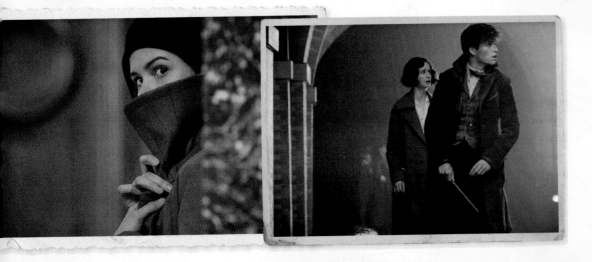

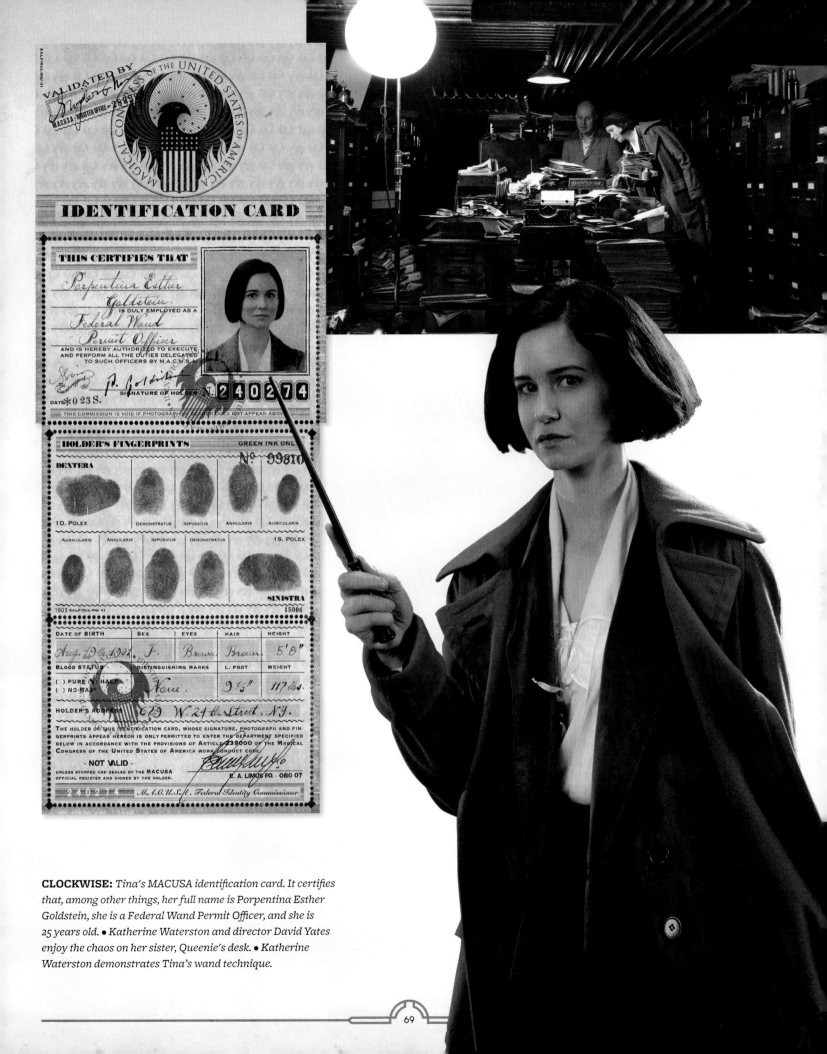

CLOCKWISE: *Tina's MACUSA identification card. It certifies that, among other things, her full name is Porpentina Esther Goldstein, she is a Federal Wand Permit Officer, and she is 25 years old. ● Katherine Waterston and director David Yates enjoy the chaos on her sister, Queenie's desk. ● Katherine Waterston demonstrates Tina's wand technique.*

QUEENIE GOLDSTEIN

QUEENIE IS QUITE DIFFERENT FROM HER SISTER. WHERE TINA IS SERIOUS AND HARD TO READ, QUEENIE IS A FREE SPIRIT WITH A DISARMING SMILE AND NONE OF HER SISTER'S AMBITIONS TO PROVE HERSELF AS AN AUROR.

With a head bubbling with blonde curls to her sister's brunette bob, she is far more fashion conscious. The script goes as far as to describe her as 'the most beautiful girl ever to don witch's robes.' It is a beauty matched by the sweetness of her nature.

'Being Queenie is just delightful,' declares Alison Sudol, the Seattle-born newcomer who won the role. 'She's really playful, but also perceptive and empathetic. She is aware, but very unaware of herself at the same time, which I just love.'

They may be entirely different creatures, but orphaned at a young age the Goldstein sisters have come to depend on one another. The décor of their apartment is a colourful fusion of their different personalities.

'They have basically raised each other,' explains Sudol, 'but it's a sort of isolated and lonely life, then our lives are suddenly transformed within a night.'

Newt and Jacob will turn the Goldsteins' world upside down and for the first time, a double act will become a foursome.

For producer David Heyman, Queenie is archetypal of a theme that runs throughout J.K. Rowling's work – don't judge a book by its cover. 'Nothing is quite as it seems,' he says. 'So with Queenie, you could easily dismiss her because she is a beautiful woman, but there are hidden reservoirs and much more that lies beneath.'

Not least the fact that Queenie is a Legilimens, which in the wizarding world means she has the power to extract memories and feelings from another person's mind. It's a form of mind reading, although Professor Snape – who has cultivated his own Legilimency skill – would find that definition to be grossly inadequate.

Entirely smitten with Queenie, poor Jacob is quite defenceless. Queenie can read everything he is thinking about her, but she is touched by what she discovers. Another element of Legilimency is the ability to detect lies and deceit in a person, and she finds none at all in the downtrodden baker. Seeing a true heart, Queenie will fall for this unlikely fellow.

'Queenie is an angel,' says Dan Fogler; 'the two of them start to fall in love. It gives Jacob a real reason to stick around.'

Director David Yates admits it was finding the untainted side to Queenie that made her so hard to cast. 'On paper, Queenie is this glamorous, beautiful, exotic woman, and we saw the most glamorous, beautiful, exotic women for that role,' he says. 'However, there was just something missing, and then Alison came in. There was a purity and an innocence to what she did that was exceptional.'

This is only Sudol's second feature film, and couldn't be a bigger contrast to her first – a low-budget depiction of homelessness called *Other People's Children*. She has appeared in a number of television shows: *CSI: NY, Dig,* and the award-winning *Transparent*. In addition to acting, she is a singer-songwriter in the

OPPOSITE: *Alison Sudol as Queenie Goldstein.*

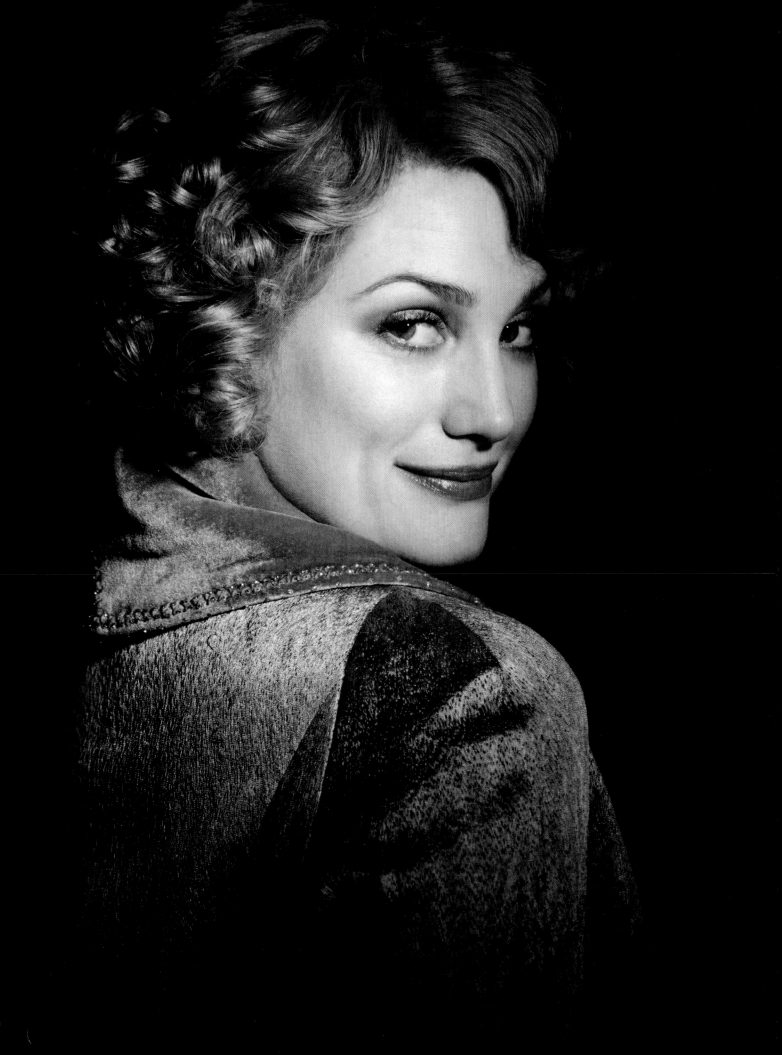

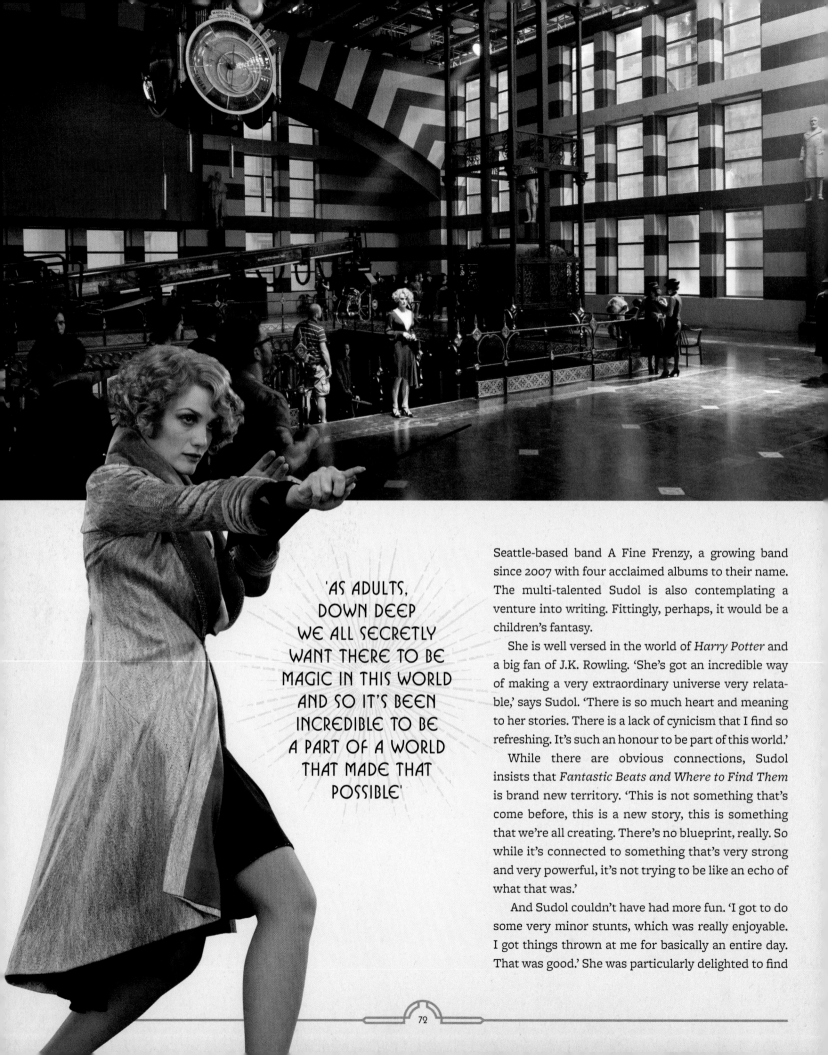

'AS ADULTS,
DOWN DEEP
WE ALL SECRETLY
WANT THERE TO BE
MAGIC IN THIS WORLD
AND SO IT'S BEEN
INCREDIBLE TO BE
A PART OF A WORLD
THAT MADE THAT
POSSIBLE'

Seattle-based band A Fine Frenzy, a growing band since 2007 with four acclaimed albums to their name. The multi-talented Sudol is also contemplating a venture into writing. Fittingly, perhaps, it would be a children's fantasy.

She is well versed in the world of *Harry Potter* and a big fan of J.K. Rowling. 'She's got an incredible way of making a very extraordinary universe very relatable,' says Sudol. 'There is so much heart and meaning to her stories. There is a lack of cynicism that I find so refreshing. It's such an honour to be part of this world.'

While there are obvious connections, Sudol insists that *Fantastic Beasts and Where to Find Them* is brand new territory. 'This is not something that's come before, this is a new story, this is something that we're all creating. There's no blueprint, really. So while it's connected to something that's very strong and very powerful, it's not trying to be like an echo of what that was.'

And Sudol couldn't have had more fun. 'I got to do some very minor stunts, which was really enjoyable. I got things thrown at me for basically an entire day. That was good.' She was particularly delighted to find

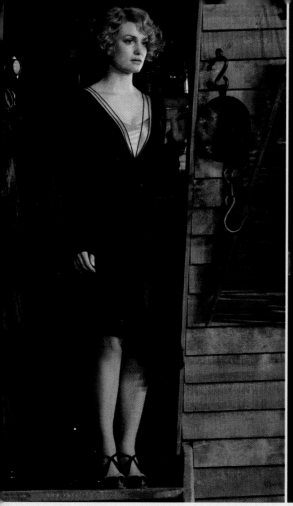

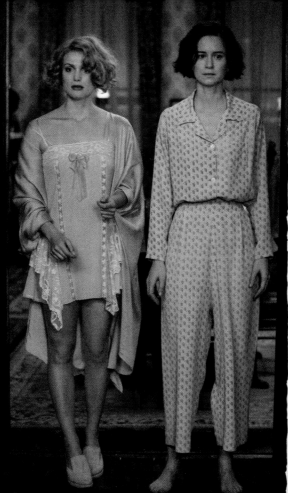

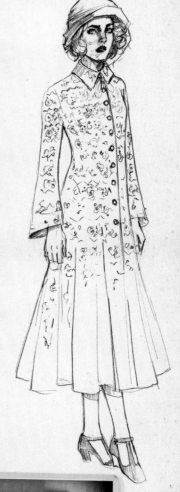

that when you crash into the walls or onto the floor, they build special sponge versions of the surfaces so that you don't get injured.

'So many lovely, heartfelt moments,' she sighs. 'As adults, down deep we all secretly want there to be magic in this world and so it's been incredible to be a part of a world that made that possible.' The only downside is having to return to reality. She laughs, 'Sometimes I'll walk around and I'll forget that I can't make things move. You get used to pointing your wand and stuff happening.'

OPPOSITE (*Top*): *Alison Sudol is illuminated as she stands in the MACUSA Entrance Lobby.* **OPPOSITE** (*Bottom*): *Queenie Goldstein, the prettiest witch in New York, casts a spell.* **CLOCKWISE:** (*From above*) *Queenie looks out from Newt's shed.* • *Even in their bed clothes, it was important to Colleen Atwood that the Goldstein sisters maintained their respective personalities.* • *Early costume sketch of Queenie's coat designed by Colleen Atwood, drawn by Warren Holder* • *The tailor's dummy in the Goldstein apartment reveals that at least one sister has a passion for fashion.* • *Queenie & Jacob get to know each other a little better while standing at the bar of The Blind Pig speakeasy.*

THE GOLDSTEIN APARTMENT

Following the chaos of Newt's arrival, the British wizard and his No-Maj companion Jacob are taken to stay at the Goldsteins' Brownstone apartment. Alongside MACUSA and disreputable speakeasy The Blind Pig, Tina and Queenie's humble residence is one of only three wholly magical locations the film will visit.

Named for the dark sandstone bricks used to build Manhattan's famous townhouses, most Brownstones were converted into apartments in the 1920s. Not wealthy, the Goldsteins occupy a couple of rooms within one such conversion.

Inspired by the Harlem terrace, the exterior set for the Goldsteins' apartment was constructed as part of their versatile New York backlot on a side street that ran parallel to the stem of the T-shaped complex. 'Just a run of five Brownstones,' says Craig. 'With three or four opposite – so you can actually shoot across the width of the street and then extend it lengthwise in both directions by virtue of green screen.'

'This was a chance for me to really think about the girls' very different characters,' says set decorator Anna Pinnock, 'in the way we dressed the detail into their own particular areas of the space.'

LEFT: *The ordinary looking apartment of the magical Goldstein sisters.* **ABOVE:** *Cover of the* Witch's Friend *designed by the graphics department to adorn the Goldstein apartment.*

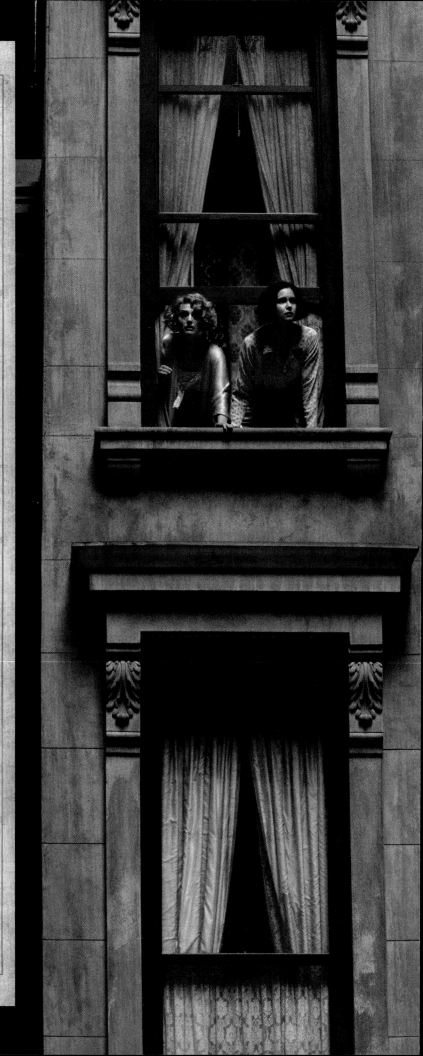

As with the exterior, the interior set was a classic Brownstone, only more so. Pinnock explains: 'To make the space feel magical and different, the architectural features such as fireplaces, the narrowness of the room, the scale of the furniture, were subtly exaggerated.'

Furthermore, Tina and Queenie will prepare dinner for their guests with the help of familiar spells. Jacob, recovering from a nasty bite from a Murtlap, wonders whether he is having a hallucinogenic episode.

'He's chucked onto this sofa and the girls suddenly swish their wands around and plates fly from everywhere and food is being chopped,' says visual effects supervisor Christian Manz, 'and we go into incredible detail about baking an apple strudel magically. But it feels workaday, it feels normal to them.'

Following the lead of the sumptuous production design and set decoration – including copies of *The American Charmer* and *Transfiguration Today* ('new contributor Albus Dumbledore') – Manz and his team just tried to think along the lines of a homespun variety of magic.

'We've got little napkins flying like birds, we've got a book jacket that will move around,' he recalls. Irons work on their own accord, a clothes-horse revolves to ensure both sides face the fire, and there is a lovely dress on a mannequin that Queenie is mending remotely.

In one of the few moments of respite amid the excitement, we get a glimpse inside a magical home not unlike the occasional taste of life at the Weasley residence in *Harry Potter*. The idea, says actress Katherine Waterston, is 'to give the audience a sense of the Goldsteins' life together that is very insulated and private.' Having two men visit, she insists, is a 'freak exception'.

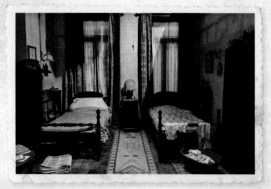

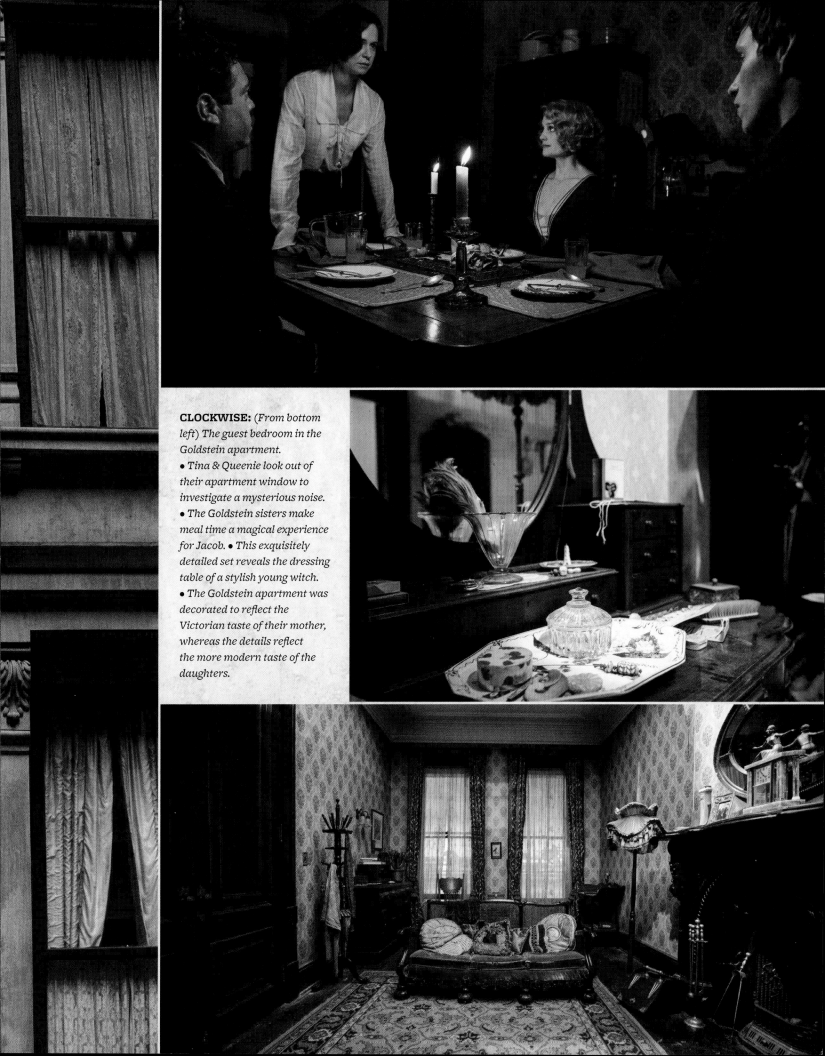

CLOCKWISE: (From bottom left) The guest bedroom in the Goldstein apartment.
● Tina & Queenie look out of their apartment window to investigate a mysterious noise.
● The Goldstein sisters make meal time a magical experience for Jacob. ● This exquisitely detailed set reveals the dressing table of a stylish young witch.
● The Goldstein apartment was decorated to reflect the Victorian taste of their mother, whereas the details reflect the more modern taste of the daughters.

COLLEEN ATWOOD – COSTUME DESIGNER

Confined to Jacob Kowalski's threadbare suit for most of film, Dan Fogler didn't fully appreciate the genius of costume designer Colleen Atwood until the day they shot the International Confederation of Witches and Wizards at MACUSA. 'You have rows and rows of people in their different styles and each costume is perfectly specific to their own culture,' he marvels. 'You're basically at the Wizards' UN. And I just sat there going, "Oh, my God. I want every single one of these action figures."'

Born in Yakima, Washington, Atwood has established herself as one of the most sought-after costume designers in Hollywood. With over 50 films to her name, she has won an Academy Award® on three occasions: *Chicago*, *Memoirs of a Geisha* and *Alice in Wonderland*. While incredibly versatile, she has a gift for blending fantasy and reality. Dating back to *Edward Scissorhands*, Atwood has been a key collaborator on Tim Burton's otherworldly tales.

She can see the similarities with *Fantastic Beasts and Where to Find Them*. 'This is a magical world based in reality,' she observes. 'Tim's sensibility is magical things in the real world, so it is a similar kind of challenge.'

Surprisingly then, this is Atwood's first venture into J.K. Rowling's Wizarding World. In fact, rather than the magical side, necessarily, the chief draw was a chance to explore the era. This was a time and a place teeming with every possible indulgence.

'I love the nineteen-twenties in New York,' she says with typical enthusiasm. 'It was a major time in America. It was before the Depression, so it was a crazy time of excess in all ways. Prohibition was going on, but people drank and people partied. The intensity appeals to me. It's like the jazz, the whole vibe of that I love.'

Director David Yates' directive had been simple – authenticity in all things. 'He wanted the sort of frenetic energy of New York,' she says, and she sourced pre-existing costumes from America, Spain, Rome and even eBay. 'All these kinds of people coming together and making a city.'

When it came to MACUSA, Atwood gave the fashions of the day a magical slant. 'I used the kind of bigger, cocoony shapes and cape shapes, and I took the cloche hats and made versions of them with little points to give them a bit of a witch's vibe.'

When it came to her lead characters, all the costumes were created bespoke, adding layers of psychological insight and wit that help define exactly who these people are – or might be.

OPPOSITE: (Clockwise from top left) Among the tools of her trade are examples of Colleen Atwood's artistry: Alison Sudol & Dan Fogler have fun showing off their costumes • Tina looks ravishing in her beaded dress • Newt reveals that he is a Hufflepuff by wearing a scarf in his House colours • Seraphina Picquery's headdress and in her ceremonial dress • Gemma Chan plays an exotic witch visiting MACUSA.

GRAVES

'I wanted to empower him in a way, so I exaggerated things. I gave him these huge spat boots and like a Joan Crawford shoulder. We had different versions of the shoulder for different shots. It was great big in the wide shots, but when tighter I went to a smaller version. But I also liked a clerical vibe of black and white. I wanted his coat to have sweep, so I designed one that was very sleek but still had a kick to the hem, and I found this amazing fabric – it's like cashmere but it had a Lurex thread in it so it had a little bit of shine but not enough that it looked blingy.'

TINA

'Tina Goldstein is a little bit gawky. A little bit not quite there in her body and just a little bit off in her costume. She was sort of a modern girl, and I made an acting decision to put her in trousers from the start, which was not so common in the period. She had an element of what the Aurors wore but not really. Hence the trousers. She was hiding a lot and doing her own private-eye things. So I gave her a trenchcoat with a really big collar she could tuck her head behind doing this kind of stealthy spying work.'

QUEENIE

'Queenie was a lot of fun. I made a coat for her that she wears a lot. I drew the design and it was woven for me – it took thirty thousand feet of thread to make that coat. It's all different colours of umber and peach like a sunset or a sunrise. There was an element of air and light that I liked for Queenie. Underneath is her take on a witch's dress, but with a little bit of a nineteen-twenties slant and a little bit of floozy.'

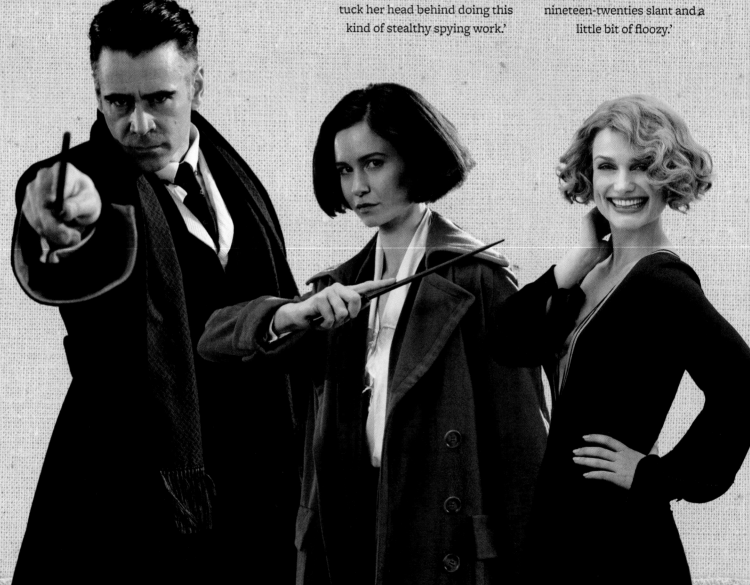

JACOB

'Jacob's kind of what you'd describe as a schlub back in the day. He has baggy pants at his waist. We meet him trying to get a loan from a bank and he had a suit that looks presentable. But as he has so little money his clothes don't quite fit the way they should. I used softer fabrics so he had a little bit more bagginess.'

CREDENCE

'I really wanted Credence to be pulling inwards, so I brought a meanness to his costumes. The collar's very high and tight, with a slightly bug shape to it. I did a lot of breakdown on his jacket, so it had a worn-out quality. It's the only thing he had. He and Jacob are the only two characters in the movie that don't have a coat and I did that on purpose. There's a poverty to not having a coat.'

MARY LOU

'With her costume, we went with something very severe but still dignified and present. I didn't want the Second Salemers to look like Suffragettes, with big hats, so I pared them down and made their shapes very loose limbed, in a way like weird marionette shapes.'

THE SHAWS

'They're not magical people, they're just wealthy New Yorkers. That group and their world is a very straight-forward nineteen-twenties world. They set a balance with the others – it was really important to me that all the costumes work together.'

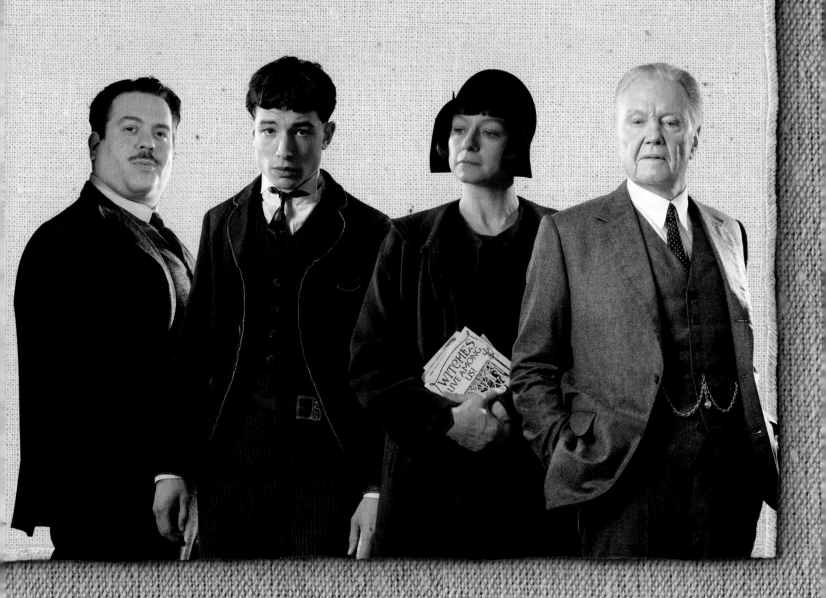

PERCIVAL GRAVES

PERCIVAL GRAVES CUTS AN IMPRESSIVE FIGURE. WITH JET-BLACK HAIR
SILVERING AT THE TEMPLES, AN UNSWERVING GAZE AND FINE TAILORING,
HE HAS THE MOVIE-STAR LOOKS OF A DOUGLAS FAIRBANKS OR A CLARK GABLE.

But he is no movie star – Graves is a highly skilled and cunning New York wizard. With the alertness of a predator, he doesn't miss a thing. All of which adds up to the fact that Colin Farrell is perfect casting.

'Graves is very high up the command chain at MACUSA, and is basically an Auror,' explains the Irish movie star proudly. 'He's a kind of officer of the law in the world of wizardkind, there to investigate and contain anyone who is potentially detrimental to wizardkind by trifling with the Dark Arts.'

And yet, as with all the characters, there is more to this powerful wizard than upholding the rules. For one thing, Graves harbours certain beliefs, political viewpoints shall we say, that wouldn't sit well in the hallowed halls of MACUSA if he let them be known. 'His ideology,' says Farrell teasingly, 'is something very particular to him.'

Making his name with war drama *Tigerland* and New York-thriller *Phone Booth*, the Dublin-born actor swiftly established himself working with some of the biggest names in the business: Steven Spielberg, Oliver Stone, Michael Mann and Woody Allen. His has been a career marked by his versatility, mixing character parts with heroes and villains across thrillers, comedies, dramas, independent films and major studio productions. Nevertheless, he has never done anything quite this magical before. Farrell calls it his first 'big departure from reality'. And he couldn't be happier.

After all, he's been saying for years that he wished the people from *Harry Potter* would call. 'The beautiful thing about the *Harry Potter* films, and particularly watching David work with all the actors, is seeing how he digs and digs and digs to find the truth of the characters.'

He hastens to add that he's also had a blast casting spells, and dashing around this New York variation on the wizarding world. And it wasn't just the sets that never ceased to amaze him; it was the sheer detail right down to the costumes.

'The costumes do a lot of work for you,' he says. 'How you see yourself in a mirror, it informs the way you move.' As Farrell puts it, he gets to wear some 'gorgeous threads'. There is a quality both dashing and officious about Graves that borders on the sinister: he wears a long, black coat that is almost a cloak, while his white shirt has a high collar neatly held in check by a black tie. He also has an interesting necklace, of which we will say no more.

'It has that kind of priestly feel to it that was more than just clothing,' he reflects. How Graves looks represents his discipline as an Auror currently on

OPPOSITE: *Colin Farrell as MACUSA's Director of Magical Security, Percival Graves.*

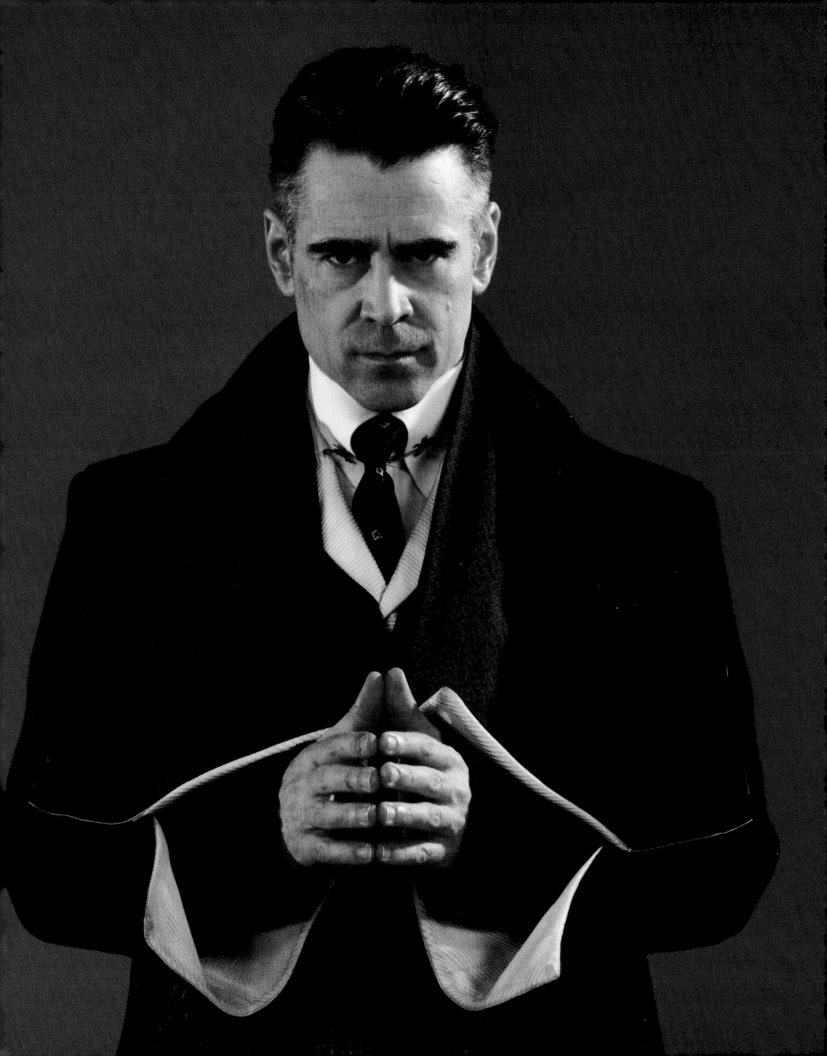

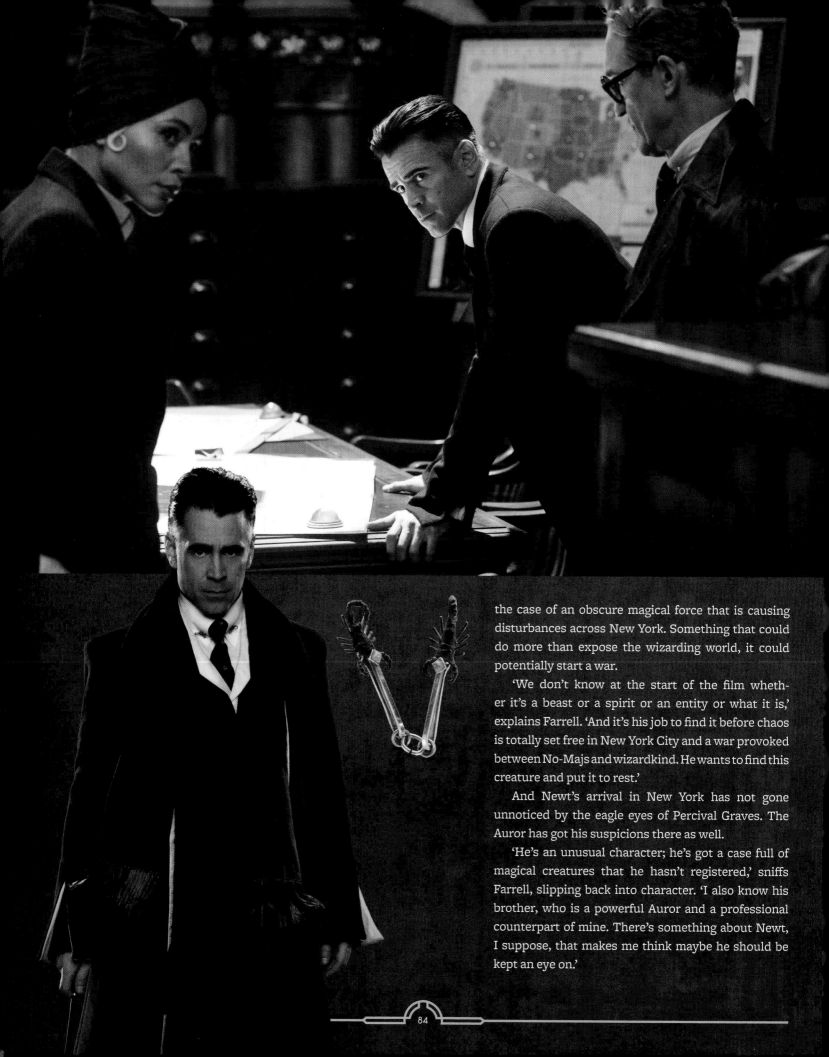

the case of an obscure magical force that is causing disturbances across New York. Something that could do more than expose the wizarding world, it could potentially start a war.

'We don't know at the start of the film whether it's a beast or a spirit or an entity or what it is,' explains Farrell. 'And it's his job to find it before chaos is totally set free in New York City and a war provoked between No-Majs and wizardkind. He wants to find this creature and put it to rest.'

And Newt's arrival in New York has not gone unnoticed by the eagle eyes of Percival Graves. The Auror has got his suspicions there as well.

'He's an unusual character; he's got a case full of magical creatures that he hasn't registered,' sniffs Farrell, slipping back into character. 'I also know his brother, who is a powerful Auror and a professional counterpart of mine. There's something about Newt, I suppose, that makes me think maybe he should be kept an eye on.'

OPPOSITE (Top): Seraphina Picquery discusses with Graves and his team of Aurors the disturbing magical events that are happening in their city. **OPPOSITE** (Left): Colin Farrell as the dashing Graves, with (inset) his scorpion collar clip, seen close up and as part of his costume. **CLOCKWISE:** (From above) Graves has some uncomfortable questions for Newt. ● Graves unleashes a powerful spell in the City Hall subway. ● Colin Farrell does his best to ignore the large yellow tape measure as he enters via the window. ● Striking a commanding pose as Director of Magical Security, Percival Graves.

'THERE'S SOMETHING ABOUT NEWT, I SUPPOSE, THAT MAKES ME THINK MAYBE HE SHOULD BE KEPT AN EYE ON'

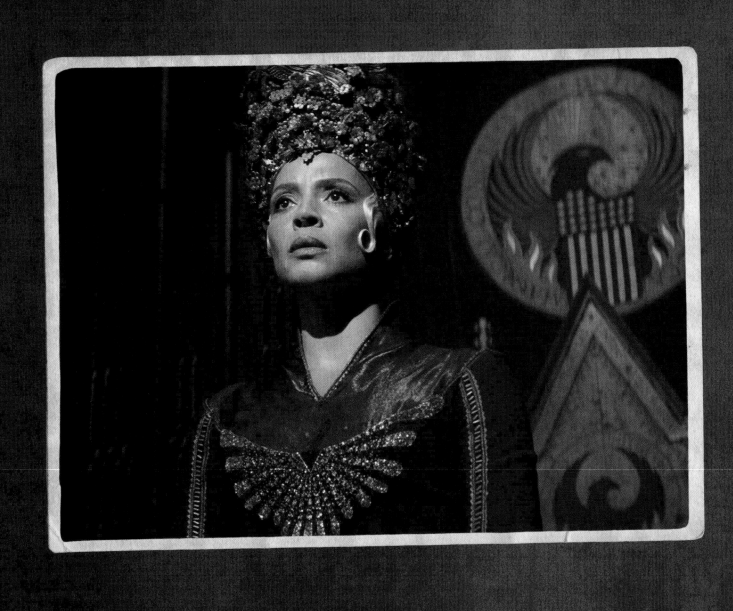

PRESIDENT SERAPHINA PICQUERY

'I am the head of MACUSA, the American equivalent to the Ministry of Magic,' announces British actress Carmen Ejogo, setting out the responsibilities that face Seraphina Picquery, 'and I suppose my most essential task in this world is to protect the wizarding community from being exposed, because with exposure could come war and potentially the destruction of our community.'

President of the Magical Congress of the United States of America, Seraphina is a leader under pressure. She is surrounded by fear and rumour-mongering, and may not be well informed by her inner circle. She presides over a divided community. There are those wizards and witches who believe they should operate in the real world being who they are, whatever the risk. And there are those, like herself, who think it best to remain in isolation. As the film begins, a fragile peace is being maintained, but civil war hovers in the paranoid air of MACUSA.

'I think in our film,' says Ejogo, 'which is somewhat different to the *Harry Potter* films, it is still very much a community that has yet to have the full courage and conviction of its own power.'

The star of *Sparkle*, *Alex Cross*, and the Academy Award®-nominated *Selma*, Ejogo was born and brought up in London but has long been a resident of Brooklyn. And she has been dazzled by the filmmakers' transformation of her home city into somewhere both real and surreal. 'There is this wonderful juxtaposition of heightened reality right next to something that feels very personal and very authentic.'

That edge of reality counts thematically too. This is an America intolerant to magic, forcing it underground. Ejogo points out that it wasn't so long ago that the Salem witch trials took place, and having that as a backdrop creates an atmosphere. 'There is a puritanical strain that is well represented in this movie,' she says.

A striking witch, Seraphina comes dressed in a business-like pin-stripe suit, with a stylish black turban covering her white hair. Later, when heading up the International Confederation of Witches and Wizards from an ornate throne, she boasts a more splendid turban fashioned of silk and elements of an Indonesian antique dance headdress. She has the grand bearing suitable for a head of state. An aloofness, Ejogo says, that means she keeps a certain distance from most of the characters in the film.

'But there are moments between herself and Tina which suggest a backstory that you never see in the film, but in the writing on the page it's implied,' she adds. 'And because Katherine [Waterston] is such a great actress to work opposite, we've both come into the scenes we have together with a sense of depth. I never feel as though Seraphina is just showing up. There is a history, a legacy. These are all fully fleshed-out characters.'

OPPOSITE: *Seraphina Picquery (Carmen Ejogo), stands in front of her throne and the great seal of MACUSA.*

NEW YORK WANDS

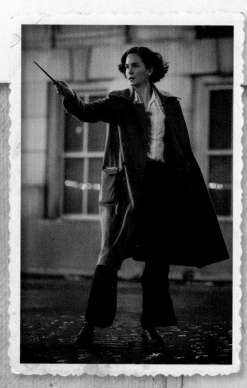

QUEENIE'S WAND

'She has a lovely wand,' says Bohanna. 'It has a much more obvious shell design – it was a piece of mother of pearl that had been sculpted into a kind of snail's shell shape. Again that had a very simple shaft to it, made out of a dark rosewood. It is a nice simple aesthetic in connection with the character.' In other words, it is very elegant but not for the sake of it.

TINA'S WAND

When it came to her wand, Katherine Waterston requested some 'heft'. She wanted to make Tina's spell-casting forceful, as if magic was something she takes very seriously. 'Tina's was nice,' says Pierre Bohanna. 'Quite simple and quite classic.'

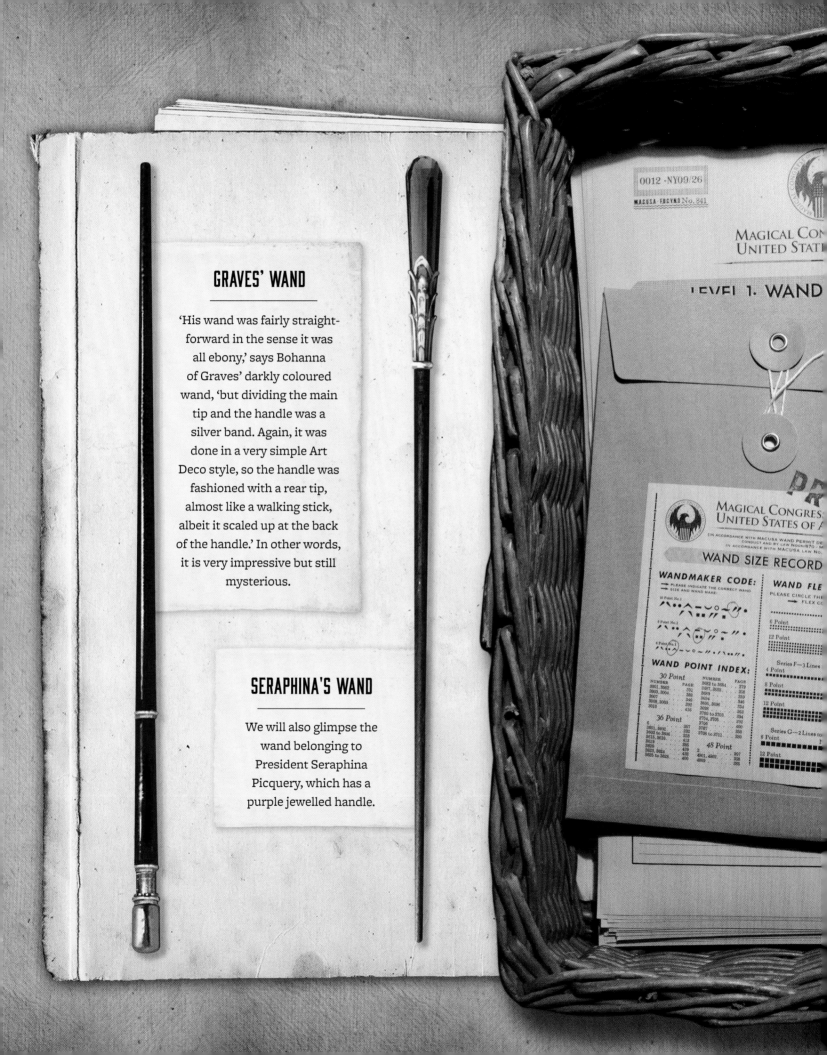

GRAVES' WAND

'His wand was fairly straight-forward in the sense it was all ebony,' says Bohanna of Graves' darkly coloured wand, 'but dividing the main tip and the handle was a silver band. Again, it was done in a very simple Art Deco style, so the handle was fashioned with a rear tip, almost like a walking stick, albeit it scaled up at the back of the handle.' In other words, it is very impressive but still mysterious.

SERAPHINA'S WAND

We will also glimpse the wand belonging to President Seraphina Picquery, which has a purple jewelled handle.

0012 -NY09/26

MACUSA FRCVNO No. 841

MAGICAL CON
UNITED STAT

LEVEL 1. WAND

MAGICAL CONGRES
UNITED STATES OF A

(IN ACCORDANCE WITH MACUSA WAND PERMIT DE
CONDUCT AND BY LAW NGGH/870 - M
IN ACCORDANCE WITH MACUSA LAW No.

WAND SIZE RECORD

WANDMAKER CODE:

WAND FLE
PLEASE CIRCLE THE
FLEX C

WAND POINT INDEX:

THE NEW SALEM
PHILANTHROPIC SOCIETY

4

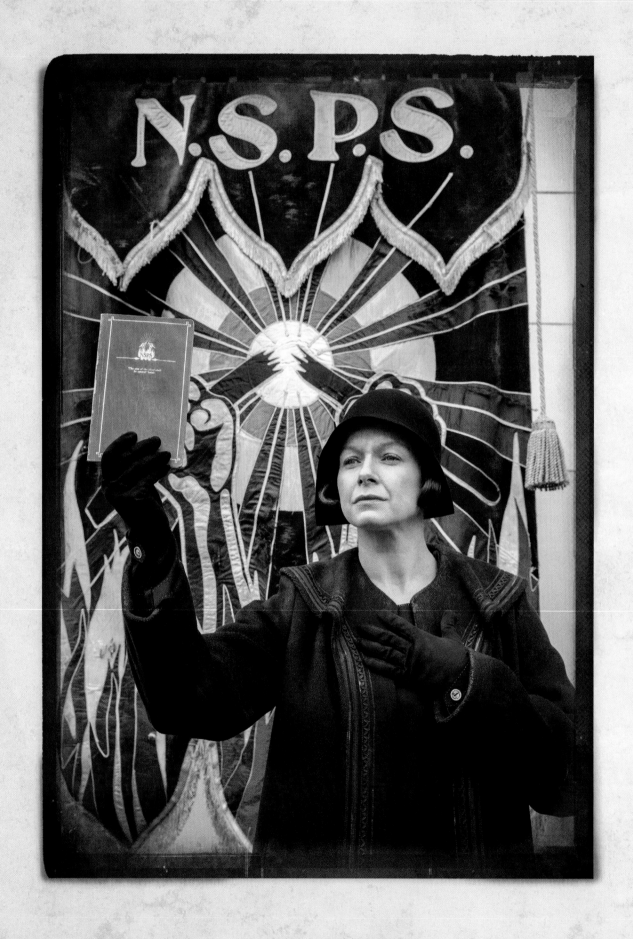

THE NEW SALEM PHILANTHROPIC SOCIETY

FOR MOST OF NEW YORK, MAGIC IS A MYTH. MACUSA GOES TO GREAT LENGTHS TO KEEP ITS PRESENCE A SECRET, AND FOR GOOD REASON.

Amid the rank and file of regular citizens, fear of the unknown has all too often swelled into bigotry. Whenever magic has made itself known in America it has been met with persecution.

In story terms, J.K. Rowling has represented this through the anti-magic movement known as the New Salem Philanthropic Society (NSPS), whose members call themselves the Second Salemers. The Salem witch trials were real events of the late seventeenth century, where in an outbreak of mass hysteria the Puritan community of Salem executed twenty people, including fourteen women, for witchcraft.

Led by Samantha Morton's stern, unsmiling Mary Lou Barebone, with her three adopted children – Credence, Chastity and Modesty – in tow, the Second Salemers are determined to stamp out magic. 'There's no fine line. There's no grey area. It has to be eradicated,' announces Jenn Murray, who features as Chastity. 'Because it challenges them.'

The Second Salemers, and the Barebones in particular, embody the film's darker themes of bigotry and discrimination – things that are just as relevant to the world of today. This is a city full of contradictions. These are the Roaring Twenties, a time of opulence

(though it is a bubble that will soon burst), but shocking levels of poverty can be found around every corner.

'It's the height of the Ku Klux Klan. It's right before the stock market completely crashes,' observes Ezra Miller, whose character Credence suffers most at the hands of his mother's severity. 'There had been the revolution in Russia and there was a lot of paranoia in the U.S., not just toward communists but also towards any non-male, non-Christian entities that were scary. A lot of people were on high alert.'

Director David Yates describes Mary Lou as evangelical in her belief that witches exist in New York. 'She wants to out them,' he says. 'She wants to bring to the attention of every New Yorker that these witches exist. She is an extremist and she has this strange family that she has adopted, all of whom work for her.'

The Second Salemers might feed homeless children, but in exchange they force them to hand out pamphlets alerting New York's population to the fact magic is a very present threat. And Credence, Chastity and Modesty are not exempt from their mother's demands.

'She represents the sort of darker, broodier, more melancholic aspects of our story,' Yates goes on to explain. 'What is interesting is that Jo has created a very rich, novelistic world with a lot of diverse colours

*PREVIOUS: Tom Wingrove's first concept artwork was an establishing shot of the NSPS church nestled within the brick tenements of the poor. **OPPOSITE:** Mary Lou Barebone (Samantha Morton) preaches in front of the New Salem Philanthropic Society's banner.*

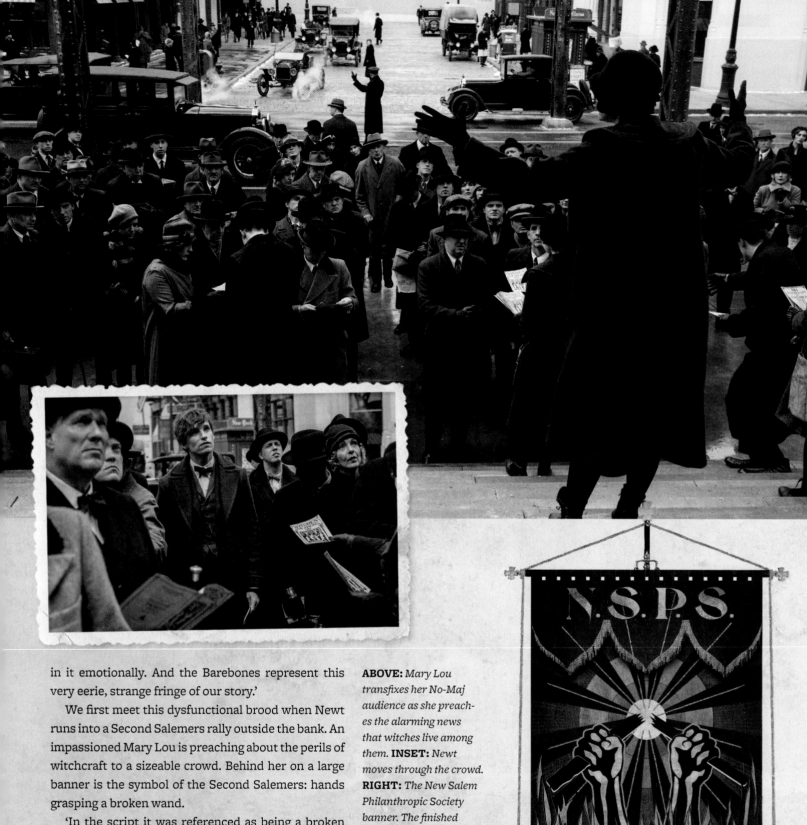

in it emotionally. And the Barebones represent this very eerie, strange fringe of our story.'

We first meet this dysfunctional brood when Newt runs into a Second Salemers rally outside the bank. An impassioned Mary Lou is preaching about the perils of witchcraft to a sizeable crowd. Behind her on a large banner is the symbol of the Second Salemers: hands grasping a broken wand.

'In the script it was referenced as being a broken wand with a dove,' says Miraphora Mina. 'But there were discussions with David [Yates] and they decided they wanted it to be more aggressive. So we gave the suggestions of the hands breaking the wand, in reference to Mary Lou's mission to stamp out magic.'

To extend the darker theme, they also created a set of placards bearing angry slogans: 'We need a

ABOVE: *Mary Lou transfixes her No-Maj audience as she preaches the alarming news that witches live among them.* **INSET:** *Newt moves through the crowd.* **RIGHT:** *The New Salem Philanthropic Society banner. The finished prop would be made in red velvet with satin applique and embroidered elements then heavily aged.*

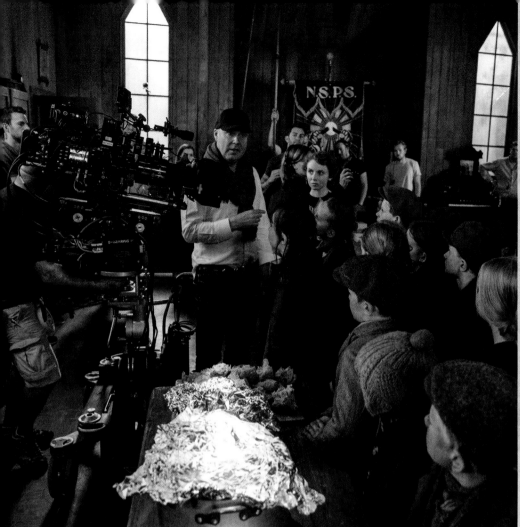

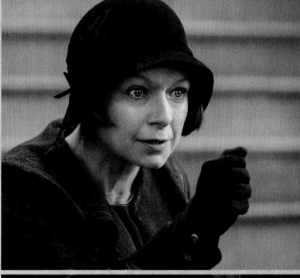

second Salem!' and 'God save America from witches!' On Modesty's bedroom wall is a cross-stitch alphabet sampler, which is an Alphabet of Sin. Modesty's dolls include one with a noose wrapped around her neck, and one tied to a stake. Theirs is not a happy home.

'Mary Lou – and the NSPS – is a quite fascinating character to design props for, because she's so evil and horrible,' says Lima, 'with her pamphlets, and all her propaganda. Yet she needs to be gentle, but at the same time kind of spiteful.'

Every crowd scene, be it this street rally or the arrivals at the Shaw's gala, is a challenge for the costume department. For the crowd who has gathered to listen to Mary Lou from the bustling New York street, they needed to represent the sheer variety of people who might be within earshot. Crowd costumer Gary Hyams lists off their subdivisions of New York society: 'We had a few bankers. We had a lot of tenements. We had Lower East Side. We had guys with horses, which we called the horse drivers. We had vendors. We had all sorts.'

To make matters more complicated, they shot the sequence toward the beginning of production in

WITCHES LIVE AMONG US

SINNERS IN OUR MIDST

REPENT OR PERISH

FIGHT MODERN EVILS

WITCHCRAFT: SIN IS DEATH

TOP (*Left*): *Director David Yates directs the children who hand out Mary Lou's leaflets in exchange for food.* (*Right*): *Samantha Morton as the zealous Mary Lou Barebone.* (*Middle*): *Credence & Modesty Barebone disappoint their mother.* **ABOVE:** *Concept art of the placards to be used by the Second Salemers for their demonstrations.*

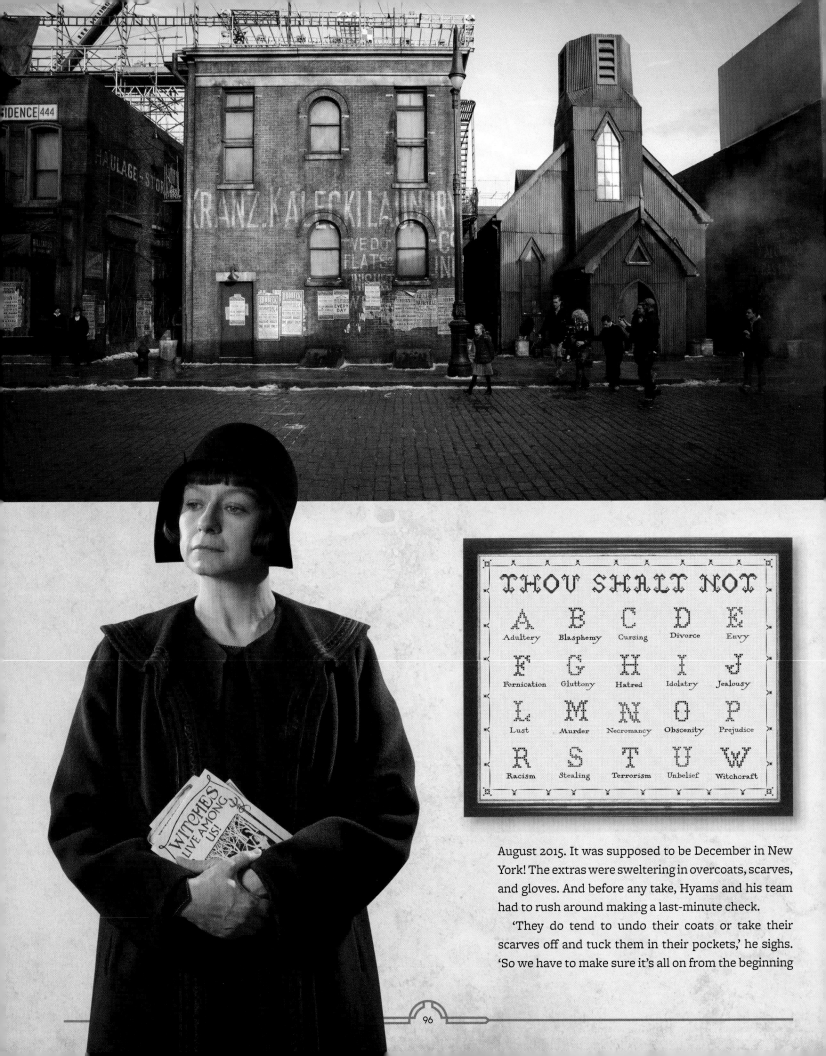

THOU SHALT NOT

A	B	C	D	E
Adultery	Blasphemy	Cursing	Divorce	Envy
F	G	H	I	J
Fornication	Gluttony	Hatred	Idolatry	Jealousy
L	M	N	O	P
Lust	Murder	Necromancy	Obscenity	Prejudice
R	S	T	U	W
Racism	Stealing	Terrorism	Unbelief	Witchcraft

August 2015. It was supposed to be December in New York! The extras were sweltering in overcoats, scarves, and gloves. And before any take, Hyams and his team had to rush around making a last-minute check.

'They do tend to undo their coats or take their scarves off and tuck them in their pockets,' he sighs. 'So we have to make sure it's all on from the beginning

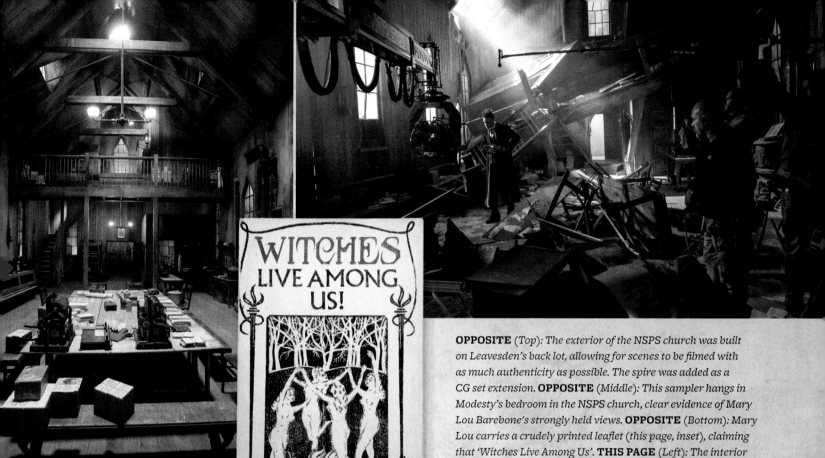

WITCHES LIVE AMONG US!

New Salem Puritanical Society

OPPOSITE (Top): *The exterior of the NSPS church was built on Leavesden's back lot, allowing for scenes to be filmed with as much authenticity as possible. The spire was added as a CG set extension.* **OPPOSITE** (Middle): *This sampler hangs in Modesty's bedroom in the NSPS church, clear evidence of Mary Lou Barebone's strongly held views.* **OPPOSITE** (Bottom): *Mary Lou carries a crudely printed leaflet (this page, inset), claiming that 'Witches Live Among Us'.* **THIS PAGE** (Left): *The interior of the NSPS church, which was built on a stage.* **ABOVE:** *The cameras follow Colin Farrell as Percival Graves investigates a disturbance at the NSPS church.*

for that take. And also we have to make sure that nothing modern is showing. Glasses are a good one. Watches are another. They forget to take their watches off and then suddenly somebody lifts their arm up and you've got a digital watch.'

Later we will discover that the Second Salemers operate out of a neglected church building on the Lower East Side. 'It is a church, but a deconsecrated one,' notes production designer Stuart Craig. 'They use it as the headquarters of this campaign to print and distribute posters, as well as putting up the posters on the walls. The form of the small chapel is quite interesting as it has a balcony, which is used to great effect. It is very rundown, very derelict, very Lower East Side: the poorest part of town. It was an interesting variation on the cast-iron buildings and skyscrapers.'

The printing presses the Second Salemers use are ancient, and the thousands of pamphlets, created by Mina and Lima, were actually printed by more modern means. 'The images on the leaflets are pretty harrowing,' says Murray. 'Like: "We're going to burn you at the stake, because if you don't think our way and you don't want to join us, you're gone." Very black and white.'

BALANCING THE LIGHT AND DARK ELEMENTS

The fine art of films set in the wizarding world lies in balancing the darker elements, which give you a sense of emotional depth and peril, with the lighter, funnier aspects.

It was something they worked diligently to achieve with the *Harry Potter* films, and Heyman says it originates with J.K. Rowling's books, where the flux between humour and death made the world more vivid. The same goes for her new script.

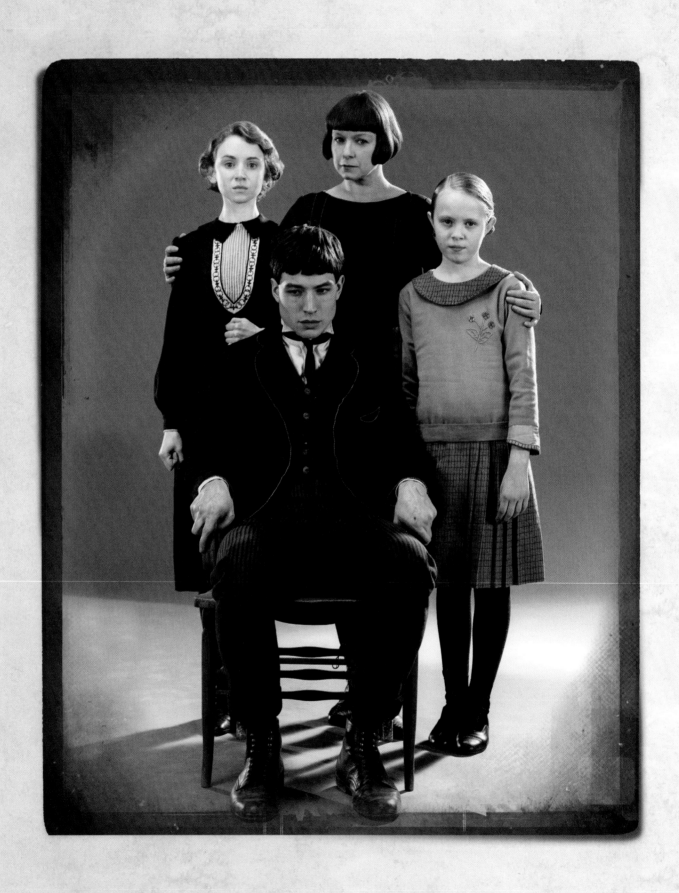

THE BAREBONE FAMILY

MARY LOU BAREBONE

Leader of the New Salem Philanthropic Society and mother to three neglected, adopted children – Credence, Chastity and Modesty – Mary Lou Barebone is a forbidding lady. Armoured in a black, loosefitting dress, she works almost from a place of blind hatred, preaching that magic is a blight on civilization without any evidence that witches or wizards even exist, let alone whether they are morally questionable.

'It is fear of others,' says producer David Heyman, searching for the psychology of the character, 'it is a dislike of something which you don't know about, something that is, alas, both timely and timeless.'

Mary Lou's anger is not only being vented outwards; she brings it home to her trio of adopted children. Focusing most of her vehemence, not-to-say violence on poor Credence, who doesn't seem able to fathom his mother's rules. Heyman notes that she represents a theme that runs through a lot of J.K. Rowling's work: 'Mary Lou is abusive. She has stopped Credence from being who he is. She is repressing his essence, which is leading to problems.'

However, when you cast an actress of the calibre of British star Samantha Morton, who has earned her own formidable reputation in films as diverse as Steven Spielberg's *Minority Report* and Anton Corbijn's *Control*, you are not going to get something as simple as pure evil.

Ezra Miller agrees, 'I think Samantha Morton brought an incredible amount of moral ambiguity and human understanding to where this woman is at. There will be a place carved out for the ominous vibes of Mary Lou Barebone, she is unbelievably evil, but also unbelievably complex and grounded.'

Jenn Murray, who as Chastity shared many of her scenes with Morton, was stunned how she did so much through restraint rather than histrionics. 'I always remember people talking about Clint Eastwood. When he gives direction he doesn't raise his voice, he doesn't lose his temper, but you listen. Samantha played Mary Lou that way. She talked quite quietly, she didn't demand your attention, but she had it. And that's kind of like Samantha as well. When Samantha walks into a room, the energy shifts. And it's just something that comes from within.'

CREDENCE BAREBONE

Living in the shadow of a domineering mother with two malnourished sisters, poor, put-upon Credence Barebone is an unhappy soul. Dressed in threadbare clothes with a pork pie hat and an unflattering bowl-like haircut, he is not so much growing up as squirming his way towards adulthood. Both a figure of pity and a little unnerving, Credence is like a shadowy version of Harry Potter: an orphan adopted into a loveless family, struggling to understand his part in the story. In the hands of the remarkably talented New York actor Ezra Miller, whose tall, slender frame and piercing features have a timeless quality, he is arguably the most emotionally troubled character to emerge from the pen of J.K. Rowling.

'It's rare that fantasy can touch on something this painful and delicate,' insists Miller, who describes Credence elusively as one of the 'wandless' types. 'It's

OPPOSITE: *Happy family? Left to right, Chastity (Jenn Murray), Credence (Ezra Miller), Mary Lou (Samantha Morton) & Modesty (Faith Wood-Blagrove).*

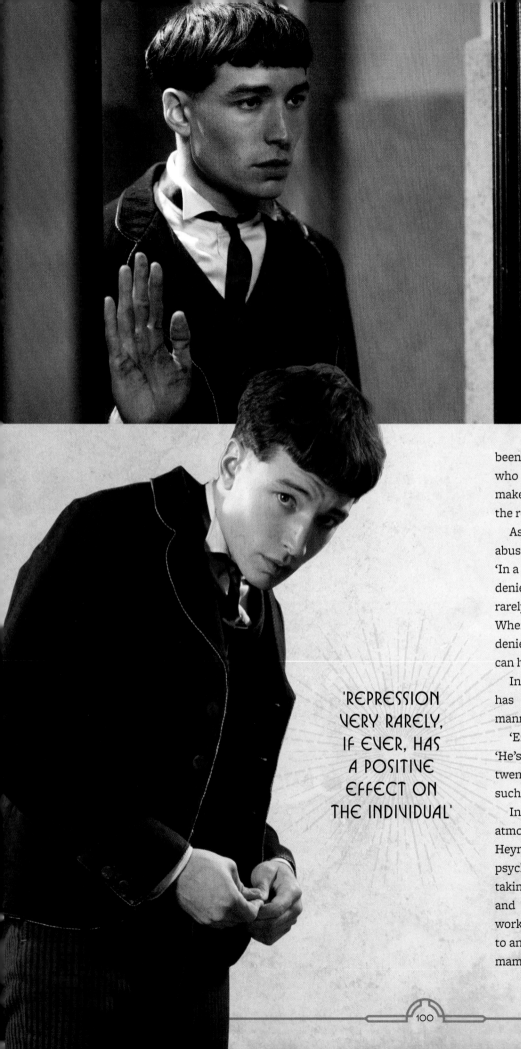

been an amazing gift to explore the idea of someone who endures trauma and then has tough choices to make about how that trauma is going to be manifest in the rest of their life.'

As producer David Heyman explains, in being abused, Credence is having his true essence repressed. 'In a way it is a metaphor for so many people who are denied the right to be who they are. Repression very rarely, if ever, has a positive effect on the individual. When he is rejected, repressed, and his essence is denied, what happens with him is a reflection of what can happen in greater society.'

In stark contrast to his character's nature, Miller has charmed everyone with his easy, thoughtful manner and boundless good humour.

'Ezra's extraordinary,' says director David Yates. 'He's fearless. He's a young man of twenty-three, twenty-four, curious, ambitious, open, and brings such a wonderful spirit to the set.'

In turn, Miller claims it is the relaxed, creative atmosphere fostered by the two Davids – Yates and Heyman – that has allowed him room to delve into the psychology of his character. 'I've felt really comfortable taking risks because I trust them. I trust their vision, and I trust the way they execute that vision. They work incredibly well as a team.' He laughs, 'No offense to anyone, but I would say that David Yates is like the mama, and David Heyman's like the papa.'

'REPRESSION VERY RARELY, IF EVER, HAS A POSITIVE EFFECT ON THE INDIVIDUAL'

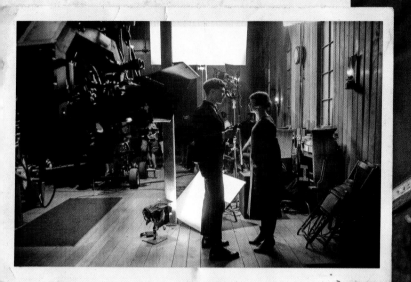

Within the story, of all people it is Colin Farrell's Graves who takes pity on Credence, striking up a strange, avuncular bond with the boy, while probing him for information about his family.

'Most of my work was with Ezra, and I adored working with him,' enthuses the eloquent Irish star. 'He's bright and talented, and all of that stuff. But he's a kindhearted cat.'

Credence is a young man who like many young men seems lost in his life. He seems to be on the outside looking in, like the world is a mystery to him. He is also a mystery to himself. 'The character of Graves is taking the lead,' explains Farrell, smoothly turning on his character's effortless charm, 'and there's a little bit of guidance, and also a little bit of support and tenderness and all of that kind of stuff.'

Miller sees things differently. The interest Graves has taken in the lonely boy is quite unnerving. 'There is this aspect of manipulation that will be sort of tangible,' the younger actor thinks. 'There's an amazing amount of ambiguity in this story, and that is a part of what's going to make it really dynamic and fascinating.'

Led by his steely mother, the spartan surroundings of the New Salem Philanthropic Society's headquarters are all that Credence gets to call home. And even among the three children he is the odd one out.

'I don't think Chastity feels very close to Credence,' agrees Jenn Murray, who plays the middle sibling. 'I

mean, they're all in the game together. They're all under the same roof. They all sleep in the same place and eat the same food. They're very oppressed, but yet when we were shooting I would never really be near him. I would turn more towards Modesty as a protective way. That's how I felt.'

Miller is no stranger to troubled loners. He is still most famous for his startling performance as the homicidal teen in the drama *We Need to Talk About Kevin*, but has softened that image with comedic roles in *The Perks of Being a Wallflower* and *Trainwreck*. The young star, who once performed with the Metropolitan Opera, also has the upcoming theatrical super hero role of *The Flash*.

Moreover, he also comes to the wizarding world an unabashed *Harry Potter* fanatic. 'I've been obsessed since as early as I can remember,' he laughs. 'I grew up repeatedly reading the books and listening to the Jim Dale audio book recordings. Clearly it paid off! This is like the achievement of my craziest, private dreams.'

OPPOSITE (*Left*): *Mary Lou's abuse takes its toll on Credence.* (*Below*): *The young man is seemingly powerless, but looks every inch the man about town in his hat* (*Opposite right*). **TOP** (*Left*): *Ezra Miller & Samantha Morton rehearse a scene.* **ABOVE:** *Mary Lou mirrors the image on the NSPS banner.*

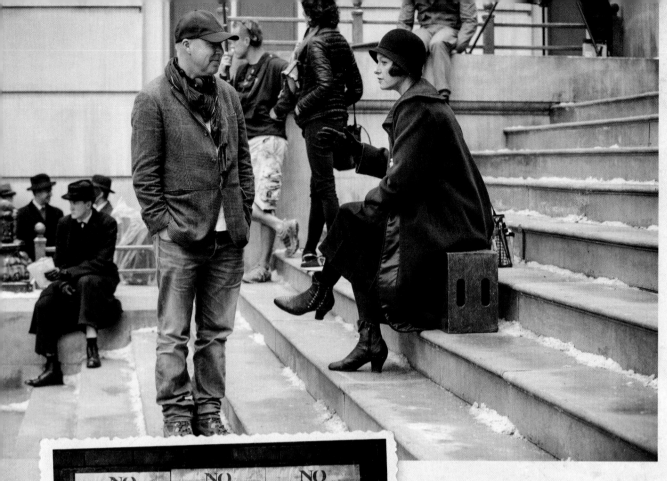

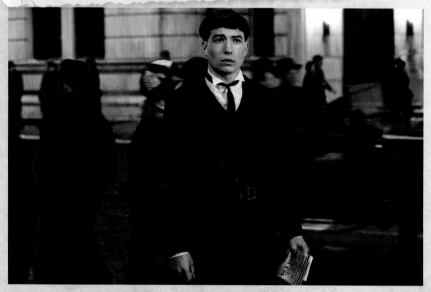

And he had his mind blown almost on a daily basis seeing these New York sets with the steam coming up through the vents and the great atrium of MACUSA. Everything about this world has lived up to his fan-boy dreams. 'They've been creating this world in the nineteen-twenties with this exquisite sense of detail,' he marvels. 'I mean, I was opening drawers in the newspaper office, and there were archives of a made-up newspaper with news articles all the way through that they'd actually written out. This is the level of detail – something that the camera will absolutely never see – inside a *drawer*.'

All the trouble and sorrow that engulfs Credence notwithstanding, when summing up his experience on the movie the altogether cheery Miller can barely contain his excitement.

'You guys are lucky to have gotten *this* interview from me, because after this, I am *gone*,' he says, launching into an elaborate comedy routine. 'I'm going to be camped out outside some theatre in Wisconsin dressed like Dobby the house-elf. They won't even recognize me, with my big ears and my big, tennis-ball eyes. They'll be like, "Where's Ezra? Nobody knows where Ezra is. He's lost his mind. He's gone way off the deep end, because he was just so excited about the expansion of the Wizarding World."'

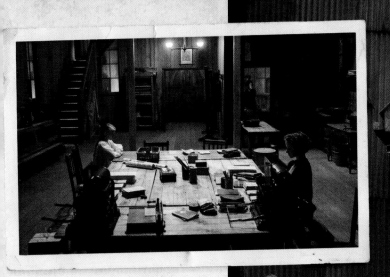

ABOVE: *Inside the austere NSPS church, Chastity and Modesty are overseen by their mother, Mary Lou.* RIGHT: *Chastity summons the orphans to the NSPS church.* BOTTOM: *Jenn Murray as Chastity.*

CHASTITY BAREBONE

Irish actress Jenn Murray thought she had Chastity all figured out. Her character, middle child of the three Barebone ragamuffins, was oppressed and lonely, and she didn't quite believe what her ice-cold mother was saying about magic. But on her first day on set, when she met Samantha Morton, the British actress playing her mother quietly said, 'Let's just find it together.'

'And it was like the best thing I could have heard,' says Murray, who speaks thoughtfully about her craft. 'Suddenly it was okay to find the answers through the course of filming. Chastity is more like a Mini-me version of Mary Lou. Like when Mary Lou is beating Credence, she thinks, "He deserves it." But another part of her is blocking it out.'

Murray adds that there were no definite answers in the script. 'J.K. Rowling writes characters that are very three-dimensional, yet with room to contribute your own personal touch.'

Significantly, Murray came to attention playing a highly disturbed girl in the dark Irish drama *Dorothy Mills*, and has recently been in another New York period piece *Brooklyn*. Although,

when she went up for the audition for *Fantastic Beasts and Where to Find Them* she didn't know a thing about the film or her prospective role. She simply improvised, and that was clearly the kind of instinctive reaction David Yates was looking for.

'Chastity is quite hard to play,' she admits, 'she doesn't have a lot of dialogue. There is a lot of stillness and a lot of listening. That was in itself a challenge. Don't do too much, but don't do nothing. Don't assert yourself, but don't disappear.'

Luckily enough, Murray had previously visited New York's Tenement Museum herself and came with a good idea of the impoverished conditions the poor had to endure at that time. 'You knew that a sink would turn into a bath,' she says, 'and they would all eat together, and they were on top of each other all the time.'

So she had some idea of what life was like for the Barebones. This was far from a conventional family. The children have all been adopted from different families, and are now cramped together under one roof with a tyrannical mother, learning how to survive. 'They are all very connected,' she says, 'yet they are all isolated.'

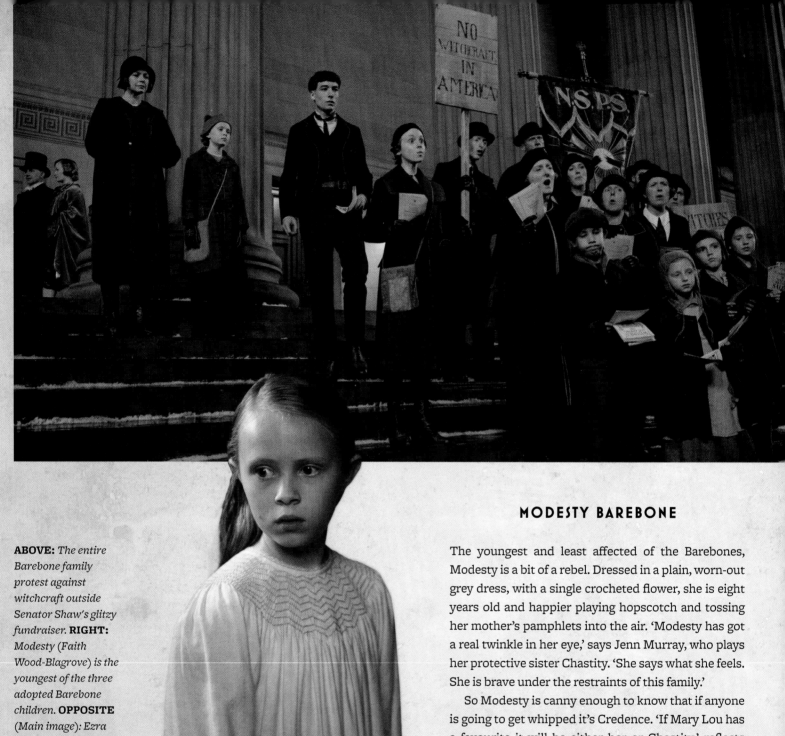

ABOVE: *The entire Barebone family protest against witchcraft outside Senator Shaw's glitzy fundraiser.* RIGHT: *Modesty (Faith Wood-Blagrove) is the youngest of the three adopted Barebone children.* OPPOSITE *(Main image): Ezra Miller smiles between takes. (Top right): Credence makes a discovery. (Bottom right): Faith Wood-Blagrove finds that filming can be fun, as director David Yates looks on. (Inset): Concept art by Molly Sole of the hand-carved toy wand that Modesty has secretly stashed.*

MODESTY BAREBONE

The youngest and least affected of the Barebones, Modesty is a bit of a rebel. Dressed in a plain, worn-out grey dress, with a single crocheted flower, she is eight years old and happier playing hopscotch and tossing her mother's pamphlets into the air. 'Modesty has got a real twinkle in her eye,' says Jenn Murray, who plays her protective sister Chastity. 'She says what she feels. She is brave under the restraints of this family.'

So Modesty is canny enough to know that if anyone is going to get whipped it's Credence. 'If Mary Lou has a favourite it will be either her or Chastity,' reflects Faith Wood-Blagrove, the newcomer plucked to play Modesty from the thousands who went to an open audition held for a 'haunted girl with inner strength and stillness'.

It's a story the young actress has gotten used to telling. How the queue felt like it was endless, and just when you thought you had got to the end, you turned a corner and found there was still miles to go. It took four hours even to get inside. There you had your photo taken before being ushered into another room. 'You had to go into a circle,' she recalls, 'and say, if you had a superpower, what it would be.'

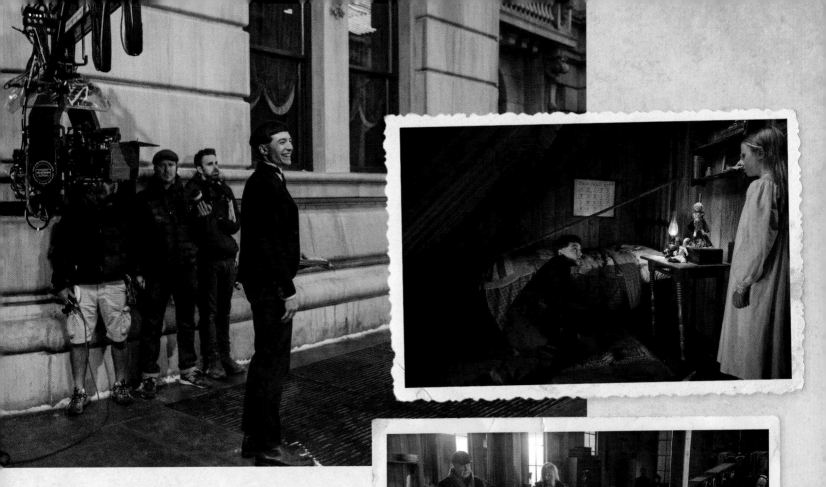

She was then selected to join another queue, for another audition. This time, thankfully, when they learned that her mother was on a nightshift, she got ushered toward the front. 'There you had to say some dialogue,' says Wood-Blagrove, 'and I just love speaking in an American accent. They actually asked me if I was American! Then they gave you a certificate to say you had auditioned.'

A week later she got a call asking her to come for yet another audition. She didn't know it at the time, but there were only a few girls left at this stage. 'You had to not memorize but know a bit of the script so you could say it a few times in front of David Yates and Fiona Weir, who's the casting director.'

Wood-Blagrove has a clear memory of being allowed to have a burger from McDonald's on the way home. When they finally arrived home, the phone rang. That was when she learned she had got the role. She says she took the news in her stride; it was her mother who screamed with joy.

Having seen all the films, Wood-Blagrove has always liked *Harry Potter*. 'I guess you could say I like it a bit more now,' she jokes. She has had such an extraordinary time. Yates as director doesn't demand things but gives 'pointers' on how you might do them.

And her immediate co-stars have been lovely. Despite playing such a dreadful mother, Samantha Morton is one of the nicest people she has ever met. As for Ezra Miller: 'It is quite an adventure with him. I actually made up a rap about the film with him while we were in Liverpool. Ezra, he brings the crazy.'

And she is certain the new film will live up to the promise of its predecessors. The New York set alone has been amazing. Look down into the snow and it was littered with cigarette butts and wrappers. 'The effort they've gone into, it's almost like you're there,' she says. 'Which is cool as I've never been to New York. I've never even been on an airplane.'

THE BLIND PIG

5

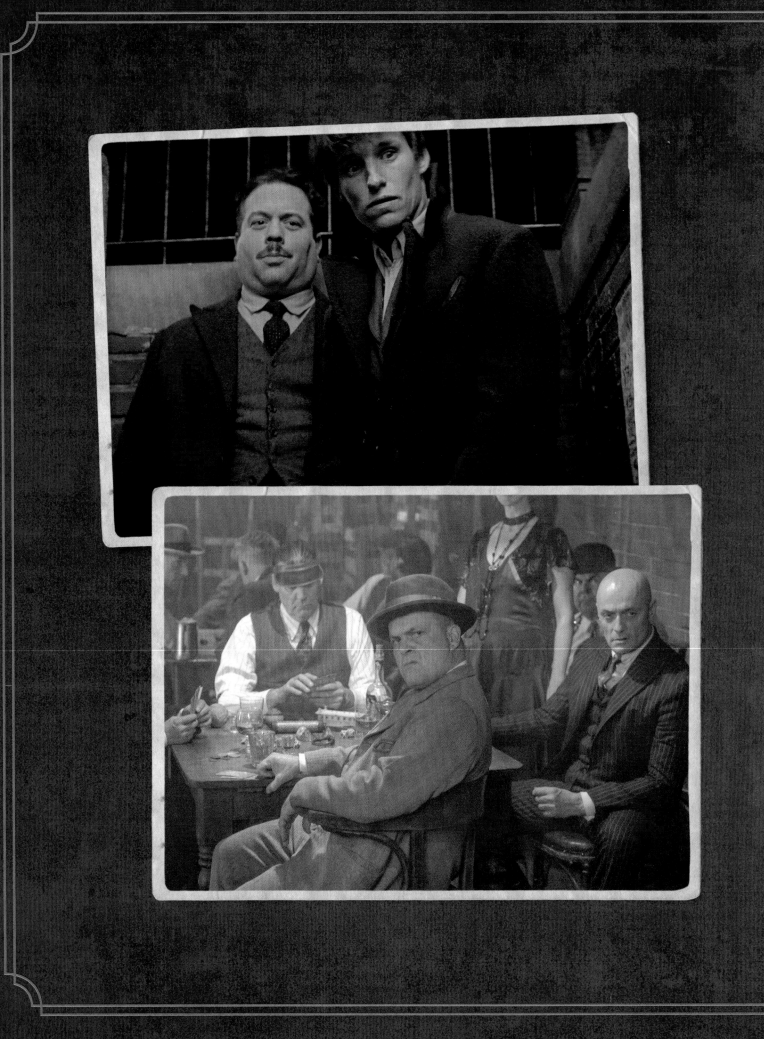

A NIGHT OUT
AT THE BLIND PIG

DOWN A DARKENED BACKSTREET, THE KIND OF UNINVITING
PASSAGEWAY THAT COULD EASILY CONNECT TO DIAGON ALLEY,
A FORGOTTEN POSTER HAS BEEN STUCK TO A BRICK WALL.

It advertises something called 'Lips That Charm' and pictures a simpering redhead in an evening dress clutching a red lipstick. Look closer and those words dissolve into 'The Blind Pig'. The debutante magically grows a pig's snout, and a slot is pulled back revealing a pair of suspicious eyes. If your face fits, out of the wall appears a door, the entrance to the wizarding world's very own speakeasy.

'You think of nineteen-twenties New York and you think of speakeasies.' Visual effect supervisor Christian Manz has relished getting to grips with this shady location. 'It is the perfect marriage of that period and the magical world.'

The year of Newt's visit, 1926, happens to fall slap bang in the middle of Prohibition, one of the most remarkable chapters in American history. After a nineteenth century awash in alcoholism, gambling and drug addiction, Protestant and Progressive crusaders successfully lobbied to have the demon drink banned. From 1920 to 1933 it was flat-out illegal to manufacture, transport and sell alcohol anywhere in America.

So alcohol went underground, and into speakeasies, the shady drinking dens run by the mob, with liquor smuggled in by bootleggers from mountain stills. The term 'speakeasy' refers to the hushed and casual tone with which one must order one's drink in such an illicit establishment, with 'blind pig' being slang for a lower class of speakeasy.

J.K. Rowling draws fascinating parallels between America's once-puritanical attitude toward alcohol and the persecution that has driven the wizarding world underground. Of course, MACUSA is not a criminal outfit, but out of necessity it has enforced its own legal separation from the No-Maj world. And there are some less than salubrious corners of the American magical community that operate outside of MACUSA's jurisdiction, whose less-than-upstanding clientele partake in the buying and selling of alcohol, gambling, trafficking, fencing and all manner of illegal magic. In short – The Blind Pig.

'It's seedy, but it's a place you wouldn't mind coming and having a drink, picking up a broad, getting your swagger on, and letting your hair down,' says Ron Perlman, who plays the club's equally shady proprietor, Gnarlak. 'There's a come-hither quality to it.'

It is to this sin-soaked joint that Tina and Queenie bring the less-worldly Newt and Jacob in search of information.

According to production designer Stuart Craig, they discovered that speakeasies came in different

PREVIOUS: *The poster for The Blind Pig promises an experience that is 'enchanting, beguiling, alluring'. But looks can be deceptive.* **OPPOSITE** (Top): *Newt & Jacob prepare to enter the wizarding underworld.*
OPPOSITE (Bottom): *With a card game in full swing, the players do not welcome the arrival of Newt & his friends.*

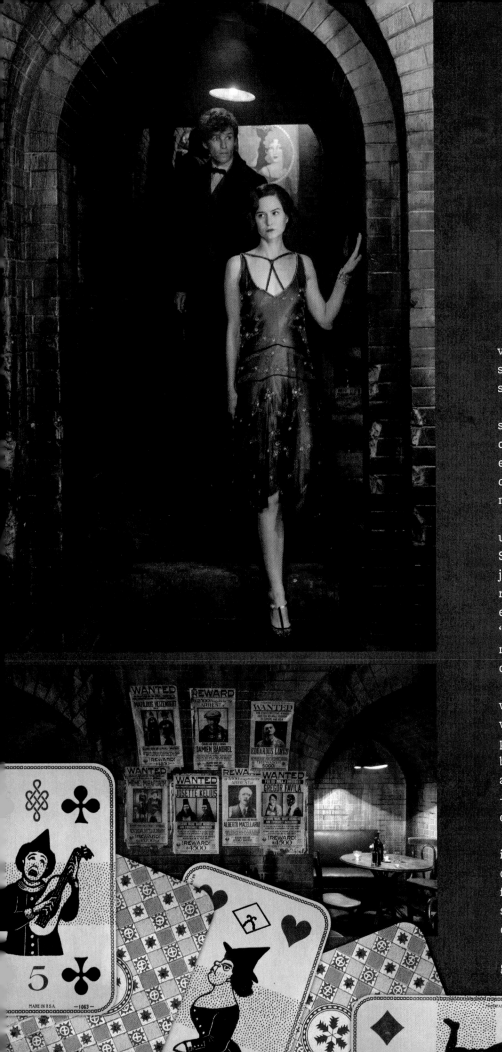

varieties. 'Some were pretty dingy and intimidating, some were actually quite glamorous and stylish, even sophisticated.'

However, as written, The Blind Pig wasn't exactly sophisticated. It was definitely of the dingy, intimidating, hive of magical villainy variety. So they elected for somewhere fairly subterranean, with a series of vaulted brick arches and low ceilings to create the necessary claustrophobia.

The walls are covered with ceramic bricks, but unlike the impermeable arches of the City Hall Subway, moisture is seeping through the mortar joints. 'The combination of nicotine stains and water running down the curved walls makes a pretty threatening environment,' concludes Craig with satisfaction. 'These guys are sinister. We've all seen films from the nineteen-thirties, and by Scorsese; our speakeasy characters are like movie gangsters.'

Witches and wizards with scarred faces gamble with runic dice for strange artefacts, humans mixing with goblins and giants created using similar forced perspective techniques to those used to give Robbie Coltrane's homelier-looking Hagrid his required altitude. We are a long way from the Leaky Cauldron – this is a much more unsavoury wizarding world environment.

'The bartender, he's an elf,' Manz points out. Amusingly, when it came to finding the perfect face for the computer-animated barkeep who serves drinks out of floating bottles with a click of his fingers, animation supervisor Pablo Grillo caught sight of an electrician on set. 'What a great face,' he recalls.

So Grillo sidled up to the director: 'Paul looks quite good, doesn't he?' David Yates simply told him to ask.

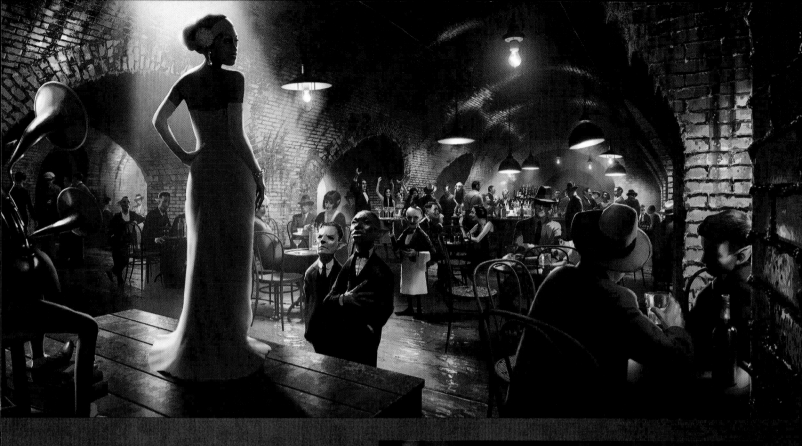

So they ended up scanning him in, and 'Paul the spark' became their bartending elf. 'I think he's going to dine out on that for years,' laughs Manz.

The visual effects team created the hovering bottles as well as drinks that are half full, but half full vertically.

'Everything is slightly askew,' says Grillo, 'which also goes for the haircuts – there's tiny little toupees and tiny little fringes.'

As this is the Jazz Age, and jazz was the signature music of the speakeasies, so The Blind Pig has its own idiosyncratic house band. This hodgepodge of goblins and humans was created via motion capture with real actors.

Behind the goblin chanteuse, the rest of the band comprises a five-piece: pianist, drummer, banjo player, double-bassist, and a goblin wrapped up in what became known as a 'sussiphone'. 'It's like a brass section in one,' laughs Grillo, and that includes bagpipes. All of the instruments were designed by concept artist Rob Bliss and then crafted by the props department.

'We made them feel slightly heightened and weird,' promises Manz.

After the actors perform, a shot is done using scale doubles with scale instruments for reference. 'Often, CG stuff looks wrong because you are guessing,' says Manz.

However, it's Gnarlak they've come to

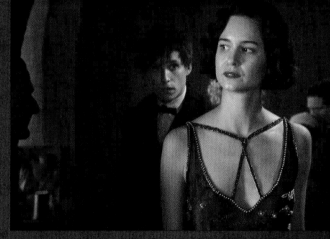

OPPOSITE: (Top to bottom) Tina, looking fantastically glamorous in one of Colleen Atwood's designs, enters the seedy speakeasy. • The walls of The Blind Pig are adorned with wanted posters, many of whose faces will be found drinking in the speakeasy. **TOP:** *Concept art by Peter Popken of a sultry jazz singer performing for the establishment's patrons; as she sings, wisps of magical smoke form pictures from her words.* **ABOVE:** *Newt and Tina enter the Blind Pig.* **LEFT:** *Some deadly looking bottles of hooch can be found behind the bar.*

see, The Blind Pig's untrustworthy proprietor. And given he's a goblin, the chisel-chinned and gravel-voiced Perlman has been transformed into him by the VFX team using motion capture.

All the while, wanted posters stare down from the walls. They have been plastered haphazardly as decoration. Somewhat ironically one would have thought, given that most of the freaks and fiends featured in the moving pictures are regulars. Lemus Pinutius, for instance, who is wanted for grand larceny and No-Maj smuggling; or John Bastedo, a known elf trafficker and No-Maj murderer; or Josette Kelnis, who has committed atrocities against the wizarding world.

There's also a wanted poster for Gellert Grindelwald, who is accused of wizard slayings in Europe. You might recall from *Harry Potter and the Deathly Hallows: Part 2* that Grindelwald was a brilliant, idealistic wizard and good friend to Albus Dumbledore. Together they planned to find the powerful Deathly Hallows. However, Grindelwald revealed sociopathic tendencies and an affinity with the Dark Arts, and following a devastating confrontation with Dumbledore, fled Britain, after which his whereabouts were unknown for a period of time.

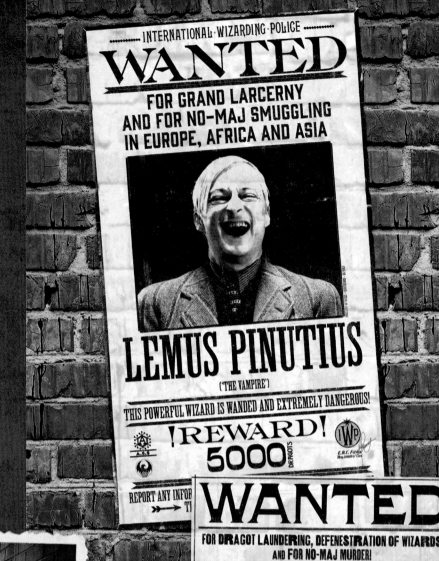

ABOVE: *The facilities are for witches and warlocks only. Wizards not welcome!* **MAIN IMAGE:** *A gallery of the wizarding world's most wanted.*

WANTED

FOR COUNTERFEITING WANDS AND FOR NO-MAJ MURDER IN EUROPE AND ASIA

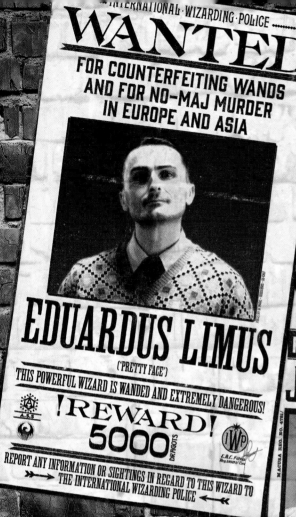

EDUARDUS LIMUS

('PRETTY FACE')

THIS POWERFUL WIZARD IS WANDED AND EXTREMELY DANGEROUS!

!REWARD!
5000 DRAGOTS

REPORT ANY INFORMATION OR SIGHTINGS IN REGARD TO THIS WIZARD TO THE INTERNATIONAL WIZARDING POLICE

WANTED

FOR NO-MAJ KIDNAPP AND MU...

JEREMIUS WARDWA...

THE ABOVE IMAGES ARE EXCELLENT LIKENESSES OF WARDWART.

BEARING WAND, MOST MENAC... AND EXTREMELY DANGEROU...

THE ASSISTANCE AND CO-OPERATION OF THE WIZARDING COM... IS REQUESTED IN THE APPREHENSION OF THIS MALICIOUS KI...

EXTREME CAUTION SHOULD BE EXERCISED AS THIS W... IS A MALICIOUS KILLER AND WILL RESIST ARREST...

!REWARD!
$4500

- PLEASE POST IN A CONSPICUOUS PLACE -

WANTED

FOR MONEY LAUNDERING AND FOR NO-MAJ MURDER IN EUROPE AND AFRICA

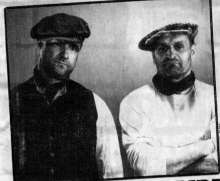

HAESITO and LAMBUS

('HERSCHEL HAESITO AND RAYMUND LAMBUS')
('THE BROTHERS')

POWERFUL WIZARDS. THEY ARE WANDED AND EXTREMELY DANGEROUS!

!REWARD!
5000 DRAGOTS

REPORT ANY INFORMATION OR SIGHTINGS IMMEDIATELY TO THE INTERNATIONAL WIZARDING POLICE

REWARD

of 4,500 dragots for ARREST of

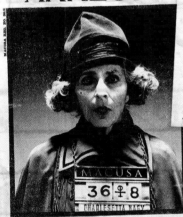

SPELLS FORGER AND ELF TRAFFICKER
CHARLESETTA NAGY

(A.K.A 'MOTHER')

CAUTION SHOULD BE EXERCISED AS THIS WITCH IS UNPREDICTABLE AND WILL LIKELY RESIST ARREST. IF LOCATED, HOLD AS A FUGITIVE AND ADVISE THE NEAREST AUROR DIVISION IMMEDIATELY!

➤ BEARING WAND AND ◄ EXTREMELY DANGEROUS!

- PLEASE POST IN A CONSPICUOUS PLACE -

WANTED

FOR ESCAPE FROM NEW YORK WITCHES' PENITENTIARY AND FOR NO-MAJ MURDER!

ELEANORA SHANKS

('CRAZY LAMB')

BEARING WAND AND EXTREMELY DANGEROUS!

EXTREME CAUTION SHOULD BE EXERCISED AS THIS WITCH IS A KILLER AND WILL LIKELY RESIST ARREST. IF LOCATED, ARREST AND HOLD AS A FUGITIVE AND ADVISE THE NEAREST AUROR DIVISION IMMEDIATELY!

!REWARD!
$1500

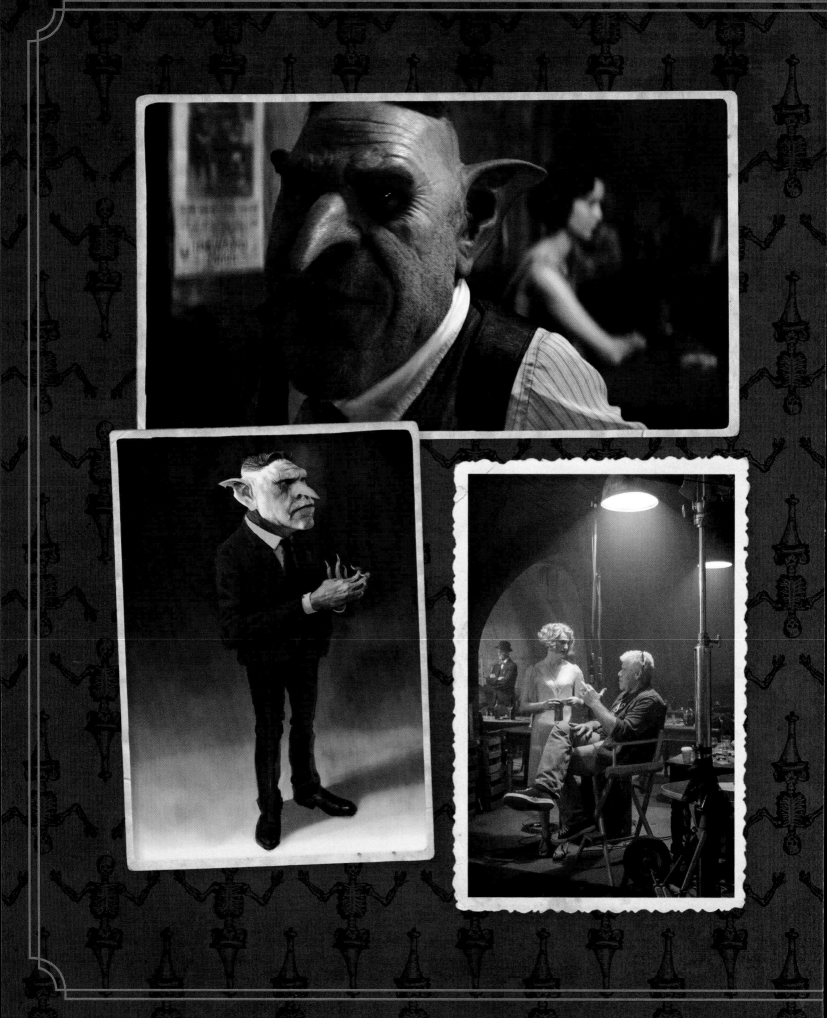

GNARLAK

Owner, manager, and ringmaster of The Blind Pig, Gnarlak is quite a character. He may be small in stature, but he's a big player in the magical underworld of New York, keeping the Aurors of MACUSA off his back with a little helpful intelligence every now and then. 'He's actually a goblin,' says a delighted Ron Perlman, launching on a typically colourful description. 'Most of his employees are goblins – it's a kind of a speakeasy, his establishment. It caters more to the seedy underbelly of the wizarding world. A few people in there have a price on their head. A few people in there have sort of uneasy deals that they've made with MACUSA in order to stay at large. This highly broad range of unsavoury types, and Gnarlak being among the most unsavoury of all of them because he's the master of all he surveys.'

Gnarlak shares his species' facility in fiscal dealings, only with more obviously ill-gotten gains.

'Well, you know, a guy in his position just knows how to make deals with every strata,' smiles Perlman, 'be it the highest stations in government or the lowest form of criminality.'

In looks goblins are not unlike house-elves, very short (often under four foot) with pale skin, elongated noses, and pointed ears that stick out at virtual right angles.

With the best will in the world, they don't look much like the tall, granite-jawed New York-born character actor most famous for playing the wisecracking anti-superhero Hellboy. Having studied theatre arts at the University of Minnesota, Perlman's career began in earnest with *The Name of the Rose* in 1986 and was cemented by playing the lead in the long-running television version of *Beauty and the Beast* with Linda Hamilton, which earned him a Golden Globe in 1989. He's no stranger to the realms of fantasy, having also featured in *The City of Lost Children*, *Alien: Resurrection* and *Pacific Rim*. A fan of the *Harry Potter* films since taking his son to see the first few, and sticking with them, even as his son moved on, for his own 'edification', he has been thrilled to be invited to the party.

'J.K. Rowling is one of the great examples of literary brilliance to emerge in the last twenty-five to thirty years,' he declares. 'Her words are deliciously specific, and very evocative. Then it was like can I play this guy? I'm not going to lie – it's not been hard for me to play. I get it. I've seen these guys. I grew up in New York City.'

Even though he is also a good deal taller than four foot.

'Actually, I think he lies about his height,' says Perlman. 'He's more like two foot something. We're doing it by a process called motion capture that brought you the great performances by Andy Serkis, whereby the actor gives the performance as a jumping-off point to render a character that exists outside of nature.'

Having seen concept art of Gnarlak, Perlman describes him as 'deliciously weird'. In capturing his facial expressions as well as his movements, the visual effects team have given the goblin the unmistakeable features of the actor.

'We wanted to bring out some of Ron Perlman,' says visual effects supervisor Christian Manz, 'and not just make a small Ron Perlman, but also look at what characterizes goblins and accentuate and almost caricature him.'

Bringing Gnarlak to life was a multi-faceted process. Perlman performed on-set in the now-recognizable leotard dotted with reflectors, and then a four-foot stand-in would re-perform the whole thing again in a scale version of the costume with Perlman delivering his lines off stage so that they had reference at the correct size. They would then shoot it again with nobody there.

All those elements are put in a digital pot and 'cooked'. Out of which comes the short-stacked, wheeler-dealing Gnarlak.

'I've thought very hard, long and hard, about this whole process,' says Perlman. 'Seeing this thing designed by another artist, and what he ultimately will end up looking like, it was about finding a way to somehow meet in the middle and make it look seamless, as if this character existed all along in the real world. That's the fun of it all for me.'

OPPOSITE (*Top*): *A close-up of Gnarlak in The Blind Pig.*
OPPOSITE (*Left*): *Early concept art by Paul Catling of Gnarlak, owner of The Blind Pig speakeasy.*
OPPOSITE (*Right*): *Ron Perlman shares his thoughts on playing Gnarlak with Alison Sudol.*

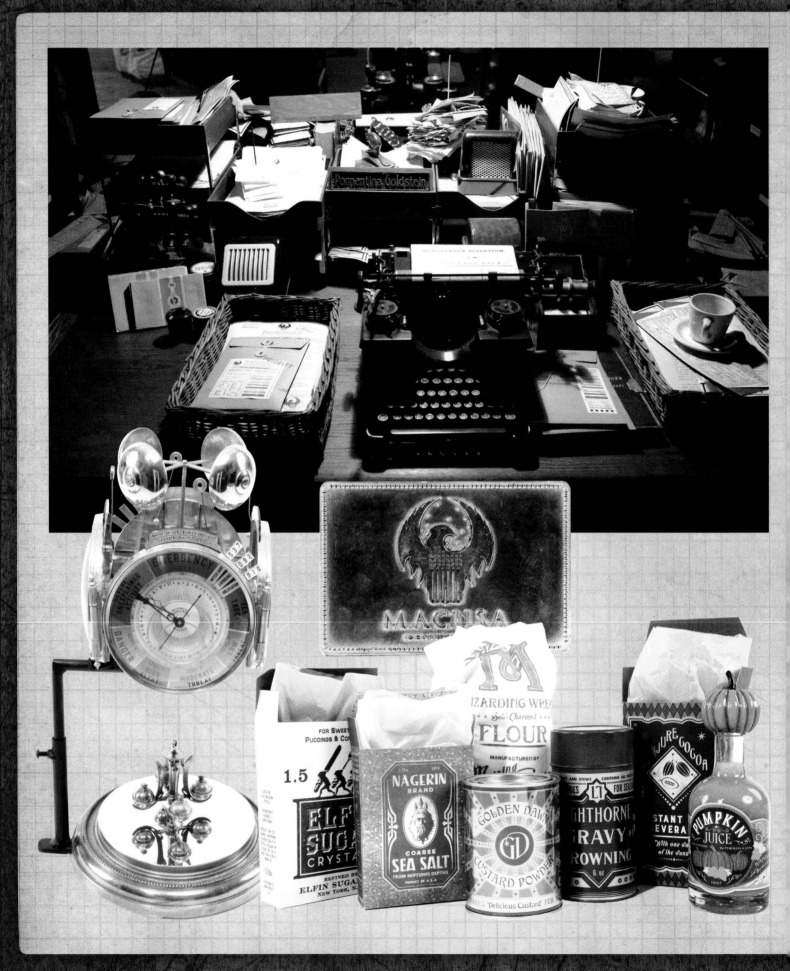

CREATING THE PROPS

Pierre Bohanna is well versed in the intricacies of the wizarding world having served as a supervising modeller on all the *Harry Potter* films. So, when a request comes through for an Ashwinder egg ('very translucent, almost like a snake's egg') or Mooncalf cowpat ('big') it is all part of the day's work. Nevertheless, compared with the strange appurtenances of Hogwarts, *Fantastic Beasts and Where to Find Them* has presented some varied challenges. The list of props – far too mundane a word to describe the incredible items Bohanna and his team have conjured up – crossed the spectrum from typewriters to New York street signs.

Most prominent are the hand props that belong to a particular character. Items that play their part in the story and with which the characters interact such as the wands, Newt's case, or Tina's ID badge. Here, Bohanna and Molly Sole would often work from concepts provided by the graphics department headed up by Miraphora Mina and Eduardo Lima.

The prop department was also responsible for the layers of intricate, not-to-say eccentric detail that defines the signature aesthetic that production designer Stuart Craig has created for the wizarding world. Items that might appear incidental, but tell you something about the characters. On Percival Graves' desk in the Aurors office there is a reduced-size version of the magical barometer from the entrance hall, as well as a giant light bulb that senses magical activity. Other props might be used specifically as sight gags such as the bejewelled, telescopic stick that Red, the dwarf lift operator, extends to hit the top buttons, or may be used to enhance the particular flavour of a setting.

'The musical instruments were really nice pieces,' says Bohanna, referring to the magical instruments belonging to the jazz band in The Blind Pig. 'Stuart Craig came up with the idea that there should be an upright piano but an upright *grand* piano. So we had to produce that, and it was slightly open so we had all the strings in it. Then the banjo player had about three different necks, it was like three banjos grafted into one. The brass player had about a dozen different types of brass and wind instruments gathered and hanging around him, held together by a magical charge, so that he could play multiple instruments. So we had to mount all these for real in the sense that they were all stood on blacked-out stands so they looked as if they floated in the air.'

Then there were props designed to connect the new film back to the *Harry Potter* series. 'Seraphina Picquery's throne was a riff off Dumbledore's original throne in Hogwarts,' reveals Bohanna. 'It's a Gothic-inspired piece, but much more regal and finished fully in gold leaf.'

While the beasts themselves would finally be rendered in CGI, the puppets used on set for reference also fell to Bohanna's industrious workshop, and each one came with a different set of remits. Award-winning puppeteers from the stage version of *War Horse* were employed to actually play the beasts.

OPPOSITE PAGE: (*Clockwise from top*) *One of the many typewriters sourced by Anna Pinnock.* • *A selection of store cupboard essentials in the wizarding world.* • *A miniature replica of the magical barometer. VFX later removed the black standing bar so it would appear to float on Graves' desk.* • *Tina's MACUSA ID card holder.* **ABOVE:** *A MACUSA paperweight.*

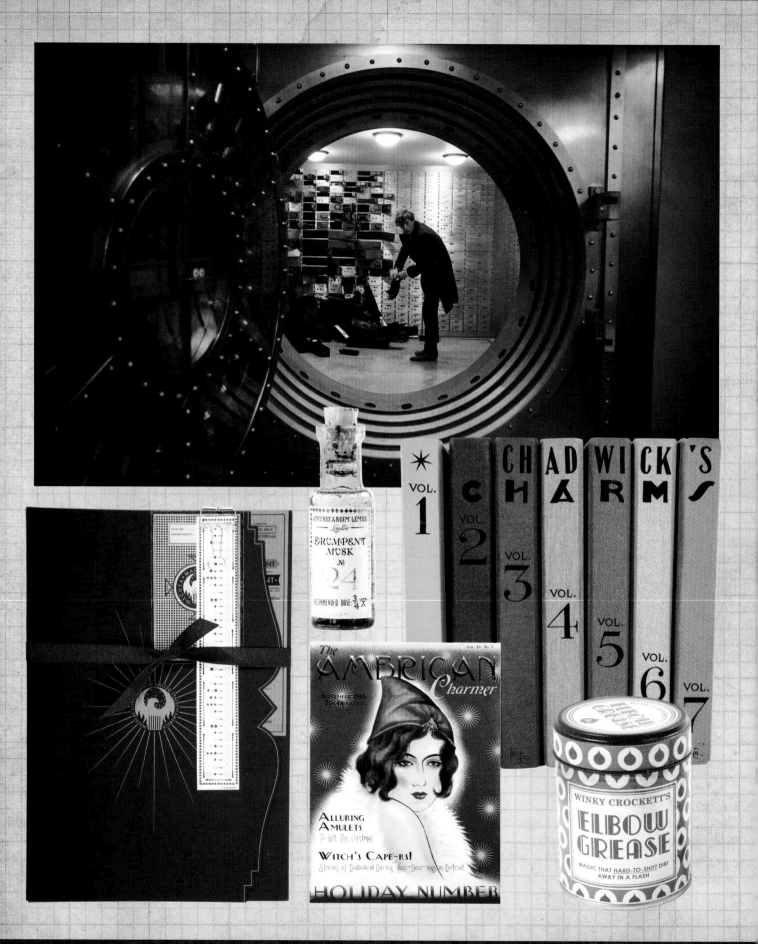

Some puppets were fairly rudimentary – the Demiguise was basically a fur coat for the actor to wear and cuddle Eddie Redmayne. Others more elaborate. 'The Erumpent was a big job,' claims Bohanna of the epic twelve-foot tall quadruped. 'Visual effects needed an in-camera reference to get scale and movement, so we made a puppet out of carbon fibre tubes for them to see a general size and silhouette.'

It was about as big as you could go and still be a puppet. The only interactive parts were the eyes and the last three feet of its horn which was hollow and translucent for the electrical department to install a lighting effect – as the female Erumpent gets more and more excited, the horn begins to glow.

On other days, Bohanna would be faced with the more commonplace but no less detailed challenge of helping to bring New York to life. Overall, while set decorator Anna Pinnock would source and populate the real-world sets with real pieces, it fell to Bohanna to create those No-Maj items that they simply couldn't find or were specific to their story.

'The street lights were a big, big job,' he says. 'In the main exterior set, along with many other things, we produced over forty twenty-eight-foot-high period street lights.'

For the bank sequence they had to make a full interior of the vault with 15,000 safe deposit boxes which all get thrown open. All the wall panels and the boxes were produced from scratch.

Bohanna estimates that three-fifths of what they did was to replicate the period rather than anything fantastical or magical. It took a 'colossal' amount of work to achieve Craig's authenticity. 'It's funny,' reflects Bohanna, 'when I first started on the film and realized it was specifically 1926, it took me a while to figure out why J.K. Rowling had chosen that period. But if you watch all the black and white films you become aware it is such a visually and stylistically strong period in America's history, especially for New York.'

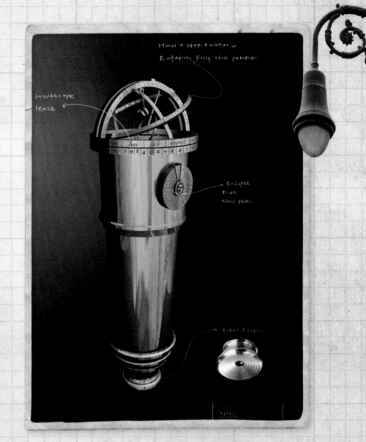

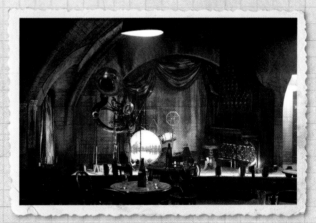

OPPOSITE PAGE: *(Clockwise from top) Eddie Redmayne wrestles with a Niffler puppet in the bank vault.* • *A complete, 7-volume set of Chadwick's Charms.* • *A jar of Winky Crockett's Elbow Grease.* • *A holiday issue of* The American Charmer *magazine, popular with young witches.* • *A MACUSA document folder together with a chart to record hex activity.* • *A tincture of Erumpent Musk.*
THIS PAGE: *(Right) One of forty full-size prop lampposts. (Top) Concept by Molly Sole of Newt's Lunascope. (Above) Musical instruments played by the jazz goblin band at The Blind Pig. (Left) A pastry version of the Niffler.*

NEWT'S CASE

6

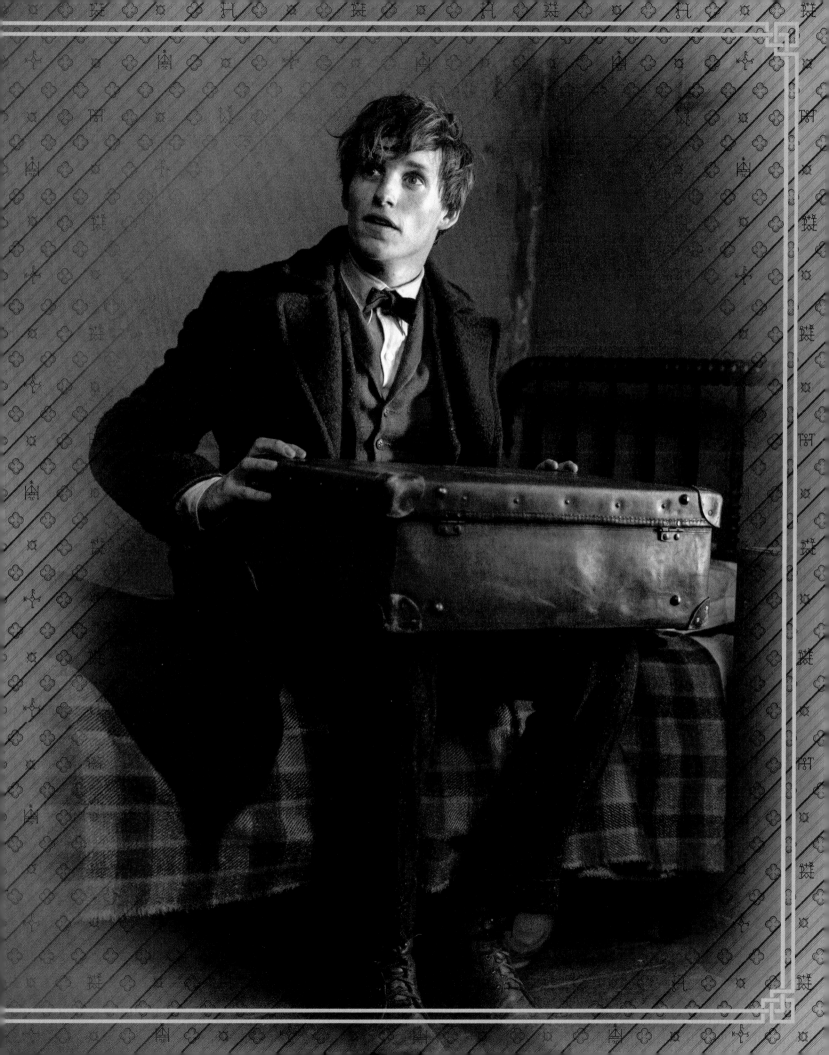

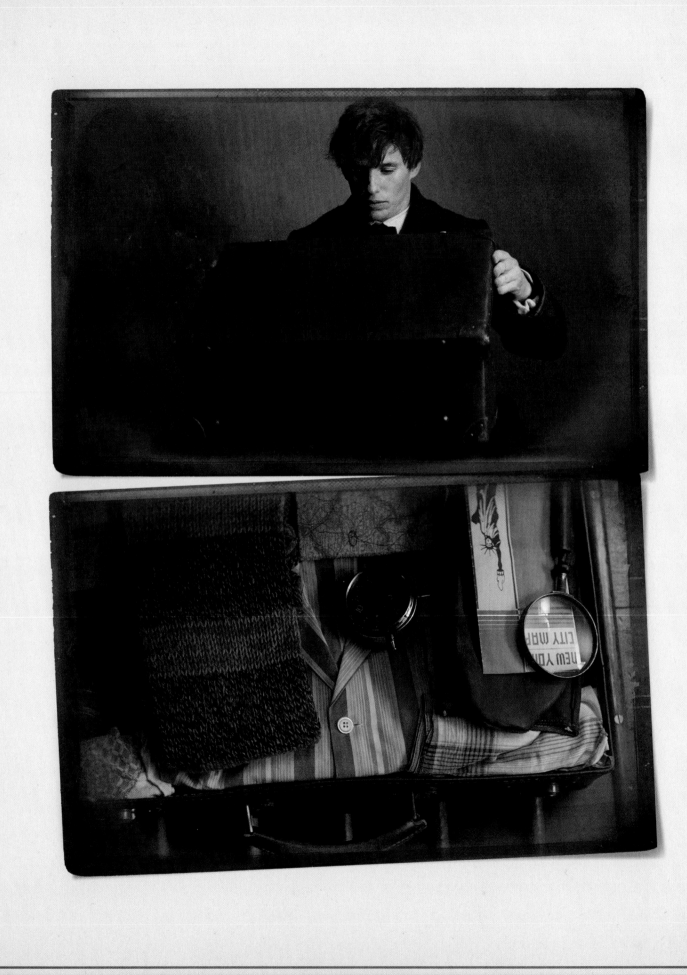

INSIDE NEWT'S CASE

AS NEWT SCAMANDER STEPS UP TO FACE THE STERN CUSTOMS OFFICIAL
AT ELLIS ISLAND, HE THUMBS A TINY SWITCH BENEATH ONE OF THE LOCKS
ON HIS CASE, CHANGING THE SETTING TO 'MUGGLE WORTHY'.

Upon inspection, all the case now seems to contain is a neatly packed selection of a New York City map, binoculars, magnifying glass, alarm clock, pyjamas, and Hufflepuff scarf... Nothing untoward.

However, when he resets the switch to 'Unlocked', rather like Hermione's beaded bag the case proves to be a great deal roomier. The primary purpose of Newt's humble luggage is one of the most astonishing inventions we have yet seen in the wizarding world. This is where to find the fantastic beasts.

'It's a huge, huge space down there,' says Eddie Redmayne. 'He keeps all these individual species in his case, which in itself is a sort of wondrous plethora of terrains.'

Here is the sum and substance of Newt's forthcoming book: field-notes, typewriter, manuscript and a cross section of the most extraordinary creatures known to wizard kind. 'All contained in something that you could take on a plane or a train,' says David Yates.

And from J.K. Rowling's incredible concept, the filmmakers have devised the magical case as a series of escalating reveals to the audience the further Newt ventures inside his tatty brown case.

'Newt's case is, in a sense, probably the most important prop we've made for this film,' declares Pierre Bohanna. After all, for much of the film Newt will be inseparable from his precious cargo.

In terms of how it looked, the idea was that this holdall has accompanied Newt around the world and is a bit battered and bruised. One of the catches keeps springing open. It is not what you would describe as entirely secure. It is also another object, like Newt's wand, which reflects his personality: a little scuffed and weather-beaten at first glance, but what is inside proves to be extraordinary.

'It started off with Anna [Pinnock], the set decorator, hiring in and buying lots of period cases to show the Davids and see what they like,' says Bohanna. 'Once they started boiling it down to a style they introduced Eddie to it, and with that they were able to get it down to a case.'

In fact, Bohanna estimates they boiled it down to a selection of two or three cases which had different elements of the ideal case: the weight of one, the latch of another, the handle of the third, etc. 'Then we started from scratch,' he says.

Combining all the elements, they manufactured their own case. One that could be reproduced multiple times to fulfil all the various filmmaking demands: stunts, close-ups, special effects. But all had to appear like they were the identical case. As Bohanna points out, in that era the original wouldn't have been leather but pressed cardboard with a 'leatherette texture', and

PREVIOUS: *'It was open?' 'Just a smidge.'* **OPPOSITE** (Top): *Newt checks that the contents of his case are all there. (Bottom): What you would see if you were a No-Maj.*

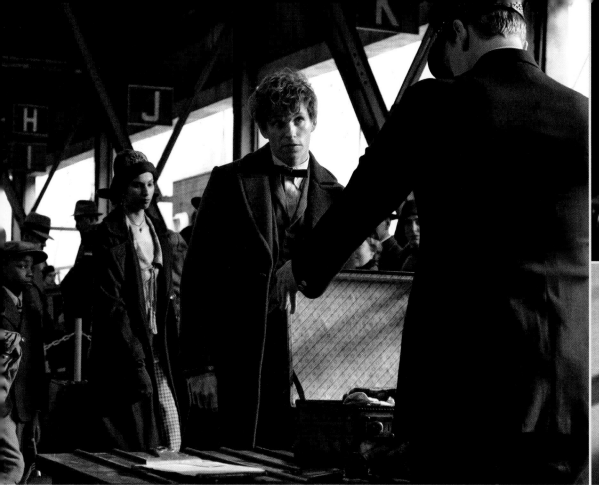

from an original model they created a mould adding in all the 'knocks and dinks' that come with years of loyal service. From this, lightweight carbon fibre versions were created for general use, and rubberized versions for the stunts. There were also versions with false bottoms for the sequence where Newt climbs inside.

As Bohanna notes, 'We also made the special latches that had security settings, where he has a little button underneath the main button that he pushes and it sets the different settings to disguise the case: Unlocked, Locked and Muggle Worthy.'

After all the kerfuffle of the Niffler's escape and being apprehended by Tina, Newt decides it is high time he do a head count of his beasts. Safely in the Goldstein's spare room with Jacob, he resets the catch, lays the case flat on the floor, opens it and steps inside. That, at least, is what it said in the script.

'Trying to work out how to get into the case was several months' work,' says Christian Manz, the visual effects supervisor.

They experimented with all kinds of ideas. Eight months of pre-production gives you a lot of time to kick things around. How Newt might project images from the case to lure the creatures inside. Or the case could come to life and swallow stuff. They put a lot of work into something along the lines of an optical illusion, trying to tap into the period and not make it, as Manz puts it, 'too science-fictiony'. The special case needed to be in keeping with the wizarding world's antique aesthetic.

'We overthought it in some ways,' Manz admits. 'At the end of the day it came back to a very simple thing which came from Jo in the script.'

Newt simply steps down into the case.

Why don't they have Redmayne simply do that? Cut a case-sized hole in a raised platform (technically a rostrum), line up some steps underneath, and the svelte actor would literally descend through the narrow opening. Once they had the right angle of attack – inspired by the tightly packed stairways between decks of a ship – it worked perfectly.

'He just steps into the case: it defies logic,' laughs Manz. Which was exactly the desired effect.

Furthermore, it could all happen in one seamless

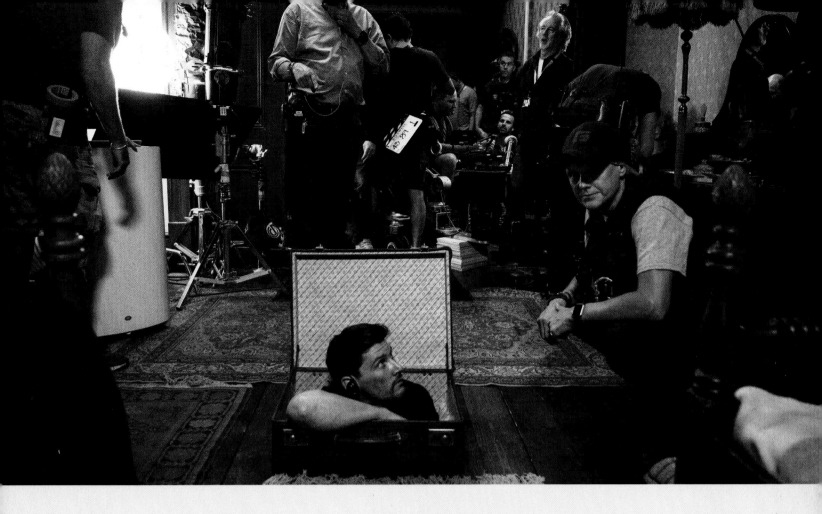

shot. Redmayne would climb out of bed, grab the case, 'register it' onto this hole and then walk down into it.

'But then Jacob has to follow after him,' says Manz. Stouter about the middle than Newt, Jacob will get stuck. Figuring out how to then squeeze him through helped the effects team conceive of how Newt managed to fit a 17-foot-long Erumpent through the case-sized opening. In a scene played for old-fashioned comic effect, a special version of the case was built that wrapped around the actor Dan Fogler like elastic. With a little digital help, Bohanna says, 'He pops through it like a cork out of a bottle.'

NEWT'S SHED

Down the narrow stairs, more of a ladder really, the first place we come to is the tiny, cluttered headquarters of a Magizoologist's intrepid life. Basically, it's Newt's shed. And it came from a discussion about particularly male habits. 'Men are better known than women for liking sheds as a refuge, as a place to be alone with your thoughts,' says Craig. 'And Newt is a very independent character: being solitary seems to be a necessary part of his life at times, and so we gave him a shed.'

While it might be cosy in length and breadth, it is vertically elongated. In other words, Newt and Jacob take quite a journey downwards before arriving at the floor. As they descend they pass all sorts of draw units, filing cabinets, little shelves. 'It's like an old apothecary's shop,' explains Craig. But there are hundreds and hundreds of these shelves containing all manner of herbs and medicines that Newt uses to maintain his world of exotic creatures. That is, as well as remedying the odd sting or bite.

At floor level, Newt's shed is like a window into his busy mind. Here are the tools of his trade: tripod cameras and a pickaxe, rope nets and collecting jars. Tacked on to the walls are notes and maps, drawings of beasts, even a few moving pictures of loved ones. He has a workbench, and a bed under the bench, along with a stove and an armchair. 'It is a great place for a man like Newt to be alone,' says Craig with a twinge of envy.

'David Yates liked the Heath Robinson approach,' explains VFX supervisor Tim Burke. 'Newt is a bit of a collector, and that is what the shed is all about. It represented his character. It was a bit higgledy-piggledy. On his travels he has picked up all these bits of ephemera.'

A line of potted plants decorates a shelf. Sacks of feed

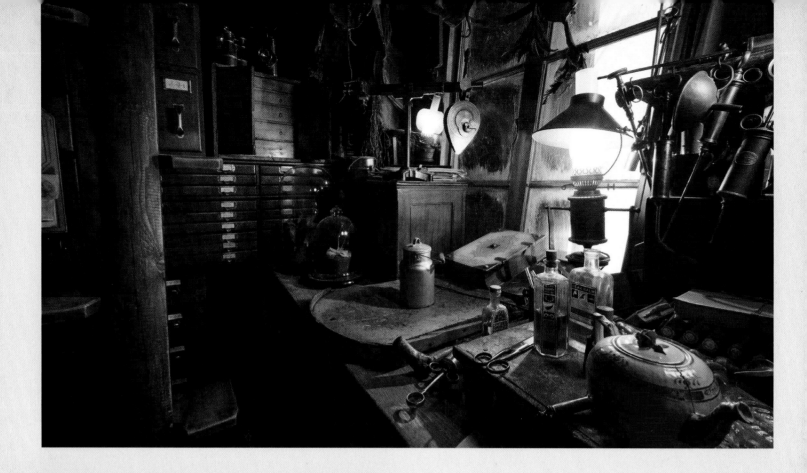

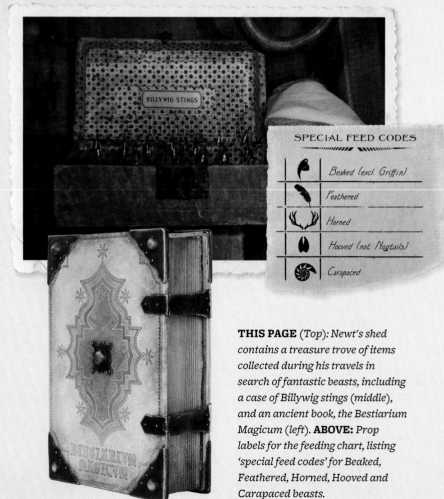

SPECIAL FEED CODES

🪶	Beaked (excl. Griffin)
🪶	Feathered
🦌	Horned
🐾	Hooved (not Nogtails)
🐚	Carapaced

THIS PAGE (Top): *Newt's shed contains a treasure trove of items collected during his travels in search of fantastic beasts, including a case of Billywig stings (middle), and an ancient book, the Bestiarium Magicum (left).* **ABOVE:** *Prop labels for the feeding chart, listing 'special feed codes' for Beaked, Feathered, Horned, Hooved and Carapaced beasts.*

are stacked against a wall and a dried carcass hangs on a hook. Pertinently, here too are the assorted potions and pills to deal with the after-effects of beast wrangling.

'Newt's case is his world,' explains Redmayne. 'It's his haven really. I mean Stuart Craig has built everything I could have dreamed of. It is his character described in the most intricate physical terms.'

It is in this haven we also see a well-used typewriter, a medieval bestiary (a request by J.K. Rowling) and a pile of manuscripts. This is where his magnum opus, 'Fantastic Beasts and Where to Find Them', is nearing completion.

At the far end of the shed a window peers out on to a dimly lit exterior beyond and a door leads onwards.

THE DECK

'It's amazing enough that you fall into the case and you're in a shed,' says Manz, 'then you just nonchalantly walk out and you've got this massive environment full of creatures.'

The visual concept Yates had in mind was for the camera to follow Newt and Jacob as the wizard gives an ever more astonished New Yorker a guided tour. The audience would see the fruits of Magizoology through Jacob's eyes. And having only just managed to take in

the shed, Newt escorts his new friend through the far door and into what Craig calls, 'the heart of the movie'.

'It is a film about fantastic beasts,' laughs Manz, 'and this is where we find them.'

The ones, that is, which haven't escaped.

'Inside the case is almost an Eden-like environment that Newt is in charge of,' says concept artist Dermot Power. 'It's not really explained where that came from or how it was developed; and you just felt that you didn't need to.'

In what proved one of the biggest visual effects challenges for the film, months of pre-production went into creating not only the different environments for each beast but also how the zoo-like collection functioned as a whole. Their initial reaction was to go with something epic. With a hint of the wardrobe into Narnia, the steps would lead Newt straight into a perfectly realised forest, and across a certain boundary you would see rolling waves and surf, and the horizon going on forever. It was an entire world.

However, J.K. Rowling pointed out that it would take a wizard more powerful than even Voldemort to create such a place.

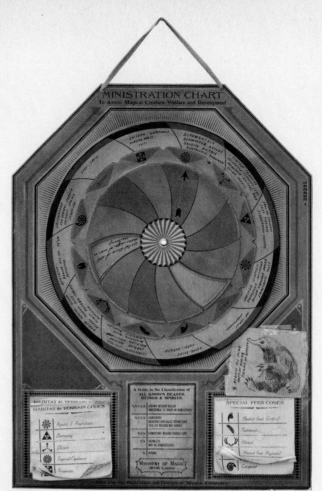

LEFT: *Ministration, or feeding chart for the beasts, indicating when and what to feed them.*
BELOW: *Concept art by Dermot Power depicting Stuart Craig's idea that Newt's shed sits atop a 'wooden dune'.*

'It was a diorama of infinite scale,' says Burke with a twinge of regret.

The key for Power was this idea that Newt happened to be more interested in dealing with beasts than becoming a good wizard. He realized that the results of Newt's magic would be 'slightly off, slightly clunky'.

The result was that their magical safari park became more homespun like the shed, albeit the size of an aircraft carrier. In the very distance we would just be able to make out the perimeter of the leather case, while in the foreground the shed would be sitting on a deck surrounded by a vast assortment of what at first look like museum dioramas. Only they appear to be alive.

'They are like living, breathing environments,' says Manz. 'But each one has a moving, painted background so the creature would go to sleep there.'

'We built the hut, partially, but without the roof, and all the deck around it,' recalls Manz, who first used pre-visualization software to map out the sequence. 'And then the entrance into each of the environments. We had a model, a real model, of what the whole thing would look like and we worked out what we would need.'

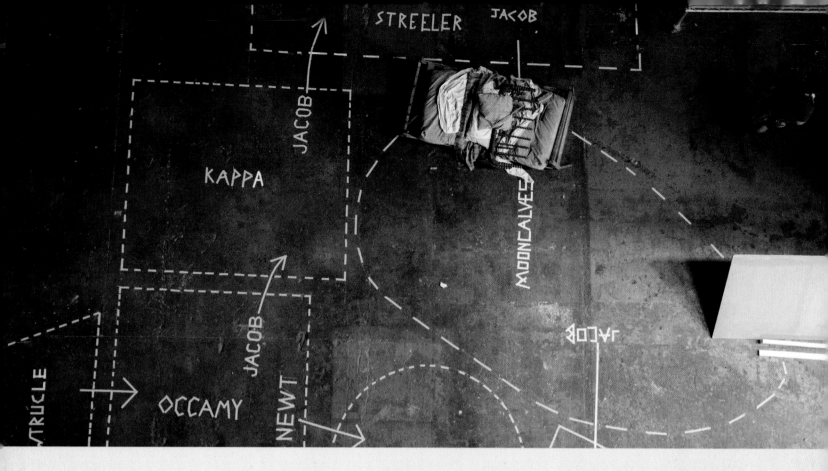

The ENVIRONMENTS

Everything within reach of the actors and close to the camera was constructed on the soundstage at Leavesden, while the rest was added digitally in post-production.

THE ENVIRONMENTS

For the props department, Newt's shed was a huge undertaking. This is where he stores all his equipment and looks after the creatures, so working with the set decoration team, as well as samples bottles, snares, nets and other tools of the trade, they found and produced all kinds of eccentric food and strange pieces of meat. Here too you'll find Billywig stings, and Occamy eggs whose shells are made of the purest, softest silver.

'They were basically electroformed silver and gold pieces on wax models,' explains Bohanna. A complex process that involves using an electrical current to plate a wax mould with metal particles from a liquid base. On camera, he says, the result looks magical.

'Also we did the Occamy nest,' he points out, 'which was a bit of a challenge.' The Occamy, a small winged serpent, lives in a bamboo forest and makes his nest out of bamboo, and it's a beautiful design. Bohanna explains, 'It bends the bamboo into rings so it has this stacked effect. It's about four foot high and about eight foot in diameter.'

Alongside the concealed MACUSA building, the multifarious way in which Newt's collection of beasts is housed in this magical inside-out case is the new film's most ambitious expansion of the wizarding world – a self-contained universe.

'It's one of the biggest sequences in the film,' confirms Yates. 'Newt introduces Jacob and us as the audience to this amazing world where he keeps all his beasts. That took a lot of R&D.'

Getting the design exactly right, says Power, is a philosophy the new film shares with *Harry Potter*. It is that same attention to detail. The sense they were uncovering a world that's already there and not just making stuff up. 'It's like we've just found it,' he insists.

Craig pushes his team to get to the essence of a set

ABOVE: *Floor plan showing Newt & Jacob's route through the beast habitats inside the case.*
LEFT: *Newt's potion rack for mixing antidotes to bites and stings.*

very real.' Beyond a flapping curtain is what might appear to be a fully realized snowy mountainscape, but it should look slightly off-key. And he adds that, 'in 3D as well, there will be optical tricks we are playing. There is going to be a weird sense of depth.'

Fogler didn't find it difficult to summon up Jacob's awe-struck reaction. This was one of the film's purest fantasy concepts. 'You walk into this case,' he says, chuckling at the how that sounds, 'and inside there are all these floating landscapes for all these different creatures. They pulled it off in a very tangible way. Technically they made it happen. And, you know, that's magic.'

There was a huge amount of discussion between J.K. Rowling, Yates, Craig and all the departments over the range of possible natural settings. Obviously, the starting point was the original book and then the script, but it was ultimately the physiognomy and temperament of each magical creature that influenced how each environment should be. So it became an

ABOVE: *Concept art by Dermot Power of the floating habitat of the Mooncalf, which is tethered to the shed floor to prevent it drifting off.* **RIGHT:** *Dermot's habitat of the tree-dwelling Bowtruckle.*

or a prop. In other words, what has motivated Newt to create such a place? The answer was to care for these beasts, albeit rather hastily: he's a Magizoologist who is always out in the field. Moreover, while wildly different and somewhat haphazard, all the environments had to appear like they were the work of the same wizard.

'So it's like he's done the most beautiful worlds he can do, and if they're a bit shaky he sort of makes sure they work,' Power goes on to say. 'He puts them back together. He doesn't take pride in being the greatest world creator. He's just pleased that the beasts are happy in the worlds that he's created.'

So it felt fitting that the backdrop to each environment would be a painting. But as they are magically painted, they would be massive landscape versions of the moving portraits in *Harry Potter*. In fact, the design process began with Power doing a few sample landscapes of how Craig wanted them to look.

'Just sections of the backdrop to give us an idea of scale,' explains Manz, 'and to be honest this was like a eureka-moment.'

From a distance they looked real, but when Manz got up close he could see the brush strokes. He thought, what if they reproduced that digitally? In other words, there should be something fake about the environments. 'Seen from outside they have this theatrical look,' says Craig, 'but when you enter them they become

exercise in hypothetically retracing Newt's adventurous steps through the world and working out how it would all fit together like a 3D jigsaw. An overall balance was important: like Newt's shed there needed to be a feeling of well-tuned clutter.

'We were pinning up pictures on the wall daily,' says Manz, recalling their process of elimination. 'We'd pin up creatures with pictures of real places and try to create a journey.'

It wasn't just about how exciting it might look; they had to keep in mind how dynamic each setting might be. One couldn't overwhelm another.

'Visually you wanted to go from seeing somewhere cold, somewhere hot, somewhere green, somewhere desert – a contrast of experiences,' says Manz, noting that each environment would also have to subtly interact with its neighbour. As Newt and Jacob pass from the snow to somewhere sweltering hot flakes of snow would turn to rain.

'Plus, the experience should be escalating as we walk round,' he continues. 'It wasn't just in terms of, "Wow, that looks cool," but what we could do to make it magical.' Each setting, he says, should demonstrate some facet of how Newt's wizarding powers are focused on these creatures, and what that says about him.

Incidentally, Power theorized that in the dark gaps between the environments, we might glimpse other environments. 'So there's a suggestion this is quite a complex place – you wouldn't have time to see them all.'

While it wouldn't do to give away all the wonders inside the case, what follows gives a small taste of the many compartments in Newt's magical case.

The very first environment Newt and Jacob come to is a version of the bone-dry desert of Arizona, home to the Thunderbird. Next door is one more like the Atacama Desert, a cooler desert found in Chile and the natural habitat of the extremely aggressive, hump-backed Graphorns. Both are as ecologically accurate as possible.

Then Power's designs begin to get more adventurous.

'Like this small cave which is contained within a Chinese pagoda,' says Manz. 'The whole thing unwraps around you like a pop-up book and you're in this massive cave where we find the Runespoor, which is a three-headed snake.'

The bamboo forest is for the Bowtruckle, the Occamies and the Demiguise. The Demiguise nest was the subject of some interesting debate. 'I put books

MAIN IMAGE: *Concept art by Dermot Power showing Newt standing in the arid American habitat native to the Thunderbird.*
INSET: *Concept of the Fwooper by Paul Catling.*

in his nest,' says Power, knowing it was kind of crazy. 'I mean, does he read? Then David thought, "Well, maybe he does."'

Then came the discussion of what kind of book? Would it just be a picture book? How smart is a Demiguise? Which gives a tiny window on to the kinds of discussion they were having.

Below a set of giant light bulbs around which flutter tiny, fairylike Doxies, is the aquatic environment for the Grindylows. These pale green water demons will be familiar from the Triwizard Tournament underwater sequence in *Harry Potter and the Goblet of Fire*,

and they are kept in a zero-G water bubble that floats around. 'As Newt's magic doesn't quite work properly,' laughs Manz, 'the water is spilling everywhere.'

In all of the design considerations for this extraordinary place, one thing was essential – the possibility of escape. As Manz points out, there are no bars. Newt would never cage his beasts. They needed to tell the story of how these creatures get out, and it came back to the fact that his magic is less than reliable. As Manz explains, 'the magic he is using to contain them sort of works, but doesn't work. It's a bit like him, a bit shambolic.'

THE FANTASTIC BEASTS

7

TAMING THE FANTASTIC BEASTS

WE MAY HAVE SEEN SUCH WONDERS AS A HIPPOGRIFF, A BASILISK,
A DRAGON (HUNGARIAN HORNTAIL BEING JUST ONE EXAMPLE),
SOME CENTAURS, AND AN EIGHT-LEGGED ACROMANTULA OR TWO
IN THE *HARRY POTTER* FILMS, BUT *FANTASTIC BEASTS AND WHERE
TO FIND THEM* WILL TAKE MAGICAL CREATURES TO A WHOLE NEW LEVEL.

It is a story centred on one wizard's lifelong dedication to the unpredictable world of Magizoology. The beasts were the reason the film existed. They are Newt's life's work, defining him as a character. The fact that some of them have absconded from his case is what drives the story.

So the beasts needed to be fantastic – it was right there in the title.

'I think we have more creatures in this than we've had in all the Potters combined,' calculates producer David Heyman. 'So it's a rich canvas with incredible opportunities. For our visual effects team, for us as storytellers, and I suspect for the endless merchandising opportunities!'

For director David Yates the key has been to think of magical beasts as actual wildlife. The audience must totally engage with them as real animals so that they don't feel like fantasy. He explains that, 'There's a whole vernacular of fantasy creatures that feel like they've come straight off the drawing board and onto the screen, and they lack a sort of reality. However extraordinary they are, however crazy they might appear, I wanted the audience to believe ours could be real.'

Each unique species was a character in its own right, but they should also cohere into a family that currently resides inside Newt's remarkable case. It's worth noting that, in the wizarding world, a 'beast' is defined as a magical creature that does not have enough intelligence to grasp the laws of the magical community. With a few exceptions (the aforementioned Centaurs and giant spiders) they cannot talk.

However, the script was asking for levels of interaction wildly beyond anything ever achieved in a *Harry Potter* film. This wasn't only a matter of designing a creature, but understanding their nature. If an Occamy were lost in New York, what would it do? Where would it hide?

They needed to think like Newt.

Beginning early in pre-production, the challenge united director, producer, production designer, fifteen concept artists, and specialist puppeteers with the visual effects team who would finally be responsible for bringing the beasts to life. 'It has been a massive collaborative process,' confirms animation supervisor Pablo Grillo. With J.K. Rowling scrutinizing every horn, wing, scale or sac of luminescent serum they

PREVIOUS: *The Niffler makes its bid for freedom.* **OPPOSITE:** *Newt & Jacob
(wearing Newt's homemade armour) arrive at the zoo in pursuit of the Erumpent.*

come up with. Yet she is full of nothing but praise for the results: 'I can tell when something's being really conceived with love and the skill that's gone into making the creature serves the creature. This thing has a soul and a personality.'

DESIGNING THE BEASTS

At the heart of the process were the visual effects supervisors, Christian Manz and Tim Burke along with the irrepressible Grillo, who would reveal a useful talent for aping the movement of a potential creature. They also began by studying the descriptions J.K. Rowling had given in both the book and the script.

Burke explains that within the art department the beasts were thought of in two categories: 'what we called "Hero Beasts" – the ones that essentially escape into New York that Newt must try to find – and then we had the "Second Tier" beasts, which are the ones that live in the case.'

With the Hero Beasts it was clear J.K. Rowling had selected them, first and foremost, to offer a range of exciting set pieces. But they also charted a large range of moods and experiences from the funny to the perilous. The Niffler, for instance, is a charmer. The Swooping Evil far more formidable.

'They all say something about the relationship Newt has with these beasts,' says Grillo, 'and that can be manifested in something mysterious and action packed. The idea was to get a balance across the film.'

The next stage was to begin a visual investigation of how each creature might look. They held big think-tank meetings with the concept artists, spending entire afternoons sketching ideas and discussing the results. Each beast needed to tell its own story quickly and clearly, so the audience could grasp how they work. They were also searching for the dramatic potential in a beast and what it could reveal about Newt. Both Jacob and Tina come to understand so much more about this peculiar wizard when they see him interact with his creatures.

'It was also about what you could get out of a sequence,' says Grillo, 'how entertaining our beasts were for an audience to watch. All these things were thrown onto the table.'

Honing in on concepts they felt were working, a two-dimensional design was then turned into a 3D sculpture (or maquette), which was scanned into the computer. Then they began animation studies.

Heyman explains that how a beast moved helped define how it looked and vice versa. 'We also brought the sound team in at the beginning to integrate the sound with the design and the movement.'

It was a fluid process. Some ideas ended up being blended, while certain beautiful concepts were found to be totally impractical once they started moving. 'Quite often we would discover that the design didn't work,' admits Burke.

Manz describes it as 'a voyage of discovery': sketching ideas, trying out movements, sounds, investing them with personality, testing them, and then showing them to the director to see if they had, well, legs.

OPPOSITE (*Left*): *This final still captures the Demiguise looking thoughtful.* (*Top right*): *Concept art by Dan Baker of the Swooping Evil, showing it curled up in its protective shell and unfurled in flight.* (*Bottom right*): *Early concept art by Dermot Power of Newt's shed.* **TOP:** *Early concept art by Dan Baker of the Thunderbird in flight.* **ABOVE:** *The Niffler, as drawn by Adam Baines, here stuffing a beggar's coins into its pouch.*

OUTSIDE THE CASE

The first beast out of the case, unsurprisingly, is a Niffler. Tricky little fellows these – they resemble a combination of platypus and mole, even a ferret, with an eager eye for anything that sparkles.

'The Niffler is the bane of my life,' groans Eddie Redmayne, who developed a unique relationship with each of his Magizoological co-stars. 'This beast just has this rapacious appetite and will eat anything. And he loves shiny things. Anything that glints or sparkles is right up his street. Newt has a kind of love-hate relationship with him.'

The design team explored a mix of charm and mischief. Vitally, the Niffler's anatomy had to be funny. Grillo talks about putting him through his paces as a performer: 'You start to develop the gags, the motions, and feed that back into what the character needs to look like.'

One of the most challenging aspects in designing any of the beasts was maintaining the authenticity Yates felt was so necessary. They found it helped to imagine what it must have been like for the explorers who first set eyes on, say, a giraffe.

ABOVE: *Final image of the Thunderbird.*
BOTTOM: *Final still of the Murtlap, which will prove to be one of Jacob's least favourite beasts.*

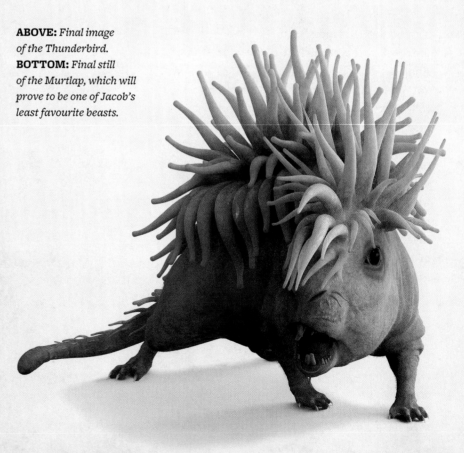

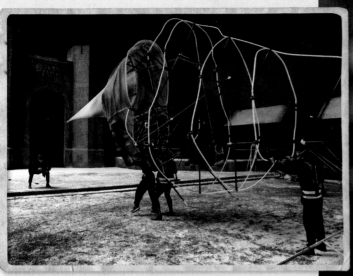

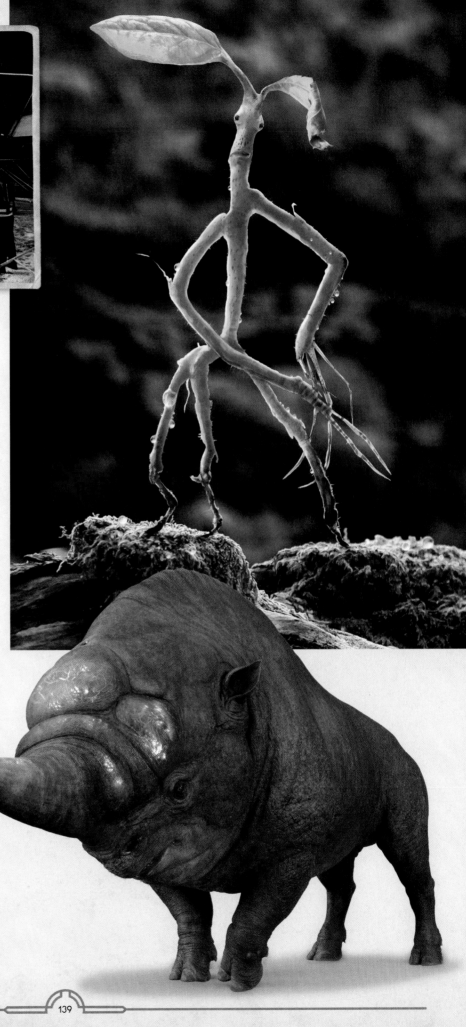

Grillo explains: 'It's real, you buy it, you completely believe that it's an animal, but it's extraordinary: look at that neck, look at its colouration.'

Once you start crossing over into the world of monsters with tentacles and whatnot things stop being believable. The female Erumpent is a good example. She's a four-legged grazer on a very big scale, somewhere between a rhino and a bull, and no more expressive than a cow. Pay close attention, and an Erumpent horn can be spotted in Luna Lovegood's house in *Harry Potter and the Deathly Hallows: Part 1*, and another on the wall of the Leaky Cauldron.

They had started with a basic quadrupedal version everyone responded to. But over time it became more and more elaborate. It ended up seriously big. And as soon as they started putting it into shots, Yates decided it had become 'far too fantasy'. So they rolled their design backwards to where it had been six months earlier, back to the grounded version.

'It immediately looked right in a real-world environment,' says Grillo, noting that when they say grounded she (for our Erumpent is a female) does feature an iridescent fluid sac on her head that glows at night. Counterintuitively, they found the character of the Erumpent suddenly resonated. And Grillo says, 'One of the other things

ABOVE: *Eddie Redmayne prepares for Newt to encounter an Erumpent, which even only in wire-frame form, still takes four crewmembers to operate.* **TOP RIGHT:** *The Bowtruckle, as drawn by Martin Macrae, one of numerous designs produced as the team attempted to make it look both friendly and formidable for the film.* **RIGHT:** *A final still of the female Erumpent.*

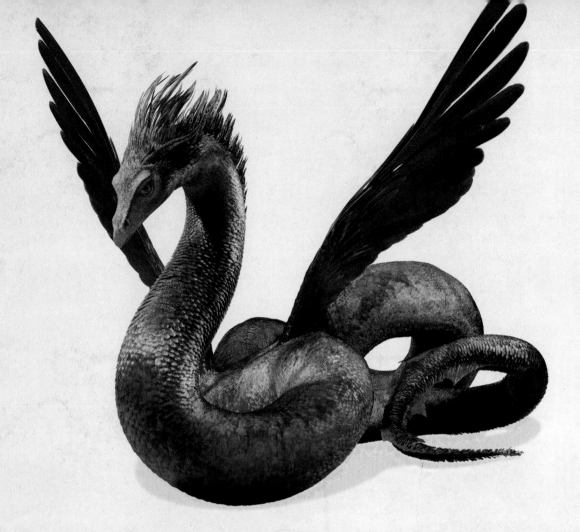

that forced judgment one way or the other was whether you could easily tap into the personality of a character.'

Indeed, it was vital for Yates that the Erumpent be sympathetic. 'There is something about the Erumpent that is really beautiful,' the director thinks. 'The fact that you can imbue this creature with its own desires and its own agenda.'

'She has a good pace on her, and this horn that punctures serum into things that then explode,' notes Redmayne matter-of-factly. 'Seducing the Erumpent was a massive high point for me.'

What they found to be true for both the Niffler and the Erumpent was that as soon as they felt authentic it allowed them to concoct more elaborate jokes. Set pieces were transformed into slapstick routines with the manic energy of a Looney Tunes cartoon.

On other occasions, it was a beast's magical nature that was the punchline. The attempt by Newt and his friends to corner a three-foot-tall, ape-like Demiguise in a department store is severely hampered by its ability to become transparent. In fact, its fur is used in the manufacture of Invisibility Cloaks.

Early on, their Demiguise looked more obviously like a monkey, but that was found to be too ordinary. The director wanted him to be more of a 'haunted, old wizened character', says Grillo, which meant going to places 'way beyond primate'.

'He's like a chimp meets Yoda, basically,' declares Dan Fogler, whose character Jacob proves invaluable in Demiguise hunting.

Moreover, rather than simply being able to turn invisible, which felt far-fetched, they went for something more chameleon-like. 'He takes on the look of the environment around him,' says Burke, who claims that they were actually inspired by the work of Japanese artist Liu Bolin – known as the 'Invisible Man' – who photographs himself painted to match his background with uncanny accuracy.

The Demiguise also has precognitive vision.

'It can see different versions of the future,' says Yates. Which means he can predict who is most likely to catch him. Therefore, it is the least likely person who has the best chance of snaring a Demiguise.

'What I love about what Jo's written is that not only has she created all these amazing beasts, but a relationship between the beasts,'

TOP: *The Occamy spreads its wings.*
BELOW: *Prop Occamy shell fragments which Jacob will find in his case.* **OPPOSITE** *(Top): Newt and Jacob examine a silver Occamy egg for signs of activity.*
OPPOSITE *(Bottom): The Billywig, which spins as it flies, as it appears in the film.*

enthuses Redmayne. 'The Demiguise has such heart, and sort of babysits the Occamies. When one of the Occamies escapes, the Demiguise goes out into the real world, which is a wildly terrifying place, to make sure it is going to be okay.'

By the way, the serpentine Occamy not only lays solid silver eggs, it is 'choranaptyxic'. In wizarding terminology, this means it expands to fill any available space. 'I don't know if that word actually exists,' muses Redmayne, admitting it has caused him no end of problems working out how to pronounce it. 'I had a long, long discussion with the dialect coach,' he laughs.

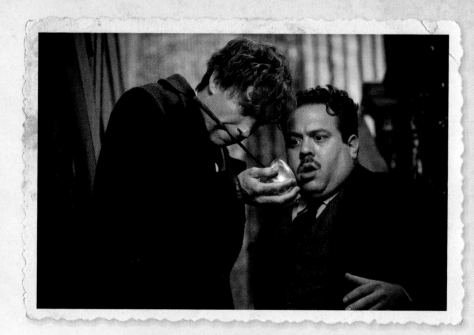

It doesn't end here; there are further beasts keen to see the sights of New York. For instance, the Murtlap, which looks like a rat and sea anemone combined; the pocket-sized, stick-limbed Bowtruckle; and the Swooping Evil, which expands like a pop-up tent from the size of a conker into a winged horror: part-bat, part-butterfly, which can suck out people's memories.

'But Newt's got complete control of it,' says Manz, and this was one more consideration. Their wizard wasn't an action hero – he uses the beasts to get him out of a scrape.

INSIDE THE CASE

Of course, not all the beasts get out. There are those left inside in the comfort of their environments, like the Mooncalves (vaguely similar to mountain goats, who can only look upwards) and Yates' favourite, the formidable Graphorns (a cross between a cat and dinosaur with two huge horns).

Within the case, the immediate challenge was to root a beast's design to its environment. So we can see the connection immediately as Jacob is given a guided tour. Playing on ecological themes, J.K. Rowling's script brought magic and science within touching distance.

How they look often relates directly to where they come from. The bigger beasts came from bigger environments, such as the Graphorn, who dwells in the case's version of an African savannah. The Bowtruckle, among the hardest beasts to get right (they did over 200 concepts) is essentially a three-legged stick with a plant-like exterior. It has the awkward, tell-tale physicality of British woodland.

'You can feel through their form and their habitat some form of ethnicity in a sense,' says Grillo, 'the way we do with real animals.'

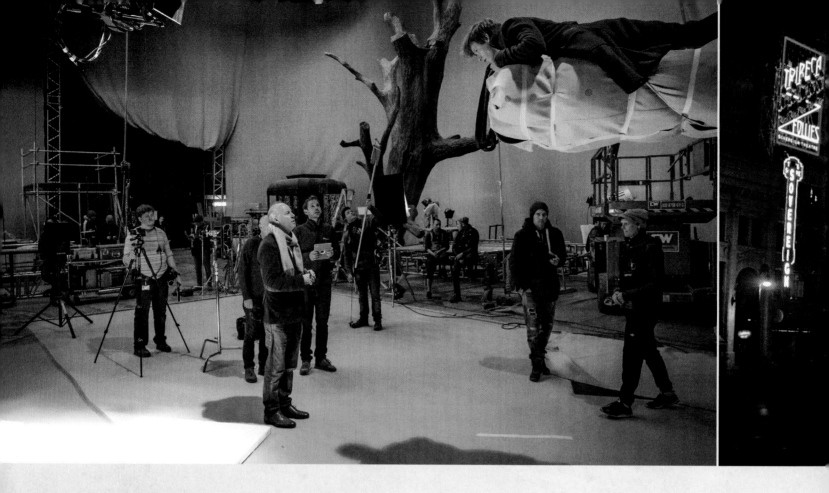

THE PUPPETS

The finished creatures, for the most part, are rendered in layers of exquisitely textured CGI across months of post-production (during which time there has been the opportunity for further design evolution). However, rather than the cliché of a tennis ball on a stick, the team created puppet versions of the beasts to be used on set.

'It was important for Eddie to have something to relate to,' explains Grillo. This began quite simply, with another actor standing in for whichever beast so that Redmayne could make eye contact and react more spontaneously. Then they thought why don't we build something that's at least to scale? This had the bonus of giving the cameraman something to frame on and reference points for the digital animators. They could literally see what a beast looked like in a scene.

'Suddenly, you're like, wow, that's huge!' laughs Manz.

The prop department were commissioned to make scale replicas, ranging from supervising creature puppeteer Robin Guiver standing on a box wearing the head of a Thunderbird, to a fully articulated model of the Erumpent, which required four different operators at once. Meanwhile, Grillo became so attuned to a Niffler's brainwaves, he could jump into shot and instinctually respond as the erratic critter might: 'What would the Niffler do in this situation? Well, I feel he would probably react like this.'

But it was Redmayne who truly benefitted. He was able to respond naturally to the puppets because the puppeteers were giving performances. It made the beasts more unpredictable, more animalistic. And the actor began developing movements, hand signals and an array of voices with which to soothe the creatures.

'One of the most enjoyable parts of the film,' he says, 'has been trying to find the noises that calm them or seduce them, to sort of bring them in line.'

It was a one-of-a-kind role.

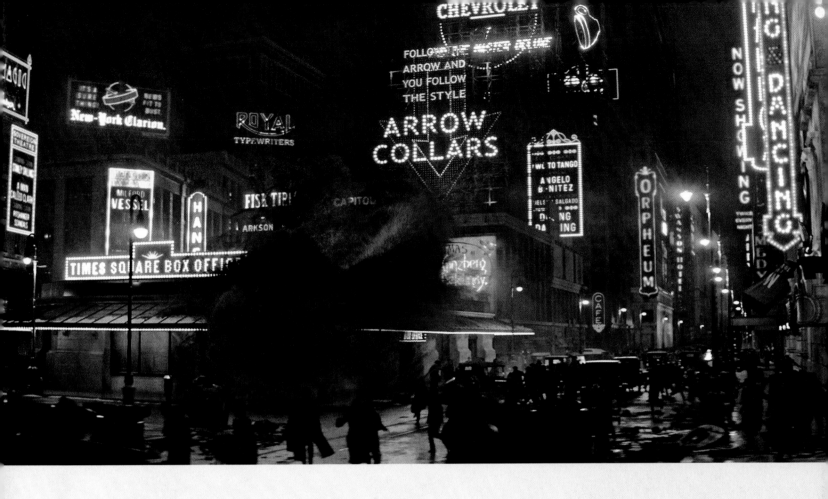

THE OBSCURUS

Haunting the story is another creature entirely, something that has broken free in New York but not from Newt's case. A creature powerful enough to throw cars across the street and blow manhole covers into the air but which nevertheless remains elusive. While its nature and whereabouts baffle the top Aurors of MACUSA, Newt has a good idea that it is an Obscurus. He may also know how to deal with it – not that anyone is listening.

'It's a manifestation of Dark magic,' explains Yates. 'It's really a wonderful idea that Jo came up with. When a young child is prohibited from developing their magic in a healthy, organic way, then this dark energy can develop, and the dark energy can suddenly get out of control and wreak havoc.'

The real story, he says, is that for all the fantastic beasts disrupting the city, the most dangerous one exists within. 'A beast that has been created in ways that feels sadly familiar.'

Who the source of the Obscurus might be is the film's chief mystery, and will provide the film's most fantastic climax.

OPPOSITE (Top): David Yates directs Eddie Redmayne as he hangs suspended from a padded beam that will become the Occamy in post-production.
OPPOSITE (Below): Concept art by Paul Catling of the Mooncalf, which has evolved so that it can only stare upwards at the moon. **TOP:** The Obscurus is unleashed in Times Square. **ABOVE:** Concept art by Peter Popken of a mysterious figure standing in the subway beneath City Hall.

Published in 2016 by
Harper Design
An Imprint of HarperCollins*Publishers*
195 Broadway
New York, New York 10007
Tel: (212) 207-7000
Fax: (855) 746-6023
harperdesign@harpercollins.com
www.hc.com

Distributed throughout North America by
HarperCollins Publishers
195 Broadway
New York, New York 10007

ISBN 978-0-06-257132-8

Printed and bound in USA

First Printing, 2016

Project Editor: Chris Smith
Editor: Georgie Cauthery
Design & layout: Simeon Greenaway
Production Manager: Kathy Turtle

HarperCollins would like to thank David Heyman, Victoria Selover,
Elaine Piechowski, Melanie Swartz, Jill Benscoter, Gina Cavalier & Niki Judd.